THE ACCOMPLICES:
A #RECURRENT Book

theaccomplices.org

THE ACCOMPLICES

Experiments in Joy

by Gabrielle Civil

collaborations & solos

"The curtains opened and closed and opened and closed and the audience refused to release the stars. Flowers were brought to the stage... When the curtains closed again, they exchanged places... When the curtain closed for the last time, we hugged each other and danced with ecstasy... They loved us, we loved them. We loved ourselves."

—MAYA ANGELOU
Singin' and Swingin' and Gettin' Merry Like Christmas

... this is my heart, these are my friends...

Awilda Rodríguez Lora
Dennie Eagleson
Duriel E. Harris
Ellen Marie Hinchcliffe
Kenyatta A.C. Hinkle
Lewis Wallace
Madhu H. Kaza
Michelle Naka Pierce
Miré Regulus
Moe Lionel
Nicolas Daily
Rosamond S. King
Sarah Hollows
Sayge Carroll
Stephen Houldsworth
Sun Yung Shin
Wura-Natasha Ogunji
Zetta Elliott

"and palimpsest / and intelligence / and glow / and you"

tell the truth

Dear Reader,

Preparation for ritual is ritual.
How shall we start this time?

Ellen told me ntozake shange came out in a white bustier & white satin robe air-boxing to some song. Ellen didn't say which one, but I imagine Willie Colón or my Detroit homegirls Martha & the Vandellas, "Dancing in the Streets," which we need to be doing right now, with dancing as a form of resistance & kicking up our heels to knock down walls. ntozake was bobbing & weaving, a black woman artist dispelling demons & conjuring glamour.

Then she smiled & opened her book & read her poems. Let's do something like that.

Get ready.
This book is a lot of things.
A mixtape of memory and fortune-telling.
A compendium of collaborations and solos.
Hidden figures shining into light.
the black woman performance artist between windflower and sea.
girls in their bedrooms.
prisons and classrooms.
rock stars and bugs.
hot combs and molecular extinction.
This book is a lot.
Really, this book is a lot of people.
My friends, blood and chosen family, ancestors, artists, muses, students, and multiple versions of myself.
Still remembering.

Still coming of age.
Now trying to claim joy.

What joy?

Right now, threats to the earth, the water, the land,
the sky, the young, the old, the black, the brown, the
female, the femme, the queer, the trans, the disabled, the
Muslim, the migrant, the scientist, the artist, the press, the
word, the constitution, the human, the animal, and every
other being have never felt more dire.
It's Book Five Harry Potter. For real.

So what then in the middle of this mess
might it mean to claim joy?

ntozake arrives in her satin robe, dancing her fists in the
air, ready to declare her voice. I wasn't there, but I love
this story so much, passed on through kindred as legend.

This opening was an experiment in joy
in real time and in this book.
A call and response. A shifting of modes.
An attempt to set it off in a new way.

To claim joy at a moment of siege
may seem selfish or delusional at first.
(Making performance art may seem this way too.)
But hum through the galleries of Adrian Piper's show.
Check out Howardena Pindell's "Free, White and 21."
Shimmy your fingers before Betye Saar's "Mojo Hands."
Behold their gifts of living presence.
Behold the legacy of black feminist ancestors.

Read ntozake shange. Lucille Clifton. ("won't you

celebrate with me.") June Jordan. Audre Lorde.
Suzanne Césaire. Jayne Cortez. Jacqueline Beaugé-Rosier.
Laurie Carlos. Octavia Butler. Katherine Dunham. *Ase.*
These ancestors don't just rest in power, they radiate it.
Black feminist joy does not disown awareness of systemic
injustice. It does not deny oppression; it defies it.
It doubles down on the imperative to imagine against the
status quo. To dream bigger. With satin & song.
With flesh & mind & fancy footwork. Don't you crave
this sweat and glow? So urgent and so lovely. Let's dance
and move and write and start some shit and change the
world and make art by ourselves and with our friends.

(What can people do together that we can't do alone?
What can we discover in ourselves only by way of other
people?)

Reader, I'm so happy that you're here.
Even as I worry that this book is not enough,
that I'm not _____ enough,
I'm still giddy at your presence.
Before we get going, will you breathe with me?
We can ground ourselves, light a candle
and honor the first stewards of this land.
We can nick a boat and sneak off to this island.
Wait, that's Björk. We can dance to Prince!
We can curl up under the covers and sip tea.
We can reread *Freedom Dreams*.
We can drink wine or sweep or clean the house.
We can scream whatever we want at the top of our lungs.
(FAT BLACK PERFORMANCE ART!)
If you're willing, we can make this invocation.

We pull strength down from our ancestors.
We pull energy up from our ancestors.

We press ourselves further down into the ground.
We take power from each other and bring it to ourselves.
We take power from ourselves and bring it to each other.

Enjoy,

Gabrielle Civil
December 2018

Experiments in Joy

"In these matters there is also something
we are eager for you to understand:
when particles are borne by their own weight...
they swerve a little—not much, just enough
so you can say they have changed direction."

–Lucretius (trans. Ian Johnston)

a swerve...

"Is it worth it? Let me work it.
I put my thing down, flip it and reverse it."

–Missy Elliott

Jane Blocker
Wed, Jun 7, 2017 at 6:03 PM
A Decade Old Apology

Dear Dr. Civil,

I apologize for writing you in email, but this is the most current address I could find for you, and I am hoping this will reach you.

I am writing to express my profound, horrified, abject regret about not having contacted you long ago in response to the lovely letter you sent me in 2006.

I'm not entirely sure how this happened, but not long after I received your letter, I was moving my office from one floor to another, and I must have tucked it away thinking I would reply once I was in my new space. It was such a beautiful letter—hand written in pale blue ink—that I'm sure I set it aside thinking "This requires a thoughtful and commensurate response." But marking it out as special seems to have sealed its fate. I feel positively ill at the thought that I never got back to you until now (the result of another office move and cleaning out accumulated papers).

I hope you will forgive this ridiculous lapse, especially since it seems you are no longer at St. Kate's, where I might have met with you in person.

I see from your online profile that you are originally from Detroit, a place that is dear to me from having taught at Wayne State for three years (in a post-doc) after getting my PhD at Chapel Hill. Your performance and writing are so interesting, and I wish I'd been able to pull my head out of the sand of teaching, research, and day to day distractions so as to havemade contact when you were here.

Along with this little digital note, I send along a large bucket of apology and my warm regards.

With every good wish,
Jane

Jane Blocker
Art History Department

Gabrielle Civil
Mon, Jul 10, 2017 at 5:19 PM
Re: A Decade Old Apology

Dear Jane,

Thank you for your kind letter. Wow. Perhaps much like what happened to you in 2006, I read your message immediately and wanted to craft a thoughtful response, and so time has flown by... And in a way, your timing is impeccable. After years of feeling blocked, stuck, disconnected, left out and left behind, I have been having a spell of manifestation. Or maybe I just cast one.

My book *Swallow the Fish* came out in February, so for the last 6 months, I've been touring, performing, reading, visiting classes and giving workshops. It's been a dream come true. I love teaching and, if I'm honest, actually love being a professor, but it was crucial in my life to quit my tenured post (for the second time) to step away for a minute. And part of why I needed to do it comes from what you mentioned about high-powered academic life. What is it about the academy that makes the most beautiful things of life "teaching, research," professing and constructing knowledge, pull us away from life? From possibilities of community?

Let me keep it real with you, Jane Blocker. It hurt my feelings

when you didn't respond. I sent that letter to you at a time when I was building myself up as a performance artist, brick by brick, trying to reach out to anyone with knowledge and insight to help me grow and become the kind of artist I wanted to be—and all the people who seemed like they had the knowledge, the artists, the curators, the gallerists, the experimental dancers in the Twin Cities and, especially the academics, didn't give me the time of day. The silence was deafening, and I couldn't understand why. Was it because I didn't come up through art school or even a performance studies program? Was it because I was black? young? too earnest? off the wall? (Why always this huge disconnect between local artists/ communities and big-time institutions? (Side-eye Walker Art Center...but colleges and universities too...)

Of course, I'm exaggerating about my own situation—plenty of people did give me a shot and help me. I've been lucky, privileged, blessed. But something about the Twin Cities felt heartbreaking and, in the book, you can see what that early time was like for me, how much I had to figure out on my own, on the fly, with my friends. And maybe that's what performance artists, and artists, and people of all kinds, but especially black women, have always had to do. (Although the danger there: the loneliness, the bitterness, the chip on one's shoulder, and also the feeling of why bother to even try to connect to "those people" over there, they don't ever want to have anything to do with us anyway... Hopelessness. The world seems so filled with that feeling right now...)

Let me keep it real with myself too. I remember writing you that letter in 2006. There were no smart phones. E-mail was for business. And I'm not even sure I had internet in the house. I remember thinking, maybe I should write Jane Blocker an e-mail. But e-mail to me was so impersonal. And so I wanted to do something heartfelt and extra, when maybe if I hadn't tried so hard, it wouldn't have felt like it demanded so much to reply. Maybe by clamoring less, I could have made it easier to get a response. ("Marking it out as special seems

to have sealed its fate.") There's a life lesson for me there, one resonant about other aspects of my life too. Recently at a St. Kate's alum discussion on *Swallow the Fish*, a student said to me: "I was extractive with you. I just needed so much." And I said: "You were my student. I never thought of you as extractive. I loved you the way I love all my students." And what I said was real, but so is emotional labor. What are the things we ask from each other without even knowing each other? What are our expectations and entitlements? What are our needs? How do we pitch or fling ourselves into the world to try to get those needs met? That to me is the heart of performance art. Or really the pulse of its questions...

Now, after all that, let me keep it real about all the people in my life whose messages to me never got answered. The nice woman at the potluck who sent me a lovely hand-written card to my St. Kate's mailbox, reminding me of my comment that "the brownies tasted like walnuts were involved." The German-Mexican whom I met at a party and, I found out later, waited for me at a cantina with love in his eyes while I thoughtlessly stood him up. One Mexican ex who keeps trying to friend me on FaceBook, even spending his very little money on a FB voice message saying "hola." An amazing black woman elder who called me and wanted to get together and I was too scattered and now she has become an ancestor. I consider myself very conscientious, and I did not get back to these people. My head was in the sand. Maybe I was careless, not paying attention. Or, maybe, my head was in the clouds... I was daydreaming and taking vital space for myself. Or maybe my head was on my body in the world and I was deeply present there: in the studio making work, or at my desk checking a paper, or in a coffee shop consoling a friend, or in a changing room trying on a dress... And maybe over the last 11 years, you were any or all of these things, too...

So Jane, no worries or hard feelings. Thank you for your kind apology. Thanks for intimating that connecting with me then would have been worthwhile and for taking the time to connect

with me now. Our exchange reminds me to be patient, to allow ourselves and each other space to do what we need and have to do; and, especially as women, to remember that no one automatically deserves our time or responses; still to keep reaching out, and to stay awake to possibilities of magic that might slip through the cracks. You never know what's coming or even more what's coming back. A slow boomerang. Or what Lucretius would call: the swerve.

See ya round the bend.
Happy Summer!

Gabrielle

shapeshifting

"Black women are out of necessity,
inherently shapeshifters. Thus, understanding
the ways in which everyday Black women make sense
of their lives by theorizing the present and imagining
the future is essential for supporting ways of living
that resist dehumanization implied in normative scripts,
that shapeshift, and that offer us opportunities
to interrogate the texture of citizenship for Black girls."

–AIMEE MEREDITH COX
Shapeshifters: Black Girls and the Choreography of Citizenship

Opening Up Space for Global Black Girls:
A Dialogue between Gabrielle Civil & Zetta Elliott

Dear Zetta,

On *Sixty Minutes*, years ago, I saw a report of a girl whose mother was on drugs and her father had left the family. And her. And so, she was in foster care. And they were trying to find her father. Harried social workers in sensible shoes with piles of case files were at least tasked to do so. And this black girl was super cute. She had brown skin and dark brown eyes and black hair in zillions. In pink shorts and a blue-and-white shirt with spaghetti straps, she was the spitting image of the girls who would sometimes play with me on my street in summertime. Or is that just my imagination?

On CBS, this black girl seemed straight from central casting, *sassy* and *so much personality*. Things that white people might have said about me. Anyway, this black girl got impatient with the social workers, so she flounced off and, you know what, she found her father herself. I don't remember all the details. What I know is that she did what the social service agencies didn't, maybe couldn't and maybe can't. With only her wits and a map of skin, that black girl recovered her own flesh and blood. So what kind of recovery of our own flesh and blood, of black girls, can we do?

Love,
Gabrielle

Dear G,

Twelve years ago my father died, and I wrote a eulogy to deliver at his funeral. The words had been swirling in my mind for weeks and my short speech was almost complete by the time I got the call to return to Toronto. My older sister was livid, however, and so wrote a eulogy of her own, firmly believing

I couldn't speak about our father in a way that would be fairly represent my four siblings. I later published my eulogy in the appendix to my 2005 memoir, *Stranger in the Family*. I predicted then that I would probably spend the rest of my life trying to figure out who my father was—and I still believe that. As you know, we had a difficult relationship and only reconciled when I learned my father had cancer (two months before I was scheduled to defend my dissertation). Managing his care was one of the most difficult things I ever had to do and once we buried him, the few remaining "ties that bind" began to unwind. I found myself alone in this country, and waves of grief washed over me as I walked the streets of the city my father gifted to me.

I think I write about fathers so often because—for better or worse—they are central to Black girls' evolution. My father was a deeply flawed man, but he loved me and made sure I knew that. He couldn't accept or respect me, yet at times I could see him marveling at me ("Where did this child come from?") and I still think about him every day. I know now that he hurt me because he had been hurt as a boy, and as a Black feminist, I know that the only way to end violence against women and children is to heal Black men. It's galling but necessary work. And our art must do that work at least some of the time. I'm no longer a professor but at my last job I started out teaching "Black Women Writers of the African Diaspora" and finished up teaching "The Black Male in Contemporary Society." No one else wanted to teach that class, and I soon figured out why.

I had never encountered that level of dysfunction in so many Black male students. Many were surprised to find a Black woman teaching the class, and some were outright hostile. Often the most intelligent students were the Black men with anger issues or previous suspensions who refused to ask for or accept help and so went off the rails. That was my most challenging teaching experience and yet since leaving the academy, I've seen similar behavior in Black boys when I visit elementary and middle schools to give book talks. It's not all boys, of course, but it doesn't have to be—one disruptive child can absorb the attention of every adult in the room. And then

there's no energy left to meet the needs of the girls...

I wonder what might happen if those troubled Black male students were required to take a performance art class with you. When I watch you perform, I'm amazed by your daring and willingness to bare so much of yourself. Black women and girls are not safe in so many spaces, and I do worry about you— that you will be punished for using your body in ways that defy society's expectations. I critique but still partially subscribe to the politics of respectability. I see Black girls showing too much flesh in the classroom or on the street and I want to tell them to cover up. I want them to find empowerment in other ways, whereas you embody a different set of possibilities by being sensual/sexual in spaces where Black women are expected to deny that part of themselves. You seem so fearless at times— do you deny yourself anything? I aim for transparency and try to talk with teens about my mental health issues, but I'm also intensely private. Is performance art about authenticity? Or does it develop one's capacity to act out/up? What should Black girls know about the value of privacy? Is it ever separate from shame?

Love,
Z

Dear Z,

It's funny that you mention teaching performance art to troubled Black male students. My closest experience was teaching in the Bard Prison Initiative. Out of 16 students, all but two were black or brown and, of the two ostensibly white people, one was an Albanian Muslim and the other a son of Swedish immigrants. Unlike your students off the rails, my black male students were behind bars. They were also my best students ever of any kind. By the time they entered my classroom, they had reckoned with Foucault's imprint of power on the body; they'd figured out how to work within discipline and transform it. In fact, when we read Foucault's "Docile Bodies," they immediately were like: this is about us in here.

And it was.

Those black and brown men were brilliant, curious, industrious, in love with history and the dictionary. They loved me too from the start. One brother's jaw literally hit the floor when I walked in as the teacher. I was brown-skinned black, cute, plump, natural-haired, and relatively young. Of course, the prison guards hated me. One actually told me that I would end up on the other side of the glass with a con's baby. Wow, I thought. Is that all you can imagine? We're in here having a meeting of the *minds*.

But don't get it twisted. Those men were fine. I mean *p-fine*, *phiiiine*, as we used to say in Detroit. Of course, they were my students and didn't interest me that way. Still, it struck me how any possible appreciation of my body was policed as hard as every other thing. My biggest terror was not being in a room alone with convicted felons, but rather not being allowed to enter that room because the guard at the door, usually a white woman, might think my attire was inappropriate. This never happened, but it could have. So, in the middle of July, I wore long-sleeved Oxford shirts buttoned to the neck, long drab skirts, and gym shoes (me, high femme in gym shoes!). That was denying myself something for sure. Still, I did it without a mumbling word because I knew that if I didn't, they would bounce my ass out on the street. Who the hell did I think I was with my fancy Ph.D. to come and offer an elite, liberal arts education that none of the guards could afford to a bunch of colored criminals? It was a trip. And once again, when we're talking about black men, we're talking about black women. We're talking about fathers and daughters. We're talking about black girls.

Because that dynamic of me with books, covering up my body in anticipation of encountering scary black boys, is a complete echo of my girlhood. Growing up in Detroit in the 80s, the number one message I received was: DO NOT GET PREGNANT. Sex will ruin your life. Boys will ruin your life. Books versus boys and books come first. Wait until after the marking period. And while some might regard this as the source of my academic "success," those messages caused incredible stress in my girlhood, tremendous repression and crisis ⸏

my sexuality. Now at age 41, with no children and my fertility gone, I feel such anger and sorrow at those messages. I went from fear of being one kind of cautionary tale to becoming another one. How can we enact a more positive approach to sexuality for black girls? How can we foster a more healthy and pleasurable dynamic around the body?

This is where performance art comes in. At my old school, I once gave a whole talk during "Body Love" week called "How Performance Art Helped Me Love My Body" (cheesy, I know, but good). I did my best to push the usual cornpone. I talked about how loving your body is hard when the world doesn't love it but can happen in precious moments when you're doing something real. Maybe it's like how you were as a kid with sports. In performance art, it's not about how you look, it's about what you do. It's not even about *acting*, so much as it is about *being* and specifically *being in your body*. What does that mean to *be in your body*? Especially if you've been taught that your body is the enemy, its desire a main threat to you having a future. What does it mean to feel and show your own body and breath? To activate your presence? To turn audiences from spectators to witnesses? What actions could you make, what power could you claim and hold from that space?

What would it mean to your troubled black male students to create work like this? I'm not sure. I imagine it would be challenging all around. But interesting. Because you're right. As much as I felt deeply over-shadowed as a girl—by the "plight" of the black boy, the kudos for black boys who got Cs when I got side-eyed at home if I got a B+, the creation of "botillions" instead of "cotillions" to show that black boys were *loved*—even as weird as I feel about us starting our own dialogue about Black Girlhood Studies talking about black men, it's real. Because in so many black communities, in my own black girlhood, the expectations and roles of black men and women, fathers and daughters, black boys and girls, have been so mired in sexism, co-dependency, fear, and distrust, we have to untangle the whole dynamic for black girls to flourish, if not to survive.

To throwback to Roni Size, we need "new forms" and performance art can be the incubator. What if black women and

men, black girls and boys, black people who are neither boys nor girls or are both, created embodied work and showed it to each other, made work with each other? No shade to Beyoncé, but what if space existed for black girls under patriarchy to have pleasure and desire in their bodies, without it looking like light skin, long hair and conventionally pretty. (No offense to you, LOL.) What if we all could witness and strive for this? Groundedness in the body. Fearlessness of the body. Yes, we could all act up and act out in more creative and constructive ways.

Folks like Guillermo Gómez-Peña would say that performance art is less about authenticity than about experimentation, the chance to explore personas, invent identities, and liberate colonized aspects of the self. Recently, I was hard on a black male student for just getting up and reading a Langston Hughes poem at our final performance. In class, he had created the most audacious, unexpected, quiet abstract works. But then I thought, maybe he's responding to an audience that isn't used to seeing *black boys read*. Similarly, a black woman student did a series of performances on hair. Again, I was like: do we really need more pieces about black women's hair? And I checked myself because if it's what she needs to say to the world, then apparently so.

The problem remains how to engage a public when that public has so many iron-clad discourses about you. You arrive already so scripted. And that script is often about a private shame, which in my case as a girl, had never even happened, never will happen. And it breaks the heart and steels the spine and enters the body as memory waiting to be activated in time and space.

Do it!
Gab

~ * ~

Dear Krissy,
(how I *loathe* that name, but it's what you would have answered to up until the age of twelve)

This letter seemed like a fun exercise at the outset but now that I've had time to think about it, I'm not sure that I have anything to say to you. I write for children and so I generally spend quite a bit of time thinking about who I used to be. I like who you are—the girl I once was—and I enjoy picturing you playing alone in the cubby under the stairs or searching for milkweed pods in the field next to the group home. You are happy, carefree, and curious. You are pudgy and wild-haired and brown-skinned, and don't yet know that the larger world of which you're barely conscious doesn't think that you're valuable. You are afraid of dogs and don't like the dark, but you laugh a lot, and put Chiquita stickers on the back of your hand, and roam your neighborhood in search of a playmate when your older siblings leave you behind. You are perfect to me and will stay that way in my imagination. When I think of my childhood, I choose to think of you in the 1970s—an Afro haloing your laughing face, the lyrics to ABBA songs spilling from your mouth.

I don't want to warn you about the ruptures that will reshape the world in which you feel so secure. At age six you will lose your beloved big brother, and a year later Dad will move out of the house he built for your family. You will remain hopeful throughout the separation, even after you are forced to move into a small, suburban townhouse with your mother and big sister. At your new school, no one looks like you and nobody thinks you are gifted and talented, even though you have already skipped a grade. For the first time in your life, you have to struggle to win your teacher's favor. You are allowed to excel at sports and just as before, you come home with fistfuls of red ribbons and golden trophies. You make friends easily and their parents praise you for your accomplishments while yours look the other way. You miss your father but enjoy the weekends you spend sleeping on a mattress on the floor of his empty house. The parade of women begins before the divorce is finalized, but you continue to adore him even after you learn that fathers will betray their daughters as easily as husbands betray their wives.

I'm proud of the way you will stand up to the man you love most. Painful as they were, those tumultuous tween years will

hone our storytelling skills. Labeled a "troublemaker" and left to linger in your sister's shadow, you seek sanctuary in books and turn tawdry tales of Dad's successive girlfriends into a triumphant narrative where the forsaken daughter righteously chooses defiance over devotion. These are the years when you learn to shield your sensitive self from scrutiny by blending into the background. You create worlds inside your head where you are blemish-free, and long-haired, and no one's consolation prize. You are admired for speaking boldly, and not blamed for every problem you dare to identify. In high school, this "second self" emerges in the classroom but retreats once more when you're at home. Eventually, Dad abandons his new family and starts a third one in the US, and you find bigger books to lose yourself in as depression narrows your world. Without dreams you might have settled for a limited life, but you believe you deserve better—and can *do* better for yourself. You begin to travel, but disappointment follows you until you reach Brooklyn at age 20 and finally feel like you belong.

This month I will self-publish my twentieth book and that will bring the total to twenty-three books for young readers. I have worked with children for over twenty-five years, but at forty-three I have no kids of my own, no spouse, no pets. I've lived in the US since 1994 and have no plans to return to Canada. This is the life I designed for myself and until recently, I have been satisfied—even happy. I decided years ago that I wouldn't damage another by being the kind of parent who made her child feel unwanted. We learned early on to be self-reliant and though those skills have served me well over the years, I have largely rejected the kind of interdependence that defines a family. If we met today, I would no doubt seem strange to you—unwed, child-free women aren't yet part of your world, though they are a central part of mine.

How can you begin to understand me, the woman we have become? As the baby of the family you are content to play by yourself, but could you ever imagine you would grow into such a solitary woman? I suspect I might be a disappointment, but then I wonder if you even think about the future. Children live

in the moment; the anxiety that plagues many of the women in our family didn't take hold until my teen years. Now I peer into the future constantly, terrorizing myself with "what ifs." Still, at times I hear in my laughter the echo of your voice. I think of your resilience and am grateful that our spirit survived the dysfunction and disintegration of our family. I see my name, Zetta Elliott, printed on my books and I am relieved that there are few people left in the world who think of me as "Krissy." I am still that girl—you are with me always—a seed buried deep within that nourishes me as I age.

Yours forever,
Z

Dear Krissy,

We haven't met yet, but I've heard a lot about you. Even though you're light-skinned and have hazel eyes and I'm dark and wear glasses, we both are pudgy and have a Caribbean father (who causes a lot of DRAMA!!! but I'm still sooo proud of him) and we both spell our names with a Y. My teacher Ms. Hughes always spells my name Gaby and I love her but that looks like baby and I am not a baby and my godmother Liz spells it Gabbie which looks babyish in another way and so I don't like that much although I do love her a lot. She is so light-skinned, she has tons of freckles all across her cheeks and her hair is red. But she is very proud to be black!!! Anyway, I was wondering what happened when you were twelve? Why did you stop having people call you your name? What is Canada like? It's right across the border from Detroit, and my dad goes sometimes, but I've never been. They say it is very clean and there's no trash at all anywhere on the streets. Is that true? What's in your bedroom? And what are your favorite books? Mine are *Mistral's Daughter, If Beale Street Could Talk, Jane Eyre* and Danielle Steel's *Wanderlust*. What black girls do you see and know?

Please write back.
Your friend,
Gabby Civil

Gabby, author's collection *Krissy, author's collection*

Dear Gabby,

When my older sister Karyn was born, my grandmother praised the Lord because she believes brown eyes are proof of our "Negro ancestry." Hazel eyes aren't special in my family. I got glasses when I was twelve, which makes me a more complete geek. Are you popular at school? I have friends, but I've never been cool, and can't turn myself into someone else the way my sister has. I talk about her a lot because she is my father's favorite—he told me so—and I spend too much time trying to be like her even though Dad gets mad and yells, "You're not her!" I know that but I don't really have any other Black girls in my life. People call us "Cosby kids" but I don't look like Lisa Bonet. Whitney Houston is the first Black girl I see on the cover of Seventeen magazine; she's beautiful and I play her record over and over, but I don't look like her either.

When my sister starts spelling her name with a "y," I do the same. Krissy is a baby name and doesn't fit me anymore. I start high school when I'm twelve (I turn thirteen in late October) and just tell everyone to call me Krys. I'm into tennis and a famous player spells his name that way. In high school, I give up all my other sports so I can be a girly-girl like Karyn. I start wearing skirts and high heels and makeup every day instead

of on special occasions. But boys only talk to me after my glamorous sister shoots them down.

Do boys notice you?

I wish that I had freckles but I have acne instead. My sister calls me a leopard because I have so many dark spots on my face. On weekend visits, Dad holds my chin between his finger and thumb and screws up his face in disgust as he looks at me. That's how I know I'm gross.

Canada is clean—too clean. Why does your dad come up here? I visited Brooklyn when I was a kid and all that grime scared me then, but I think I might like to go back someday. Real things—things that matter—don't happen in Canada. I have to take Canadian History this year but next year I'm going to take US History instead. My Dad always talks about California and whenever he goes there, I'm not sure he'll come back. He brings us cool gifts, though. I got Christie—my first Black Barbie!—from one of his California trips.

I'm really into Dickens right now, though I'll read anything that's old and comes from England. Dad thinks I read too much, like my mom. He liked that I was good at sports but he never came to my games or my track meets so he never saw me win. He told me before running a race to say in my mind, "I know I can! I know I can!" So I do, and it works. I cheer myself on because doing your best matters even when no one else seems to care.

Your pal,
Krys

Dear Gabby,

I've been thinking about you a lot lately. Well cowering a little at your judgment. Am I ruining it? Being a grown up? Some of the things I do, I know would meet your approval. I make money and have sex (although not enough of either). Yesterday, in the middle of the day, I felt so worn out by the white school that I drove (!) to the grocery store in my own car (!) with my coat over my pajamas, something Mother would never approve of in a million years, and bought a whole bag of cheddar Kettle

chips and then slipped back into the house and under the covers and ate them all, alternating between reading *Shapeshifters* and watching Hulu, which doesn't exist for you now but which you will greatly come to enjoy. This is all something you would do. Or rather would have wanted to do all those years when you felt worn out by the white school, but couldn't drive and dreamed and worried about it and depended on other people to take you places when you knew so much where you wanted to go.

Where did you want to go? Everywhere. The peaks of the snowy white Alps in a Nestle commercial. Pretty word places like Montparnasse and Beijing. Faraway, cold places like Alaska. You would threaten our mother: I'm going to Alaska for college. Such imagination for white places when what you really wanted was to go to a party... To have your hair done, pressed and curled with no rain out, no frizz, no rain scarf and have it stay. To be put together. Or at least to look that way. I've managed that, well, at least most of the time. Okay, some of the time. It's those furtive, fugitive moments when you come back to me. In a bodega, what we called the party store in Detroit, when I'm standing next to the candy and see the Bubblicious and Now-a-laters, I think of you. Now and later.

I don't eat as much candy but I'm still listening to white music sometimes. What a revelation that was. The Cure and Depeche Mode. Right now, "Anthems for a Seventeen Year Old Girl" by Broken Social Scene is on. This makes me think of you. The kind of song you would have loved when you were ten and felt artsy and special listening to a mixtape made by a white friend from the Roeper School for the Gifted. The summer drama program there changed your life. Remember when they wanted you to come to the school for real, and mother told you point blank that you weren't gifted. This was your biggest pain. (White people now singing, *"Bleaching your teeth, smiling flash, talking trash, under your breath"* and I'm singing along.) Years later, she confessed that she only said that because we didn't have the money for the tuition and she didn't want to say that. So better to say I wasn't good enough. And your little voice back then protesting, "That's not true. I am gifted." But it didn't matter. I didn't get to go. Better to think I wasn't gifted

than that we were poor. Thanks though for sticking up for us, Gabby. It all worked out and of course we love mother and she loves us and has apologized for all this and we've made it okay and it hasn't come up in years.

You obeyed.

You were such a good girl. When you first read "A Song in the Front Yard" by Gwendolyn Brooks, you knew it was about you. And you felt like a dummy, because you would have found it a lot earlier if you had talked more to the librarians, but they were your sworn enemies because they kept foisting those bookmarks at you with books suggested by age and age wasn't nothing but a number and you didn't want to be told what to read. Not in the children's section of the Main Branch of the Detroit Public Library which was your favorite place on earth and maybe still is. And I see you there running your fingers across the spines in the front yard and I love and miss you so much even as I know you're still right here. And I'm not sure if I can remember what you dreamed about then or whether I'm making those dreams come true. Damn. That raw open feeling.

Then another dream.

One hard winter, Gabby, in the faraway cold place where I used to live, my friend Ellen told me that you came to her in a dream. You know Ellen, the tall white lady who ended up the mother of a black girl of her own. She told me that she saw you on a playground and that you stepped away for a minute to transmit a message. You said to her: "When you see me, tell her I said you have time..." Let me say that again, "when you see *me* tell her I said you have time." Then you bounced back to the swings, your books and dreams. And it reminded me that as much as people ask what we would tell our younger selves, a better question might be what those black girls would say to us? What kind of channels do we need, can we find, will we make to hear them? Thanks for the message, Gabby. But next time, will you please come to me instead?

xoxoxo
S.W.A.K.
Gabrielle

~ * ~

Dear Z-

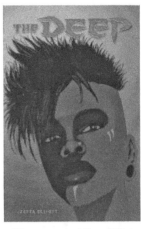

Of all the covers of your many books, I think I like the one for *The Deep* the best.

So many shades of blackness: charcoal grey, obsidian, and slate. Spiky black hair tipped in maroon, unapologetic African lips and nose, and those midnight ear gauges that signify both presence and absence Unapologetic, undeniable Afropunk glamour. Vulnerable and fierce. In my own girlhood, I never one time saw a book with a cover like this. Did you? How does an image like this, a book like *The Deep*, resonate with black girls? With Black Girl Studies? Do you feel in any way like you're writing for Krissy, the earlier version of yourself? Are the books finally materializing what she's always wanted to say?

Photo, courtesy of Zetta Elliott

As usual, this brings me back to performance. A few weeks ago, I saw 600 Highwaymen's "Employee of the Year" at the Wexner Art Center. The piece featured 5 performers, all ten- and eleven-year-old girls, who together told the story of one woman's life. They all played that one woman, one at a time, from ages 3 to 80. They touched each other, danced together, responded to each other in gestures, but the girls never spoke to each other in the piece. After a girl delivered her monologue, she didn't speak again. It was deeply stylized. And walking into the theater with students, I had said to my colleague Louise Smith: *I hope I don't hate this.* And I loved it. Because the girls weren't cajoling or simpering. They weren't precious princesses or head-rolling wisecrackers. They were serious and wise, vulnerable and sincere. They were grounded in their bodies and

captured our full attention. And, of course, they were all white. (Or at least they all had white skin.)

What would happen if these girls on stage were black? When do we get to see black girls and how? Who produces those representations? How do the routines that black girls make up together in bedrooms or on the block, or videos uploaded on YouTube get seen or circulated? How can the performances of actual black girls be engaged? How can I, as a black feminist performance artist, engage my own black girlhood and the experience of current day black girls?

Those questions motivated "Girls in Their Bedrooms," the pop-up micro-festival that Ellen Marie Hinchcliffe and I co-curated at the PoppyCock ArtSpace, a large house in South Minneapolis. Ellen and I had been watching *The Punk Singer*, the documentary about Kathleen Hanna from Bikini Kill (did you know about Riot Grrrl in Toronto?) and she was talking about her album "Julie Ruin" which was completely composed and recorded in her bedroom. Kathleen Hanna asked: "What would happen if we could harness all the creativity of what girls are doing in their bedrooms?" You know making up dances, songs, poems, raps, hairstyles, outfits, stories, new identities for themselves and each other.

Immediately, Ellen and I were like: "Yes! How can we crack back into the energy of our younger selves? How can we reframe the notion of a bedroom?" While not shying away from the pleasure and possibility of sexuality, we didn't want to be fixated there. "Girls in Their Bedrooms," both the micro-festival and our special issue of *Aster(ix)* on the event, explored the transformation that can come from creativity in intimate spaces. We wanted to celebrate girls dreaming, making, and doing in their own worlds.

Of course, not all girls have bedrooms. In *Shapeshifters*, Aimee Meredith Cox showcases how black girls in a Detroit homeless shelter construct, negotiate and perform their identities. The creativity and tenacity of these black girls without their own bedrooms are models for all of us, even as we must fight to get them better options, more and better spaces to dream.

*Gabrielle Civil in "Say My Name (an action for
270 abducted Nigerian girls)" /
Photo credit: Dennie Eagleson*

Safety was a major theme. This was why, as a part of "Girls in their Bedrooms," I created "Say My Name (an action for 270 Nigerian girls)." Boko Haram had abducted the Chibok girls just a few weeks before, and my body was keening with it. I wanted not only to bring back our girls, but also to bring the girls into the space and somehow activate their absence. It began as a spare installation in a cleared- out powder room. A photocopied *New York Times* article about the girls was taped on the wall. A candle burned and 270 sheets of white paper sat in a stack atop a red plastic crate. Each sheet had the name of one girl printed in the center. Visitors could come and activate the space however they wanted, but very soon I noticed that it was too much for them. Folks didn't know what to do. So, I sat behind the crate and began to read the names aloud. Because I could only find about 100 names or so, I replaced names with phrases like "the girl who was snatched" or "the girl who got away." It became a ritual roll call. When the girl did not answer, the sheet with her name dropped to the floor.

The room flared with pregnant energy. At the sound of my voice, some folks arrived, shook their heads and left the room. Some peeked in and walked away. Some stayed and read names

along with me. One woman cried. The action didn't bring the girls back home. I wish it could have. But the girls were there and not there all at once. I have felt this in the many times that I have done the action since. It wasn't enough, it isn't enough, but it is something. The performance opened up global space for us to feel the loss of those black girls, to love them, and strengthen our pledge to bring them home.

la lucha continua,
Gab

G,

I grew up in a White community and the only Black girl I saw on the cover of books was Cassie Logan from *Roll of Thunder, Hear My Cry*. I was so starved for representation that I revisited that book over and over again—even in high school when I had to do a creative writing project in English class. That was probably my introduction to lynching and as you know, I went on to write my dissertation on representations of lynching and rape in African-American literature. Cassie planted a seed in me…

And I hope Nyla does the same for the young Black women in SOLHOT. I discovered their group when Prof. Ruth Nicole Brown chose *The Deep* for one of their book club selections. I never saw a fictional character or a real girl like Nyla—as a teen, I never even imagined a Black girl like Nyla could exist! She speaks fluent German, she roughs boys up when they put their hands on her without her consent. Nyla *is* fierce! I did a school visit last month and a 5th grade girl came into the auditorium, took one look at the books projected onto the screen, and said to her friend, "I want to read *The Deep*." It's a book for older readers, but there is something about that cover that speaks to girls of all ages. I think Nyla intrigues them because she looks defiant—and unapologetic. Black girls are regularly framed as "bad girls" but rarely do we talk about POWER, and how the *desire* for power—the insistence upon it—is precisely what gets Black girls into (or

labeled as) trouble. I write about young women who are victims/survivors; they encounter threats on a daily basis—particularly sexual assault—but they resist and through resistance are able to define themselves for/by themselves. My young adult novels show how Black girls crave power and yet don't always know how to wield it responsibly. As they learn how to shape the world around them, the Black girls in my books are forced to make certain sacrifices—namely the young men who feel threatened by their growing independence. I'm not a romantic any more... I think I was when I was younger, but now that I've embraced my middle-aged "spinster" status, I find it hard to generate stories that adhere to "the coupling convention." Happy endings are suitable for little girls, and my picture books generally provide reassurances that everything will work out in the end. But my young adult novels are more ambiguous and open-ended, which speaks to my ambivalence when it comes to teaching our youth the truth. What empowers rather than embitters young women? The unadulterated truth? I want my books to show not only what's real, but what's *possible*...

I don't write for Krissy because I want my stories to have a broader appeal and my experiences often seem too particular. Of course, there are parts of me in everything I write. *The Deep* is a novel I wish I'd had as a teen when I often felt powerless and vulnerable but wasn't always responsible when wielding the little power I did have. I could be something of a bully—in part because I was bullied mercilessly by my older sister, and in part because I felt frustrated by the people above me who seemed less intelligent and/or appallingly incompetent. They had more privilege and more power than me, and that was so arbitrary, so unfair. I was clever and had a sharp tongue and I used those gifts as a weapon, which made me a little bit scary. And I liked that—I liked knowing that people turned to me for permission to speak on certain topics. I was the expert on Civil Rights in the US and South African apartheid, but I knew nothing about hip hop. And at the end of the day, guess which topic White kids cared about most?

From my teen years, I learned not to let those around me define what was truly valuable. It's a lesson the universe has

forced me to learn over and over again. Self-publishing is my way of never casting pearls before swine. The traditional publishing industry is dominated by White women and they have rejected my stories for more than a decade. And it has taken me that long to accept that they will never see value in me or my stories; they don't come from my community and they don't truly appreciate my culture(s). So my stories aren't for them, and that's okay. I have another audience and connecting with even one Black girl who feels alone makes it all worthwhile. A teacher in California sent me a photo via Twitter last year. She had bought a copy of *The Deep* and gave it to one of her students who seized the book and said, "Finally—a girl who looks like me!" Her name was Amaya and she really did look like Nyla—brown skin, shaved head, facial piercings—but Amaya was smiling because she'd finally found the "mirror book" she craved.

How do Black girls respond to your performance art? If it weren't for our friendship, I probably wouldn't know a thing about it! When I watch you perform, I feel as if you're trying to tell me a secret—it's like you're embodying some type of code that can be hard for me to decipher. I know you often address the problems of migrants and the impossibility of return. There is this endless process of packing and unpacking that never really ends. But the girls of Chibok, Nigeria did not choose migration. Their abduction, imprisonment, forced marriage, and rape triggered outrage around the world. You talked some about how your performance tried to decode their particular displacement. How else do you think performance can make a difference?

Z

Dear Z,

Such juicy questions! And I loved the story of Amaya and your mirror book. As a girl, I craved many "mirror" books and still do. Recent reads like NoViolet Bulawayo's *We Need New Names*, Edwidge Danticat's *Claire of the Sea Light* or even Mary Gaitskill's mixed bag novel *The Mare* reveal the black girl as the

barometer of entire communities. Depicting Zimbabwe, Haiti, the Dominican Republic and upstate New York, those books open up global space for black girls. They move from and feed diaspora consciousness, so crucial for both of us. Even though my Haitian heritage always mattered to me, my book life as a girl was very (white) American because that's what I could find. I'm so glad that has changed some—although your activist work in publishing shows there's a helluva lot more work to do.

My all-time favorite black girl book is Gwendolyn Brooks' *Maud Martha*: "What she liked was candy buttons, and books, and painted music... and dandelions..." And, of course, the gold standard for performance is ntozake shange's *for colored girls*... The opening lines slay me: "dark phrases of womanhood /of never having been a girl..." Those lines came to mind when I saw Okwui Okpokwosili's "Bronx Gothic" in Cincinnati a week after "Employee of the Year." (It's been a big month for girls on stage in the cornfields!) "Employee," showed the power of seeing girls. "Bronx Gothic" testified to seeing black girls *as girls*: young, innocent beings, even if their bodies are always coded as something else. Okwui answered shange's call to "sing a black girl's song:" she brought that fight to see black girls deep into her body.

Still, Z, I'm not sure how you would have judged Okwui's corporeal unleashing... For the first thirty minutes, all that you could see was her body in a corner, her back undulating and snapping, her arms pumping and reaching, her pelvis thrusting to a morphing soundtrack of city sounds and hard bass. Performance time formulates its own reality and those thirty minutes felt like centuries. It felt like slavery and emancipation, the Jazz Age and Black Power.

Okwui's woman body became the channel for the eleven-year-old black girl she was bringing back to life. Later, she told me that those thirty minutes offered an overture, a preview of everything that would happen to the black girl and her friend, including the arrival of her friend's mother's boyfriend and the quandary of the body of the urban black girl. It was all sexual and innocent, mesmerizing and hard to endure. The black girl asks, "What is an orgasm?" She lies on her back,

dreams of a new dress, a bedroom of her own. She gets called ugly over and over again and has to grow up and find and make her own beauty. This performance broke my heart and made me want to live. It stoked my hunger for Black Girl Studies. That was the difference it made to me.

Still, there's a good chance that I would have hated it when I was a girl, the way I hated the film version of *The Color Purple*. Why did Jennifer King's mother make us go to see some movie where the black women were dirty and poor and ugly and abused? I was ten or eleven and so distressed that after the first twenty minutes, I got up to sit outside in the empty lobby just staring at the stilled popcorn machines, until I finally slunk back in. (By then, they were in Africa.) I love that book now and sometimes teach it. As a girl, it came too close. It wasn't pretty or sweet the way girls were supposed to be, the way I wanted myself and the world to be. It was terrifying. So wouldn't I have found Okwui terrifying too? Too real? (Gabby just poked me in the ribs. She says that I should give her more credit. That she clamored for new people, places and things and maybe she would have thought Okwui's performance was kind of weird, and the beginning too long, but she would never have seen anything like it. Held rapt by her presence, her passion and honesty, Gabby would have given her a chance.)

This is what I hope black girls will feel one day about my work. I'm not sure what they say now or how many black girls have even seen it. I know one black girl saw my performance in Montreal. She took pictures with her phone. A few were on the beach in Ghana. But I don't know what they thought. Your question makes me want to ask them more questions and build more performance art opportunities for black girls today. I can't wait to see what we will do.

Hugs,
Gab

G,

Lately, I've been thinking about developing a new workshop for young women of color. You know I don't read a whole lot of poetry, but I've had Jayne Cortez' words in my mind lately: "Find your own voice & use it, use your own voice & find it." I teach part-time now and identify as an artist/educator; I still care about girls and young women of color and hope I embody a different set of possibilities when I walk into a classroom or step on stage in a school auditorium. Principals insist on introducing me as "Dr. Elliott," and I understand why even though my credentials don't mean that much to the kids I meet.

To them I am a conjure woman—the lights go down, my slides flash by, and I weave magical stories set in the parts of the city they know best. It's different when I'm teaching teens. Over the past few years, I've had several female students say, "I want to talk like you." I thought they meant codeswitching, that they admired the way I could move from the Black vernacular to "standard English." But I now realize it's something more. Last fall I met a young woman in training to become an English teacher; we were in a meeting together and she struggled when asked to describe her college-prep class. When the meeting ended, I found her waiting for me outside. She asked me how I learned to speak with such confidence. I reminded her that I had been talking about my own books during the meeting and then assured her that until recently I used to get sick to my stomach before walking into the classroom. But taken together these questions and comments got me thinking about voice and the way self-doubt can lead us to swallow our own tongues.

I was at Harvard last week; Prof. Robin Bernstein assigned *A Wish After Midnight* in her course "The Child in African America," and after meeting her students I gave an informal talk at the Women's Center. I had dinner with a group of students afterward and asked two young Black women how they learned to survive in what they admitted was often a hostile environment. They told me how they formed friendships with other Black women on campus; they live together and organize around issues through their extracurricular groups. Then a graduate

student shared stories of her own childhood when she was so White-identified that she refused to eat her mother's Dominican cooking and insisted on having frozen TV dinners instead. The next morning a young Black woman emailed me to say she had given up on her young adult novel but after hearing my talk on self-publishing, was going to give it another chance.

The day after that I returned to Mt. Holyoke for the first time since leaving in 2009. I gave my talk on inclusivity and indie authors and saw the heads of Black women in the audience nodding in agreement as I talked about the need to decolonize our imagination. I'm starting to talk about self-publishing as a radical act of self-love and a radical act of self-care. Black women and girls are so often told that we are not beautiful or desirable or intelligent, and we dim our shine in order to appease gatekeepers who'd rather shut us out than let us in. In his introduction to my talk, the director of the Africana Studies program told the small group of students that I taught the first course on Black feminism ever offered at MHC. It didn't seem possible that in the twenty-first century, students at a women's college had to wait for a visiting professor to introduce them to the Combahee River Collective.

I still remember a special ceremony for graduating students of color where the young women got to pay tribute to a favorite professor. One student from Zimbabwe selected me; she had removed her extension braids and faced the audience with a short 'fro to tearfully thank me for teaching her that "Black women are inherently beautiful." I didn't correct her, of course, but what the CRC wrote in their 1977 statement was that Black women are inherently VALUABLE. That one line was a revelation for me. And so much of my teaching and writing is about offering Black girls the radical ideas I didn't access until my twenties. I was so angry when I moved to the US—I wanted to make a clean break and start anew, and it took years for me to cultivate the compassion my child self deserved. I felt responsible for my own ignorance and graduate school was meant to be the antidote. But we would sit in those three-hour seminars and I'd be trying not to fidget; I'd sit near the door so I could bolt if my anxiety got

the better of me. Your pediatrician sister once gave you samples of children's cough syrup, and I remember sucking back a bottle of the grape-flavored stuff just so I could calm down enough to focus during class. Then the next day, I'd go out to Bed-Stuy or Ft. Greene and I'd tutor kids in an after-school program.

Once their homework was done, we'd work on a mosaic or I'd take them to Central Park to learn about Seneca Village. The city was still new to me and I wanted them to share my sense of wonder at its rich history. When those girls were with me, they weren't the same "problem kids" who threw a desk or cursed out their teacher during the school day. We let each other be new—I didn't feel like an imposter when I was with them, and teaching remains the space where I feel most like myself—where I am able to be my best self: present, engaged, flexible.

How do we teach our girls to be selfish? How do we let them know that they are valuable because they exist and not because of what they can do for someone else? Will they ever demand the reciprocity from Black men that we have failed to achieve? I don't know. Some days I feel like an absolute failure; I see how vulnerable Black girls still are and realize we have not created the world they deserve. But when Black girls see me walk into their classroom, I think they know why I'm there. It doesn't take long for them to sense that I love them, that I see them, hear them—they soon learn that they are not invisible or insignificant to me. You and I—we are the sowers. I don't know what our harvest will yield, but you will keep making performances and I will continue to make magic, and plant pride, and nurture defiance in my stories.

Z

Discipline and Knowledge: Teaching at a Maximum-Security Prison

*"Disciplinary control does not consist simply in teaching
or imposing a series of particular gestures;
it imposes the best relation between a gesture
and the overall position of the body."*

–MICHEL FOUCAULT, *Discipline and Punish*

I do not wear lipstick.
I do not wear anything short or tight, or even well-fitting.
I do not show my arms or my legs. I wear white cotton over-blouses.
I wear dark stockings although it is 80 degrees outside.
Although it is completely dismantling my personality and killing my soul,
I even wear gym shoes into the classroom.
(No high heels. Open-toed shoes may lead to inappropriate thoughts.)
I need to be absolutely drab, absolutely diminished.
I cannot give the officer at the front desk any reason not to let me in.

To understand my experience teaching this past August for two
intensive weeks at a maximum security male prison in NY state,
you have to know the rules.
Each morning before leaving the house for different facilities,
my fellow teacher and I would inspect each other closely.
There were restricted objects to avoid, but appearance was
equally important. Volunteer Services told us:
"If you think you look good, you might want to change."

But how can we change?
I am black and she is Indian.
We are both young, female, attractive, women of color.
We are both highly educated and believe deeply
in the power of education.
We have come to teach Aristotle, Kafka, Judith Butler,
Edward Said and other intellectual heavyweights
to convicted murderers, rapists, robbers and drug dealers.

No matter what we wear, we will always look wrong.
We know we will always be suspects.

> *"But the guilty person is only one of the targets*
> *of punishment. For punishment is directed above all*
> *at others, at all the potentially guilty."*

–MICHEL FOUCAULT, *Discipline and Punish*

My 16 students were mostly Latinos and blacks but also included
a native Chinese, an Albanian and the son of a Swedish immigrant.
Together, they were some of the best students I have ever had the
pleasure of teaching. They carried around dictionaries and discussed
etymology; they compared the footnote on page 36 to the one on
page 12. They were disciplined in every sense of the word.
The coercive nature of the prison system had created this
byproduct, diligence and hunger for knowledge.

I loved these students.
And they loved me, so many of them proud that someone like me
could be their Professor, could have a Ph.D., could shake their
hands and push their minds, could take them seriously as scholars
and give them hours of homework which they stayed up all night
completing.

Some of them loved me more because I was a young black woman;
and, some of the staff distrusted me more for the same reason.
What was I really doing there? Teaching liberal arts to inmates?
I must be gullible, untrustworthy. I could be manipulated
into breaking rules, or, as one staff member warned me,
end up pregnant on the other side of the glass.
(This was not a concern expressed to my white male colleagues.)
In order to even get to my students,
I had to bend over backwards to prove that I was not a threat.
I had to shut up and follow.

I hated the walk.

After the metal detectors, the initial pat down, the investigation of my person and belongings, the wait for an escort (who was often slow), I had to walk through the bowels of the prison to and from the classroom. Officers either talked to me about how terrible the prisoners were or talked over me to each other (about home improvement projects, future overtime, and possible inmate weapons). Because no one could find a way for me to eat lunch inside between classes for an hour (instead of outside at a picnic table next to the parking lot), I did this walk four times a day. Twice in the morning, twice in the afternoon, navigating multiple physical controls (gates, locks, logs, stamps), staying quiet and demure. I never complained to the staff or my students. I did my best to smile.

> *"Knowledge is not for knowing: knowledge is for cutting."*
>
> —MICHEL FOUCAULT, *Discipline and Punish*

In truth, I was a threat.

Outside my classroom, the prison environment was toxic, racist, sexist, smug, and dehumanizing. Once I arrived, everything we did in the classroom was working against the system. To me, this is the power of the liberal arts: its potential link to liberation.

Although I had to submit myself to power in often uncomfortable, gendered and racialized ways, I do believe my prison teaching was empowering. Moreover, my challenges were only a fraction of what my students have to deal with every day. Teaching in the prison forced me to reckon with power and knowledge, academic and state discipline. It helped me think about the complexities of advocacy and pushed me to put my money where my mouth is. I believe in the power of knowledge. But prison teaching forces me to remember that we must maneuver knowledge—and power—in and against its own conditions.

~~BLACK OUT~~ ~~WHITE WASH~~ **fall out**

WHITE WASH

A black woman walks into a room
and regards a wall of whiteness,
from floor to ceiling, rows and rows of books.
The spines are white. The pages are white.
The words are white. How can she read
such blinding whiteness? The black light of her body
illuminates the words. Reverses impressions.
She feels it as a violence in her body.
A throwing up. Of words, of bile.
She would throw up her hands if she had them.
She no longer has hands. She is no longer a body.
She swallows. Disembodied poetics.

~~BLACKOUT~~

What to name this thing that has happened to me?
That has happened to my people?

FALL OUT

A wraith arrives.
A black woman professor stands before the class.
She is a guerilla. Not a monkey, although some might think so.
A warrior. A black savage intellectual with a flat cut diamond
on her finger spread as large as her palm.
It is like a slice of mining on her outstretched hand.
Her reminder of the wrongness of everything, catching the light.
She is jumping, screaming: "YOU HAVE TO BE READY!!!
This Is Intellectual Warfare. What They Are Saying Is We Don't Exist."

BLACKWASH: SPILLERS

Spill her here.
The first paragraph of "Mama's Baby, Papa's Maybe: An American
Grammar Book" first published in *Diacritics*/ summer 1987. "Let's
face it. I am a marked woman, but not everyone knows my name.
"Peaches" and "Brown Sugar," "Sapphire and Earth Mother,"
"Aunty," "Granny," "God's Holy Fool," a "Miss Ebony First," or

Black Woman at the Podium." I describe a locus of confounded
identities, a meeting ground of investments and privations in the
national treasure of rhetorical wealth. My country needs me, and if
I were not here, I would have to be invented."
Yes, this would be our first text.

~~BLACKOUT~~
[*S C R E A M*]

BLACKWASH: KENNEDY
The spooks in Adrienne Kennedy's 1964 play "Funnyhouse of a Negro,"
Queen Victoria, the Duchess of Hapsburg, Jesus described
as a hunchback albino, Patrice Lumumba wandering the jungles of Africa,
they all screamed in the visions of the hero of the play:
a quiet, modest black college student named Negro-Sarah.
Negro-Sarah "spend[s] her days preoccupied with the placement
and geometric position of words on paper. [She] writes[s] poetry
filling white page after white page with imitations of Edith Sitwell."
Her hair falls out incessantly throughout the play.

FALL OUT
What to do with these visions of history?
the problem of these bodies? the grappling of power and violence?

BLACKWASH: KENNEDY
In the plays of Adrienne Kennedy, the world of history and knowledge
reckons and constitutes a world of violence, the world we live in.
Negro Sarah tells us her mother was "raped by a wild black beast."
This beast is her father. Or in the Suzanne Alexander plays, "the
ones I always return to, a black woman professor
named Suzanne Alexander witnesses terrible murders.
In her college years, she loved 19th century English verse and wrote
long encomiums about the wind on the moors, so good that her white
professor was sure they were plagiarized. In the plays, he seduces her,
wide-eyed and innocent, and leaves her in the lurch with a baby to raise.
The mingling of violent urges, the body and the mind.
And what to do with the fall out?

WHITE OUT

I am trying to explain to you something that you already know.
That insidious twirl of brown ivy feeding green on white ivory towers,
the way a certain kind of violence enters the body, is intersected,
intercepted by ideas.

~~BLACKOUT~~

A few months ago, I was grabbed on the street.
It was a dark street. He was a stranger.
Although the idea of him was familiar.
The intimacy of touch. Grabbed from behind,
Swiped. Snatched. It is so easy to snatch a body.
I told my lover—a man grabbed me in the street
He said why didn't you hit him.
I did, I told you that I hit him.
That's right baby, you hit him. I forgot.
False memory.

IN BLACK & WHITE

Vi•o•lence noun

1. swift and intense force: the violence of a storm.
2. rough or injurious physical force, action, or treatment:
3. an unjust or unwarranted exertion of force or power, as against
 rights or laws
4. a violent act or proceeding.
5. rough or immoderate vehemence, as of feeling or language

FALLOUT

The violence of feeling or language.

BACKWASH

The backwash of what you have to swallow.
It gets thrown up. Hands thrown up in the air.
But you have no hands.
I told him that I hit him.
I hit him and kicked him in the stomach.
I ran after him and my shoe fell off in the street.
A violence was done to me but it gets blacked out.

I can't remember the moment precisely.
An unwanted—turn, shove, push, kick.
The idea of such a thing. The idea.
The thing is happening. Me, the thing.

WHITE WASH
Go back to school.
Forget it happened.

FLASHBACK
In *Poetic Justice,* the second feature length film by director John Singleton released in 1993, Janet Jackson plays a young hairdresser named Justice who falls in love a with a postal worker played by Tupac Shakur on a road trip in a mail truck. In many fanciful dream sequence-like scenes, she incants poems actually written by Maya Angelou. These poems exist only inside her head. She never says them aloud. The actual dialogue of the movie goes something like this. Fuck you. No, FUCK YOU. FUCK YOU FUCK YOU FUCK YOU MOTHER FUCKER FUCK YOU.

When I am invited to participate in a symposium on violence and community, I think of this.

~~BLACKOUT~~
[A *Lite Brite* offers this bright, colorful message: *FUCK YOU*]

BLACKWASH: ELLISON
from *Invisible Man,* 1952
"Meanwhile I enjoy my life with the compliments of Monopolated Light & Power. Since you never recognize me even when in closest contact with me, and since, no doubt, you'll hardly believe that I exist, it won't matter if you know that I tapped a power line leading into the building and ran it into my hole in the ground. Before that I lived in the darkness into which I was chased, but now I see. I've illuminated the blackness of my invisibility—and vice versa." This from the black man who strings up 1,369 light bulbs.

FALL OUT
MONOPOLATED LIGHT AND POWER

~~BLACKOUT.~~
A woman is writing in Haiti.
It is 1966. She is a schoolteacher. There is a dictator.
She teaches the children to sing hymns to him.
She teaches them to pray to him "Our Father."
In the darkness, she writes of the darkness.
The dictator tries to whitewash their language
in blackness. In the ~~BLACKOUT~~,
she writes in a different way.
Transforms whitewashed blackness to shadow.
She aims to move from the shadow to flight.

FALL OUT
I am running up stairs.
I want to throw my hands in the air
with glee. I have no body. Fingers. Only rustling
through my pocketbook for change for the copy machine.
I have found the school teacher's book in this place.
It is the black library. The Schomburg.
I will copy the pages to enter her shadow.

BLACKWASH: JACQUELINE BEAUGÉ-ROSIER
She writes:
> Toute la nuit la persistance des marches
> Toute la nuit le feu le verre
> L'heure anonyme des lunes interdites
> A longueur de jour la ronde chronique
> De ta frayeur renversée contre mon mutisme
> Les discours du temps des statuts du temps
> De la stature du temps qui s'oublient
> Dans l'espace
> N'ont pas synchronisé la musique
> Antérieure à mon appel à la vie
> Je suis au seuil de l'histoire
> qui passé le dépit le vertige

L'abîme d'ombre où je te retrouve
Vie de névrosée
En éclats brisées de verre
Dans l'ivrognerie de la douleur

I translate:

All night long the persistence of walking
All night long the fire the glass
The anonymous hour of forbidden moons
All day long the chronic round
Of your fright turned against my muteness
The discourse of time of statutes of time
Of the stature of time forgotten
In space
Have not synchronized the music
From before my call to life
I am at the threshold of history
Passing the vexation the vertigo
The abyss of shadow where I find you again
Life of a neurotic woman
In broken shards of glass
In the drunkenness of pain

FALL OUT
What are disembodied poetics?
What does it mean to be a black woman poet?
How to chronicle and embody a certain kind of violence?

FLASHBACK
In college, I took a poetry class which I hated.
We learned about sonnets which I loved.
I was at the start of trying to reconcile content and form,
ideas and body. And so I did a project on racially righteous sonnets.

BLACKWASH: MCKAY
"Tiger [a sonnet]
The white man is a tiger at my throat,
Drinking my blood as my life ebbs away..."

FALLOUT

My professor hated this poem.
He told me that there were no good African-American poets
(except for a few lines of Countee Cullen
which displayed promising prosody.)
He told me he disagreed with my analysis
of transforming poetic form through poetic content.
My professor hated my paper and was I wrong
in believing that he hated me too?

BLACKWASH : BARAKA

A paraphrase from the first lines of *Wise Ys Wise*,
When you find yourself in a strange place
With strange people speaking a strange language
You know you're in trouble

WHITEWASH

My professor gave me an A for the paper and an A in the class.
This is how I knew he really hated me.

BLACKWASH: DOUGLASS

Give a nigger an inch, and he'll take an ell.
Mr. Auld said this about teaching
Frederick Douglass his A B Cs.
Something about epistemology.
I was born.
I was born.
I was born.

STEP BLACK

There is a dance called the Electric Slide.
You ivory tower vine to the left and snap.
You ivory tower vine to the right and snap.
You shimmy your hips back and snap.
You sashay forward, bend and twist.

FALL OUT

What happens when you turn a person into a thing?
What happens when you think this?
What happens when a person is told she is a thing?
What happens when a person is taught she is a thing?
What happens when a person is taught disembody?

[Words no longer decipherable]

LIGHTS OUT / LIGHTERS UP

I am writing this in the dark.
Not just a room but a body.
Not just a body but a mind.
Illuminated by violent light.

Black Swans

Thwack!
Ballet slapped the black girl in the face and destined her for greatness.

~ * ~

Mabinty Bangura was born in Sierra Leone with spots all over her body. Her parents had loved her very much, but after they died, she turned into a war orphan. One day, Mabinty slipped out of the orphanage into the Harmattan wind. Keening towards calling, she pressed her face up against the wrought-iron gate. Suddenly, a magazine filled with white people hit her smack in the face. *"Ugh! Trash!" I exclaimed. But it wasn't trash at all. I had been attacked by the pages of a magazine."* Mabinty had never seen white people before. *"The magazine was stuck in the gate, exactly where my face had been. I reached my hand through and grabbed it."* On the cover, a white woman wore a short, pink skirt and shiny, pink shoes. How strange and magical! Might she be dancing? *"Someday I will dance on my toes like this lady. I will be happy too!"*

Mabinty tore off the cover and hid it in her underwear. This became her secret treasure. Later, she showed the picture to her new American mother. Before she could even speak English, Mabinty wanted those pink shoes. Like a sugar plum fairy, her new mother granted her wish. Mabinty got to take ballet! She wore leotards and tutus and pinned her hair into a bun. She grew up nourished and safe in a loving (white) family. She became American. She became Michaela DePrince. She became a ballerina.

~ * ~

How do we tell stories about black girls and ballet?
How do ballet stories tell black girls how to be?

~ * ~

As a black girl in Detroit in the 1980s, I didn't read Michaela DePrince's *Taking Flight*. It didn't yet exist. In fact, no books existed about a black girl ballerina, or at least none that I ever saw. Back then, I couldn't have named even one black ballerina, black bodies in white boxes.

[Janet Collins.
Joan Meyers Brown.
Raven Wilkinson.
Judith Jamison.
Debra Austin.
Anne Benna Sims.
Llanchie Stevenson.
Lauren Anderson.
Misty Copeland.
the incomparable
Katherine Dunham
who some people say isn't technically a ballerina,
but she trained in ballet and is such a force
of nature, in dance, you have to say her name!]

Despite the fact that none of the ballerinas looked like me, I devoured ballet stories. *Ballet for Laura. Laura's Summer Ballet. As the Waltz Was Ending. Ballet Shoes.* This funny habit of reading ballet has spanned my entire life. *Girl in Motion. Bunheads. Astonish Me. Holding onto the Air. Dancing in the Wings. Firebird. The Cranes Dance. Pointe. Dancing Shoes. Winter Season. The Sleeping Beauty. Balanchine and the Lost Muse. The Walls Around Us. Vanishing Rooms. Breaking Pointe. Life in Motion: An Unlikely Ballerina.* Fiction and memoir, this list doesn't even count movies and TV. *The Red Shoes. The Turning Point. A Ballerina's Tale.* (Go Misty!) *Black Swan. Dancer. First Position. Center Stage. Dance Academy.* Even *Flesh and Bone,* that grim ballet series I binged after my hysterectomy...

Despite the fact that I never received serious training; despite the fact that I never saw even one live ballet as a girl; despite my recognition that this form of dance defines itself

completely against me—my dark skin, my flat feet, my round belly, my wide hips, my nappy hair, my big ass, and, most of all, my insurgent black feminist performance art practice—ballet somehow remains bedrock to my sense of art, dance, and self. Despite or perhaps because.

~ * ~

"Who's there, when the black body has been interrogated, tried, and convicted on the basis of a white aesthetic?... At the equator of our race consciousness, who's there?"

- Brenda Dixon Gottschild, *The Black Dancing Body*

~ * ~

Anna Linado, a white, teenage girl from Rock Island, Illinois, is completely devoted to ballet. Quiet and shy, she has dark hair and impressive arches in her feet. Like all ballet heroines, she is more beautiful and talented than she realizes. She isn't rich, but her middle-class family sacrifices for her training. After receiving a prestigious internship to a ballet school in New York City, Anna must prove herself to her ballet teachers to continue a life of dancing. Her dream is a job offer from the school's professional ballet company. Nicole, a mean girl, blonde and rich, is jealous of her talent and tries to jeopardize her future. Tyler, the most talented boy dancer in her class, adds a dash of romance. Only there to keep things heteronormative, Tyler is really beside the point/e. Anna loves dancing more than anything else.

A complete innocent at seventeen, she's never even been kissed. Anna never masturbates, never craves good sex, never feels the guilt of doing it in the back of a car, never suffers the humiliation of sexual neglect, the shame of STIs, or the absolute catastrophe of teenage pregnancy. In Detroit, in the 1980s, I was told that getting pregnant would ruin my life. These things can happen to teenage ballerinas. (I saw *Fame!*) However, in this book, ballet is her lover, her baby, her baby mama and daddy, her contraception and immaculate conception. Her body, her desire,

are under complete control, for use only for creative expression. To me, a dreamy black girl going to a predominantly white, Catholic school, this situation seemed like heaven.

High minded, the ballet book girl is competitive and tough. Underneath her pink skirt and shiny pink shoes, her ribs jut forth; her toes blister and bleed. Her anxiety about her success marks her modesty, her ambition and perfectionism. *'I'll die if I don't get into Ballet New York. Die!'* In *The New York Times*, on June 26, 1987, Isabel Wilkerson writes "in Detroit, nearly 21 of every 1,000 babies dies in the first year of life. This is the second-highest infant mortality rate in the country." Describing Hutzel hospital where my sister later had weekly lectures in medical school on obstetrics, Wilkerson reports: "Last December, a 13-year old girl showed up pregnant. She had no prenatal care and gave birth to a boy weighing 1 pound, 4 ounces." Although never named, we know this nameless girl is black. In June 1987, I was almost thirteen years old. The romance, tortured and full of suspense, is always between the (black) girl and her future. Will Anna get a plum role in the student workshop production? Will she get a chance to start her dancing career? Of course, she will. *Girl in Motion* follows the script. The ballet girl may look like a princess, but she operates like a machine. Dancing is her life.

~ * ~

On a panel at a conference in Iceland, Elizabeth Kendall's eyes welled up with tears. A dancer and deep writer about ballet, she's been describing the passion of young girls for dance. Afterwards, I talked to her and Margo Jefferson, another amazing writer, about the impact of ballet books in my girlhood. "Wow, I thought at first you were just being nice to me," Elizabeth said, "but I can see how much you care." Indeed. Despite the capitulation to white male authority and patriarchal ideals, the constant hunger, the need for approval, the anxiety about height, weight, excessive flesh, the hyper-femininity, the suffering in silence, the heroines in these books forged me. Despite or perhaps because.

Girls in ballet books/ ballet book girls are glamorous and diligent, glamorous in their diligence. Young, serious,

disciplined, ambitious, and indomitable: they epitomized the artist as a girl. This is who I wanted to be. This was the only place I saw her. The girls in the ballet books never saw me. Margo commiserated: *"What does it mean to dream of something that doesn't dream of you?"* So what if the ballet book girl was thin, white, and not from Detroit? Those weren't the parts I wanted to emulate. Before I could even articulate it, I wanted those pink shoes. Trajectory, tenacity, and talent.

~ * ~

A couple blocks away from my house, on Livernois, the erstwhile Avenue of Fashion, stood a storefront dance studio. It's not there anymore, and I don't remember the name, but for a short while it was where I took ballet. The teacher was black, and I can't really remember her name either, although thinking of her makes me feel warm inside. My story goes that she had danced in Chicago and New York and then come back home to Detroit to start her own school, so kids could learn to dance. Everyone was black, with the exception of this white girl named Amy who claimed a black girl in class was her foster sister. I never knew if they were joking... The vibe overall was playful and pleasant, as we learned ballet, tap, and gymnastics. I think I liked it. I don't think I was very good. For some reason, my memory is hazy, not sharp like my recall of *Laura's Summer Ballet* or *Dancing Shoes*, which is still my favorite.

~ * ~

Rachel and Hilary aren't blood sisters although it doesn't matter to them. This black girl named Octavia loaned me *Dancing Shoes* on the last day of fourth grade. This was the end of my first year at Shrine of the Little Flower, a predominantly white, Catholic school outside of Detroit. We didn't live close by or go to each other's houses, so I got to keep the book the entire summer. Before their mother died, a lady came to the house in Folkestone to say that Hilary was a natural. The family was poor—before the book began, the movie star father had died in a plane crash without saving any money—but Hilary and Rachel's mother still managed to put aside a

little each week for Hilary's ballet lessons. (One summer in New York, as a broke graduate student, I bought this book and read the whole thing again in sunny Prospect Park in one afternoon and then promptly returned it the store.) Ballet cost but was *real dancing*. So even though Hilary was lazy and funny and liked to turn cartwheels and walk on her hands and didn't really care about ballet, Rachel was convinced she had to do it. Why else had their mother sacrificed so much?

"Rachel, her eyes on the stage, was just about to slide off into another daydream when the Fairy Queen began to dance to Tschaikovsky's Sugar-Plum Fairy music." Quiet and serious, her nose always in books, she had her own nascent dreams of the stage. *"The Fairy Queen put an arm around Rachel. 'You have a dancer's face. Can you dance?'"* Rachel had become a Wonder, but that didn't count. *"Rachel pointed to Hilary. 'No. She can.' Rachel's whisper was more fierce than she knew. 'She's to go to The Royal Ballet School and be a proper dancer like you.'"* Before she could even speak up for herself, she wanted those pink shoes. *"'Like Me!' The Fairy Queen looked half sad, half amused. 'I'm afraid that won't do her any good...'"*

(What do you do when your dream doesn't dream of you?) *"Rachel watched the Fairy Queen rise on her pointes, lift her arms, and glide onto the stage. At that moment, though she did not know it, the first tiny seed of doubt about Hilary's future was sown in Rachel's mind."* The real twist is that neither Hilary nor Dulcie, their spoiled cousin, the best dancer in the school, end up as ballet stars. Despised, discounted Rachel gets discovered by a movie director and becomes the lead in a motion picture. After starting with ballet, it moved in a different direction.

~ * ~

At the studio in Detroit, I was finally doing ballet, or was starting to learn how to do it. As has happened so often in my life, reality differed somewhat from my reading. We did not live together in the school or form a troupe of talented moppets. No former principal dancer named Madame presided over class. No accented, white man served as mercurial artistic director. No portly Russian accompanist played piano (we had

no live music at all). No one smoked. No one sewed, slammed, or burned any toe shoes. No mothers meddled and tried to live vicariously through us (they were just nice enough to drive us and maybe wait around). No one cut themselves or starved (at least that I could see, young and absorbed in just trying to follow the steps).

No one lifted ballet up as better, told us that we had to or couldn't do it. This ballet was no drama. No glamour. No whiteness. No sweat. Well, maybe sweat. Huffing and puffing and shuffling across the floor. We were black kids dancing! Living the dream! Trying to leap and have some fun. I was finally fulfilling my class aspirations. *Plié. Relevé. Chassé.* I was fleshing out words found in every ballet book, assuming the five basic positions. In ballet classes in Minneapolis and Mexico City, I have assumed these same positions. Often, I find myself the darkest, fattest one in the room. I turn up. I turn out. I point my foot and *tendu*. The black swan claims her place.

~ * ~

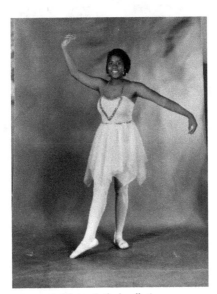

Photo: Author's collection

In the Detroit recital, our teacher placed me dead center on stage in the ballet routine. Was this due to some magnetism or talent? Was this even true? Has my memory failed? I have no idea. In my recital costume, I am brown and plump, more beautiful than I realized. I love the picture of me in my bright pink skirt, and light pink shoes. It's the only evidence that I ever did ballet. The audience bobbed their heads to the tap. They hooted and hollered for the gymnastics. Their appreciation of the ballet was more quiet and polite. Suddenly, in the middle of the dance, the conformity of our bodies freaked me out. *What would happen, I thought, if I just didn't do the step? How would I feel? Shameful or subversive? Could I survive it? Would anyone be able to tell?* It was my dream to take ballet and dance in a recital. There I was on stage and, for some reason, just for a moment— *a tiny seed*—I wanted to do something different. So I did.

~ * ~

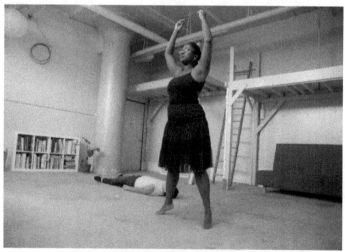

Black Swans (meditations on ballet) / Photo: Sayge Carroll

As a black feminist performance artist, I have a complicated relationship to dance. I do it, make it, use it, watch it, pursue and consume it. I seek it out, feel rejected, and return to it

again. Most often, I disclaim it. Or at least myself in it. "Well, I'm not really a dancer," I say, while dancing in performances around the world. Ballet books taught me that dancers have impeccable training, technique, and perfect bodies. (White) dancers are long and lean, willowy, elegant and graceful. (Black) dancers, when they are allowed to exist on stage, are strong, compact, rhythmic, and athletic. In her brilliant cartography *The Dancing Black Body*, Brenda Dixon Gottschild explodes these stereotypes, body part by part. *Feet. Butt. Skin/ Hair.* She exposes the undermining of (black) potential as well as a rich, resistant history of black dance in many forms.

Her interviews with dancers are especially telling. Bill T. Jones states: *"a black dance is any dance that a person who is black happens to make."* Marlies Yearby says: *"on some level, all of it is black dance because you know, when you look at the history of ballet, its rhythms were drawn from Africa..."* Brenda Bufalino declares: *"When I saw a contraction, I almost fainted from ecstasy! [I learned] this wonderful animal-like quality... And I definitely do associate it with black dance... Not European... When I saw that, I didn't see it separate from my white body. I saw it as... a symbiosis of 'Oh! That's also me!'"* Both Gottschild and I have some questions about this "animal-like quality" and its association with blackness. (Really? Did white people never evolve?) Still, this feeling of symbiosis resonates. How else to explain my connection to ballet, my fascination with ballet stories? Cognitive dissonance? Delusion? Disidentification? Imagination? Or sheer, stubborn will?

~ * ~

A few years ago, I collaborated with performer Moe Lionel on *[] doesn't know [] own beauty,* a performance art work based on Melvin Dixon's *Vanishing Rooms*. In this 1991 novel two black dancers, Ruella and Jesse, negotiate the aftermath of a tragic hate crime, the sexual assault and murder of Metro, Jesse's white gay male lover. In our performance, we explored race, violence, submerged history, and desire along with the nature of our own interracial, sexually blurred love affair. We read sections of Dixon's novel to each other live on stage. We played hangman, moved, and stretched like dancers. After

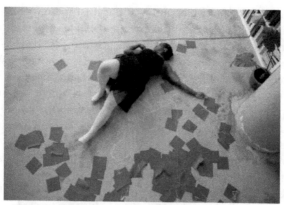

Gabrielle Civil in (_____) Doesn't Know (_____) Own
Beauty / Photo credit: Sayge Carroll

dancing to Janet Jackson, we activated Nina Simone's classic
song "She Doesn't Know Her Own Beauty." We followed the
novel's footsteps.

My specific gestures in this work embody my history with
ballet stories. Ruella says: *"My memories were ballerinas gliding in
and out on point."* I don flesh-colored tights, pin my hair up into a
nappy bun, and become the ballet dancer. I wear my glasses and
read from a book where a black girl makes dances and claims
artistic power. She lives in a hard city. She wants her loved ones
to live. She wants to live fully herself. *"Dancing solo requires your
own motion. You follow your own lead... Where was I leading myself?"*

I wanted to take ballet, stand center stage, and do something
else. *"I hate walls. I hate ceilings... and metal gates... hold you hostage
inside."* I think of Mabinty / Michaela and her magazine cover
at the gate. I think of the nameless black girl in Detroit and her
baby. Did they make it? Michaela de Prince made it, dancing,
living her dream, living my dream too. I think of myself making
it up: my reading, a germination, my dream, not to become a
ballerina, but something beyond words. A black woman artist.
A black swan. In symbiosis, transposition. *"I want to be in air.
Make a space out of movement. A space I can break if I want."*

make

something

new

Behind the Orange Door: Gabrielle Civil and Rosamond S. King in collaboration

"You don't do it right," Rosa said. The steups, the distinctive mouth movement and sound found in Trinidad, where her family is from, and throughout the Caribbean. When people suck their teeth, they do it at someone or something, to show disapproval or derision. When I try to imitate it, I fall short. It's clear—I may be black, I may be Caribbean (Ayiti ap kenbe la)—but this impression of authenticity is not on my lips, on my mouth, on my body. I do it wrong. I am wrong. But who can tell the difference? Only she can.

Or any Trinis or Bajans or Guadeloupeans in the house... But unless we are in the Caribbean, how many people will even recognize it? Who will see? Who will know? Until after a while, after much schtepping and steeping and stupping, Rosa says off-camera, "Wait, I'm not even sure if I'm doing it right." We laugh. What, oh what, is an authentic gesture of the black woman's body? Of the Caribbean woman artist? What happens when Caribbean women artists work together? When they name this collaboration?

Collaboration

For more than fifteen years, we, Gabrielle Civil and Rosamond S. King, have collaborated as diasporic black Caribbean women artists. We have worked together on specific artworks and community arts–based projects. More broadly, we have engaged each other's work, sharing performance bills, organizing events, and, most important, raising key questions and offering critical feedback. Through this experience, we have come to understand artistic collaboration as shared artistic practice but also more broadly as shared participation in artistic process, even in our own individually authored work.

This expansive notion of collaboration has been essential for our development as artists—especially for our experimental performance work engaging Caribbean themes. Our different experiences of Caribbean heritage have pushed us to be more precise and, at times, more visionary about our images and claims. At this time, neither of us is based in the Caribbean,

and for much of our collaboration, we have not even lived in the same place. This has forced us to be dynamic and flexible, working together in person and over the phone, across e-mail, in chats, and over Skype. Collaboration for us as diasporic Caribbean women artists in a technologically mediated, global economy is rich and multidimensional.

Sucking Teeth

Sucking Teeth is a four-minute video about authenticity and embodied Caribbean identity. Our individual ability or inability to "suck teeth" is as arbitrary as any other test and stands in for any number of other markers of Caribbean authenticity: the ability to speak Krèyol or patois, the ability to dance well or behave "properly." We made the work quickly and premiered it (along with other new performance art pieces) at *R.S.V.P.*—a No. 1 Gold collective performance event that we organized in 2006 with artist Madhu H. Kaza at the Center for Independent Artists in Minneapolis. *Sucking Teeth* was also shown in 2010 in the Latin American Shorts series at Labotanica Art Space in Houston, Texas, and continues to circulate.

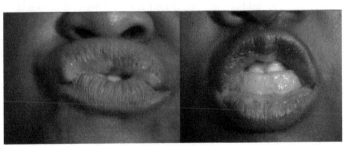

Rosamond S. King & Gabrielle Civil, in "Sucking Teeth" video

RSK: *Sucking Teeth* was organic; it came directly out of us chatting and laughing. We'd been *steuppsing* (sucking teeth), and Gabrielle said "I can't do that," and I replied, "Of course you can"—but she really couldn't. From the initial humor, it quickly became clear that, especially for people not familiar with the

term "sucking teeth," the piece would have a sharp eroticism. The finished piece is actually not funny or "light" at all but uses a single, repeated gesture to ask questions about what and who is *authentically* Caribbean, how we perform ethnicity inside and outside the region, and how the answers to these questions relate to the workings of community. Who gets to determine Caribbean authenticity? How we judge ourselves depends on our confidence in that identity—and both of us, both born and raised in the diaspora, might be considered inauthentic and unqualified to judge each other. In addition, when the audience of *Sucking Teeth* has no relationship to the Caribbean, race collapses ethnicity. Without the lipstick, some people may not even be able to tell the lips and noses apart. Similar questions appear in much of my work, from my one-woman show *Still Dreaming America* to my written poetry.

GC: The final work was very simple. The video features close-ups of our mouths, the shapes of our moving lips and tongues with the accompanying soundtrack of our sounds. As we filmed, something interesting happened. The more we both did it, the less exact Rosamond's initial gesture became. While the piece was initially for me about my problem of doing it or being "correctly" Caribbean, it quickly became a meditation on the problem of that very idea. While I was trying to emulate something Caribbean, indeed a different form of Caribbeanity than my own, the specificity of that distinction was largely lost on the (predominantly white) Minnesotan audience. This allowed the piece to become even more about Caribbean illegibility.

Sucking Teeth was also one of my first forays into video art, and our collaboration helped me become more confident in making solo video work. Later, *Sucking Teeth* and my solo videos *Haitian Tourism* and *Mexican Tourism* were interspersed with live performance in my fantasia *Comedy & Other Work* at the Bedlam Theater in Minneapolis in 2008. This is just one example of how my collaboration with Rosamond has helped enrich my solo practice.

RSK: I'm more minimal in terms of presentation than you are...but I always appreciate and enjoy your work - is that why we collaborate so well, that our core aesthetics are the same, but our actual styles are so different?

Sent at 6:03 PM on Sunday

GC: I think that's a major part of it. I think if our styles were too similar, we wouldn't have as much to say to each other... we couldn't see each other's blind spots so well. But the core aesthetics are really key. To have become friends with another black experimental artist so early in my trajectory was huge--esp. one who also had strong Caribbean connections.

Sent at 6:06 PM on Sunday

RSK: Yes, I think of the time we spent in PR together and the performances we made there behind the orange door. The piece I made there "..." was major for me, and I really appreciated your pushing me to make the original vision - black wall, black breast...

Sent at 6:08 PM on Sunday

Behind the Orange Door

In 2003, we were both accepted into the National Endowment of the Humanities Summer Seminar on Caribbean Theater and Cultural Performance, organized by Lowell Fiet at the Universidad de Puerto Rico in Río Piedras. Near the end of an intensive summer of reading and discussion, we decided to organize *hipotéticas*, a performance event named after a series of collaborative poems we had been writing over a number of years. More specifically, these "hypotheticals" would be new, original live performances.

Our NEH seminar had a coffee-break room with a bright orange door. We repurposed this room and transformed it into a site for performance art. Behind the orange door—*détras de la*

puerta china—we strategized everything about the performance event: the major actions and images of the works, the order and sequence of the program, the transitions between the works, and more. Each of our performances, "..." and "Anacaona," was created as a way to think through particular ideas about gendered Caribbean bodies in time, space, history, and the present. We were each other's primary audience, and our shared goals were to hold each other accountable to our respective creative visions and to challenge ourselves, each other, and our audience. Behind the orange door, we manifested another kind of collaboration. We never took authority or authorship over each other's work. Our artistic practice was individual. But we shared a strong vision about the tone and impact of the artistic event overall. We created and shared a context for each other's work and helped each other clarify and commit to our specific artistic aims.

"..."

RSK: I had a dream while we were both living in Río Piedras, Puerto Rico—a black wall with a black(brown) breast protruding from it; in the dream, I observed people walking by, noticing it or pretending not to, touching it or not. When I woke up, the dream, the image, had a visceral impact on me. It seemed like a performance, but one far too risqué for me. I told Gabrielle all of this, and she suggested I do it, pushing me through my own resistance to both the nudity and the difficulty the set proposed. We agreed to both create solo performances. For me, the process of building the wall—slowly cutting and taping enough cardboard together to create a false wall, and then painting it all black—was meditative, and allowed me to mentally prepare for what I knew would be a personally challenging piece.

"..." began with me standing behind the wall, the room in darkness, and one of my breasts protruding through a hole on the wall. My "assistant," Don Walicek—a young white man dressed all in white save a black and purple minstrel-like mask and black gloves—was the interlocutor with the audience, pushing them toward me and holding the single light in the darkened room. A few women tittered uncomfortably; several people laughed more enthusiastically, fondling and playing with

Rosamond S. King, in "…" / Photo credit: Don Walicek

my (the) breast. (All of these people knew whose breast it was, having been invited to the performance.) For me, it took to the extreme the sense of being simultaneously hypervisible as a body and invisible as a person.

After a few minutes, Don switched off the light and we moved into the second stage of the piece; when the light snapped on again, I was standing in front of the wall, still naked from the waist up, a large box on my head, my bare back to the audience. My wrists were crossed behind me as I struggled to be released from invisible ties. Don again unsubtly nudged the audience toward me, but now, confronted with a full body, they hung back and were much quieter. Only one woman tried to free me from my invisible bonds; the others just watched. After a few more minutes, Don snapped the light off again and roughly pushed everyone out the door to await the set change for "Anacaona."

The mask Don wore, which I made during the workshop, was used to highlight race: his, mine, and the audience's. Having a black person, and particularly a black man, in that role would have encouraged a reading of intra-racial gender dynamics rather than historical and contemporary cross-racial heteropatriarchy.

Rosamond S. King, in "..."; Photo credit: Author

During the performance, the white man seems to be in charge, but both his mask and his manner makes him a part macabre and part madcap master of ceremonies. I had hoped that some audience members would try to disrupt him or "free" me, but only one person even gestured toward that response.

What was Caribbean about "..."? What was *not* Caribbean about it? What about the presence of the black woman as body, as object, even as there is a question about whether she is dominant and in charge (the strong Caribbean matriarch) or whether she is a defeated victim (of men who hold power as bosses, politicians, lovers, or husbands)? "..." reveals that even in Puerto Rico, where the black female body is common (and commonly ignored), it remains an object of fascination, confusion, and fear.

"..." was a very important piece for me. It was the first time I performed semi-nude (something I've not done since) and the first of many times I performed silently and with my head covered. Gabrielle was key to its creation because without her insistence—and without her on the double bill—the piece probably would not have existed.

GC: Dark space. Dark light. Dark box. Black breast. Black box. Black body. Rosamond's piece "..." was a classic art action, a strong central embodied image that became amplified through

the tension of an audience. It was a piece very much about power and control. While Rosamond remained fairly immobile during the piece, she was actually the one who had set up the circumstances for the encounter. The spectators had to negotiate how to relate and respond to her loaded presence. This emphasis on audience interaction was one similarity between Rosamond's piece and my own.

As I recall, my role in *"..."* was largely to hold the energy of the piece, to help her stay committed to the boldness of her original vision. When Rosamond told me about the image of the bound, bare-breasted woman with a box for a head, I told her that she had to make that image come to life. I was curious what she would do, and I also had my own ulterior motives. In the throes of creating "Anacaona," I didn't want to be alone. I knew that Rosamond and I could provide good synergy for each other.

"Anacaona"

GC: Inspired by Jamaica Kincaid's novel *The Autobiography of My Mother*, Salomé Henríquez de Ureña's long poem "Anacaona," and especially Haitian playwright Jean Metellus's play *Anacaona*, my "Anacaona" was a site-specific performance intended to re-embody Caribbean history. A former indigenous queen of what is now Haiti and the Dominican Republic, Anacaona is a source of pride and legend on both sides of the island of Hispaniola.

I was particularly interested in the version of her story that named hospitality as the queen's tragic flaw. In Metellus's rendering, Anacaona invites Spanish soldiers to her home for a party to celebrate their offer of "friendship" and "solidarity." The soldiers tell the queen's guards that their armor and swords are party attire and then proceed to enter the castle and massacre everyone, including the queen. This became the central performance gesture of my work.

Once spectators left the site of Rosamond's performance, they were ushered downstairs to enter a lavish party scene filled with sweet-corn cakes, red wine, champagne, and other delights—including a sharp machete. A note instructed them to eat, drink, and play music (Miles Davis's *Sketches of Spain*). In a

reversal of history, they were already celebrating the overthrow that had not yet occurred. At a certain moment, Don Walicek ushered them back upstairs, where the performance space had been transformed with palm fronds, jars of corn mixed with cut ribbon, and a queen—me—tied to a chair with red ribbons. Each "partygoer" had to offer a gesture to the queen in order to enter the space. The last person to cross the threshold was Rosamond, who offered a ceremonial transfer of the machete.

This was Rosamond's only express gesture in "Anacaona," but it marked an important continuity for the audience and for myself. Our machete exchange became a transfer of performance energy that linked her work—and the memory of that bound black woman with/in the black box—to the colonial history reimagined in my own piece. It also felt right for me to have one last moment with Rosamond before the piece began, since she had been an indispensable sounding board for me in the development of the work. Rosamond was present for the development and manifestation of my ideas. Aside from Don Walicek, she had been the only person to watch an early walk-through of the work. Together we had discussed the renovation of the room into a performance site, put the word out about our performances, and made programs. All of this was artistic collaboration.

Like many of my works, "Anacaona" was a fantasia. I danced, gnawed corn, told stories over a background of projections, and, at a key moment, passed out handfuls of corn and instructed the audience to pelt me with it. It was the first piece where I gave over an extensive amount of control to the audience, who moved from traditional art spectators to unruly partygoers, banging on drums, eating, talking, and at times disobeying my commands. At one point, the great Puerto Rican dancer Merián Soto wouldn't stop hitting me with corn kernels, and I understood that in performance anyone could rise to take power at any moment. This reinforced the conceptual underpinnings of the work. The piece ended with me chewing and spitting the corn at the audience and speaking aloud all the Spanish words that I knew (which at that time were fairly few).

Gabrielle Civil in Anacaona / Photo credit:
Rosamond S. King

RSK: The differences between "..." and "Anacaona" represent the difference between my and Gabrielle's aesthetics; my pieces are spare, often with a single primary image, while hers are full of abundance, even of visual excess. While we both often address issues relating to the black Caribbean female body, I think part of why we can be such strong supporters of each other's work is that we each make pieces the other would not have thought of. This allows us to be excited by each other's work.

I felt that "Anacaona" was—and is—a deeply significant piece, not because it animates the individual person but because it animates *the spirit of the encounter* between the Caribbean and the European. I was meant to have a technical role in Gabrielle's piece, and I completely missed my cue, which meant there was no sound played during the piece, and so that layer was lost. I felt terrible, and in retrospect, it wasn't wise to take on such responsibility immediately after my own piece. As I remember it, my role in the preparation of "Anacaona" was to encourage

Gabrielle to maintain the excess and the confrontation of the piece. The confrontation had a particular flavor because, while it reenacted a historical moment, in the real moment it took place between largely white-identified Caribbean bodies and a single black Caribbean body.

Gabrielle Civil in Anacaona / photo by Rosamond S. King

Since *hipotéticas*, Gabrielle and I have made many performance artworks, but we have rarely had the opportunity to share a bill or to create pieces within the same space and time. We will certainly do this again. In the meantime, however, we have continued to discuss our creative processes and to encourage each other to push to the edge of our, and our various audiences', comfort levels.

> **GC:** Yes—and in Trinidad, we met the studio 66 artists together and talked to them about their work, drinking rum with them, and I still have the painting that I bought from one of them... And then of course you went with me to Haiti where your presence actually allowed me a lot more freedom that I would have had otherwise with my relatives.

I could just say that you and I were going to my grand-mother's house--and we always went. We just stopped by markets and galleries and other places before we got there... Kind of around the corner to go next door! Even though we didn't make new work on those trips, I think there's something of intra-Caribbean travel and sensibility that's been important for us...

When we were in Haiti, what struck you the most?

Sent at 6:25 PM on Sunday

RSK: I was absorbed by how different Haitian rara is from Trini carnival - I knew that academically, but to see small bands of people with homemade costumes - similar joy and not dissimilar music and steps - but a very different setting. That was striking. And the guns - I'd never been in a bookstore that had armed guards. And the fairly obvious - and yet unspoken (in front of me) presence of Vodoun - objects hanging in the corners of people's homes, for instance.

If we were to collaborate on another performance in the Caribbean, what elements or themes would you like it to include?

Sent at 6:52 PM on Sunday

And so chats become thought experiments become conversations become videos become individual and collective artworks. As diasporic black Caribbean women artists, we venture once more behind the orange door—to raise new questions for ourselves and each other, to challenge and reclaim authentic gestures, and to imagine and embody new possibilities of collaboration.

PERFORMANCE SCORE
Behind the Orange Door—Revisited
for Small Axe

Put the altar in the corner.
Do a Caribbean step.
Put white eggs in a brown paper bag.
 Put the bag up high.
Unwind a very long cord.
 Plug it in.
Don't get the joke.
Suck your teeth.
Move yourself to _____.
 Do it again.
Do it right.

—Gabrielle Civil and Rosamond S. King

**

D R O P E V E R Y T H I N G A N D R E A D

"The Great Camouflage: Writings of Dissent (1941-1945) - Suzanne Césaire"

The Great Camouflage is a book both necessary and problematic. A slim volume of Suzanne Césaire's *Writings of Dissent (1941-1945)*, it offers the complete collection of her seven essays for the groundbreaking literary and political journal *Tropiques*. Born in 1915 in Martinique as Suzanne Roussi, Césaire cuts a glamorous figure. A co-founder of *Tropiques*, she faced off with fascist censors, loved and married Negritude giant Aimé Césaire, charmed André Breton, taught and raised brilliant children. Alas the cinematic aspects of her life have long overshadowed her intellectual contributions. *The Great Camouflage* redresses this in part by recuperating rare documents and making them available for the first time in English. The book, however, has trouble navigating her legacy as beautiful woman, wife, mother, muse and visionary thinker.

For Césaire was a visionary thinker. Her writing bursts with intelligence, fervor and conviction. In her essays "Leo Frobenius and the Problems of Civilizations," "Alain and Esthetics," "André Breton, Poet," and "1943: Surrealism and Us," she mobilizes anthropology, philosophy and poetry to awaken global black consciousness, resistance and liberation. Her other three essays go even further in asserting her own lyrical voice. Anticipating *A Small Place*, Jamaica Kincaid's 1988 screed against Caribbean tourism, Césaire's essay "Poetic Destitution" blazes with derision. She writes: "Far from rhymes, laments, sea breezes, parrots... we decree the death of sappy, sentimental, folkloric literature. And to hell with hibiscus, frangipani, and bougainvillea. Martinican poetry will be cannibal or it will not be" (27).

With this cannibal spirit, Césaire devours and denounces the forces of Martinican oppression. In "The Malaise of Civilization," she rejects European assimilation and bourgeois

competition with the desire to reconstitute the consciousness of her homeland. She proclaims:

> "And let me be clear. It is not at all about a backwards return, a resurrection of an African past that we have learned to know and respect. On the contrary, it is about the mobilization of every living strength brought together upon this earth where race is the result of the most unremitting intermixing; it is about becoming conscious of the incredible store of varied energies until now locked up within us" (33).

Amen. Eloquent and visceral, these words alone urge you to buy a copy of this book!

Inspiring this volume's title, Césaire's final essay "The Great Camouflage" goes even further. Again anticipating Kincaid, Césaire moves from the romantic vision of the islands from an airplane window to arrive at "total insight" (41).

> "Here the poets feel their heads capsize, and inhaling the fresh smell of the ravines, they take possession of the wreath of islands... and they see tropical flames kindled no longer in the heliconia, in the gerberas, in the hibiscus, in the bougainvilleas, in the flame trees, but instead in the hungers and in the fears, in the hatreds, in the ferocity, that burn in the hollows of the mountains" (45).

Césaire reveals how the great camouflage of beauty threatens to disguise the persistence of oppression in the Caribbean as well as its simmering, revolutionary possibility.

This camouflage becomes the problem of the larger text itself as *The Great Camouflage* swaddles Césaire's work in testimonials by great men. The book begins with introductions from translator Keith L. Walker and editor Daniel Maximin. While both provide some good context, especially Walker's introduction which analyzes the significance of camouflage throughout Césaire's work, Maximin's introduction "Suzanne Césaire *sun-filled fountain*" slips too easily into sexist tropes. Beginning with an epigraph from Aimé Césaire: "in those days, it was the time of the parasol of a very beautiful woman /

with the body of golden corn and cascading hair," Maximin describes the Césaires' wedding day and writes: "In those days, her sun-filled beauty and power, visible in the sparkle of her eyes and the radiance of her hair, also revealed a fragility in her vine-line body, rarely still and never rested" (xxv, xxvi). Césaire's physical body comes to compete with her body of work.

Maximin describes Césaire and two of her friends as "luminously beautiful with an inner radiance, bearers naturally of great culture without gloss or glitter, intelligent while distrusting of the strictly cerebral, seductive while refusing to be seductresses, fiancées of Dionysus more than sisters of Eurydice" (xxxii). Maximin also mentions Césaire's singing voice, her preferred brand of cigarettes, and her love of reading "outside in nature, perhaps Nietzsche or Frobenius, in the sunlight, barefoot" (xxxii). While Maximin's reverence for Césaire seems sincere—she even appears as a character in his 1989 novel *Lone Sun*—these descriptions remythologize her as muse rather than significant thinker in her own right. Maximin declares: "she was the torchbearer, a major inspiration, the mediator of the most profound exchanges" (xxxii).

This notion of Césaire as muse undergirds the book's organization. Only Part 1 presents her actual writing. Part 2 and Part 3 feature writing inspired by Césaire including a rhapsodic poem on her beauty by Breton, love poetry by Aimé and a final loving poem by Suzanne and Aimé's daughter Ina (herself an established writer) entitled "Suzanne Césaire, My Mother." Rather than showing these authors' appreciation for Césaire's *ideas*, these inclusions foreground an appreciation for her *beauty* and *personality*. This is a familiar, gendered pitfall, one deftly avoided in two very strong books: T. Denean Sharpley-Whiting's *Negritude Women* (2002) and Jennifer Wilks' *Race, Gender, and Comparative Black Modernism: Suzanne Lacascade, Marita Bonner, Suzanne Césaire, Dorothy West* (2008). These books situate Césaire's production more appropriately in a wider trajectory of brilliant, marginalized black women intellectuals. If it belongs at all, the supplementary writing in *The Great Camouflage* would fit better in an appendix.

In her essay, "The Great Camouflage," Césaire writes: "if my Antilles are so beautiful, it is because the great game of hide-and-seek has succeeded" (46). Appreciative of her whole life, the reader of *The Great Camouflage* should take her words to heart.

Introducing Rita Dove

Amongst her many titles, Rita Dove can claim another: she is bar none, the Poet I Have Most Loved in My Whole Entire Life. *"When I was young, the moon spoke in riddles and the stars rhymed."* When I was young, I read a poem that changed my life. *"The day? Memorial."* The poem "Grape Sherbet" and the poet Rita Dove. I was 14 years old and enrolled in Henrietta Epstein's summer poetry workshop in Detroit. I had come for fiction but poetry was part of the deal. I had never really read poetry before. At least not by somebody alive. And certainly not by some Alive Black Woman —and I could scarcely believe such a thing could exist. *"swirled snow, gelled light."* Meditative and elegant, distinctive and spare: *"We cheered: the recipe's a secret."* It was like nothing I had ever read before.

"Are you sure she's black?" I asked. "It says the grandmother is *diabetic.* Not black." "Aren't there black diabetics?" Henrietta Epstein asked me. Sure, my own black grandmother had been diabetic. And she was certainly black. "So maybe this time, being black gets to be something understood." *"We thought no was lying there under our feet/ we thought it was a joke."* And the poem opened up to me. And what being black in a poem could mean opened up to me, and what being black in the world could mean opened up to me too... And I moved beyond the literal into the actual, beyond the posture into the figure, beyond the stranger into the family, into seeing and saying myself in myriad ways and this was the presence and promise of poetry. *"Each dollop of sherbet, later, is a miracle, / Like salt on a melon to make it sweeter."*

Years before writing about Dove's poems for my undergraduate and master's theses, I used to carry her books in my purse like talismans. I'd show them to my family and friends, pull out her poems and say them aloud over and over. Some were stubborn locks refusing my picks. Where is it in "Medusa" that *"my eye / can't reach?"* How in "Pithos" have *"I ceased to ache?"* *"my "spine... a flower?"* I didn't always understand—but that was valuable, pleasurable too: the wondering, the figuring out, the revelation that somehow words can become something else just

by being themselves. Those lines in "Dusting" from *Thomas & Beulah* when Dove writes *"Each dust / stroke a deep breath and / the canary in bloom"* come to mind and the day I discovered that yes, a bloom is a flourishing—but also in the dictionary, a bloom is "a thin layer of dust." *"Each dust / stroke a deep breath and / the canary in bloom."* And so Dove's bloom is not just a figure of speech, but is also an act, a recognition. And that just by being itself, a word can be many things all at the same time. Which is what poetry is, how it works. Which is also what we are as human beings, how we work. Just by being ourselves, we are, we can be many things all at the same time.

In her short stories, her novel, her verse drama, her seven—soon to be eight—collections of poetry, Rita Dove offers us race, relationships, history, memory, politics, family, many things all at the same. Her work world-travels home through Africa and Europe, freedom rides back to Montgomery Alabama, genealogizes Ohio, castle walks through the First World War. Dove surprises us with resonant diction and technical verve. From a taste of grape sherbet to a ride with Rosa Parks, *"How she sat there, / the time right inside a place / so wrong it was ready,"* Dove offers us small moments with big implications. She mesmerizes us with the music of experience: Hully Gully humming, cornets, spoons, Blues in Half-Tones, ¾ time and her new *"Sonata Mulattica."*

"How do you use life? How do you feel it?" Tonight we have the honor of hearing from an extraordinary poet who orchestrates language and expands the world. *"I prove a theorem and the world expands,"* she writes. *"What good is the brain without traveling shoes?"* With her voice: *"You start out with one thing, end up with another, and nothing's the same, not even the future."*

**

flashbacks

Hyperbolic: those black girls and the Indian one.
Cooing, wondering, burning.
Has she fallen?
Have you ever thought so hard that the world
has cracked open like an egg?
Enter strangeness.
—No. 1 Gold

HYPERBOLIC

Hyperbolic was the second performance of the No 1 Gold Artist collective, a tiny, unknown group of three women of color ("those black girls and the Indian one") founded in New York City, at the tail end of the go-go 90s.

*Hyperbolic was written and performed in 2002. The collaboration involved not only the script and its performance but also the way in which we were in process together making sentences, gestures, and meaning in order to form ourselves as writers and artists. The notes indicated in different fonts—*Avenir for Gabrielle, *Calibri italicized for me, Madhu,* and **Palatino bolded for Rosa**– *added fifteen years later in 2017, are our edits and annotations from the future, where we are still in conversation. This collaboration, then, is also a collaboration with time.*

> Performers: Gabrielle Civil (GC) aka GFC, Madhu H. Kaza (MK) aka MHK, and Rosamond S. King (RK)
>
> Tech: Slide projector, audio, general lighting
>
> Props: a typewriter, a pail, rice, cloth, books (Ovid's *Metamorphoses* – 2 copies, 1 with pages ripped out and stenciled in gold w/ No. 1 Gold text – to be handed to the audience midway through show)

We didn't put in a line for costumes. I don't remember what GFC or I wore, but MHK's hair and the bird in it are legendary to me. *(Rosa, that was Chimerical, an earlier performance we did, not Hyperbolic. I wore a beautiful grey cotton kurta for Hyperbolic—oddly simple given the show's title.)*

Performers are separated on the stage, speaking in each other's directions, but without seeing each other.

I was teaching in a summer program in the Hudson River valley and had to sneak off and take a train to get to HERE on 6th Avenue in NYC where the performance took place

as part of the American Living Room Festival. By then, I had officially moved to the Upper Midwest, and so our artistic and conceptual experiments had occurred at a distance. We built the show by each contributing a sentence.

GC: We are actually already legendary.

MK: I never learned the subjunctive.

RK: Is this a job, or is it work?

Fifteen years later, I'm blown away by how those sentences still resonate with our personalities...

Yes, GFC, I am still asking this most pedestrian question.

Gabrielle, always already starring. Me, worrying language. Rosa laboring.

RK standing, looking at the typewriter. GC is reading. MK is washing her hands over a pail.

RK: Is this a job or is it work? Some people get paid to be professional audience members, clapping and laughing at the right times. But usually, that's for Jerry Springer and Ricky Lake. This shouldn't be a job *or* work.

Those TV shows SO date this piece!

MK: *(RK begins typing.)* Were I to love the boy that (beat) who stole my red chinese bicycle... If he was here, if he were here, he stole my red bicycle and if he were a boy, he was Uruguayan and if he stole my bicycle, I would want, I would have wanted, I should tell him, I would have wanted to tell him... I would have wanted... would have... I never learned the subjunctive.

That/who. That who. I can see now how much the "that" which is also a "who" has stayed with me. In the novel I am writing now, there is a moment where the narrator says, "Every time I say 'what?' I mean 'who?'" What is in the past, what is in the future?

GC: Hi. My name is Gabrielle. My name is Jesus. My name is Persephone. My name is Asher Lev. My name is Daniel Webster. Your life is amazing. Not as amazing as mine. But we are actually already legendary.

A flashback. Walking into the St. Mark's Poetry project and having a world unfurl. A troubadour playing poetry on a violin, a pun slam, a poetry machine (operated, I discovered later, by an Ugly Duckling), a typewriter inferno in which a person shouted things at you through a megaphone while you typed... This Anti-Reading by the Loudmouth Collective exuded wonder, sensuous language, wacky artsiness, fun—everything that I had imagined New York City could be, what I missed, what I had longed for even when living there. It was a problem of recognition. Couldn't they see that I belonged? That they were my cousins? That they were art stars? That young and plump and brown and bespectacled, I was actually an ART STAR!

Blackout.

MK: Hyperbolic: those black girls and the Indian one. Cooing, wondering, burning. Has she fallen? Have you ever thought so hard that the world has cracked open like an egg? Enter strangeness.

I remember the pleasure of coming up with this language together (which was also the official description of the piece). I am embarrassed by "Cooing, wondering, burning. Has she fallen?" now, perhaps because of a romantic strain in it. But it feels true, too.

Slides projected (10 consecutive blank bright blue slides)

Lights fade up. MK comes over to RK, who tries to teach her to dance and do pirouettes. MK practices the steps but is bad. She is not listening to RK's words and begins to speak as she continues to practice.

MK: *(RK does not hear her speak. GC goes over to the typewriter, which does not work.)* "Why don't you say what you mean?" a man said. He, she, they, their mother, her neighbors, their friends, the postman, the president say, "just say what you mean."

If I should... If I could say what I say and mean what I mean there wouldn't be a need for trees, beyond shade. There wouldn't be trees beyond lumber.

GC: Damn typewriter!

MK and RK ignore GC. MK dances away from RK, who begins to stretch.

MK: There shouldn't be bicycles that are red and shiny... There shouldn't be the tiny parts, gossamer threads bundled into nerves. If there be trees. If there be dust. If troubadours and if saints; if recorders and if bells. If girls with red bicycles and not red dresses.
If icicles. If gold.
If torrents. If bulbs.
If it be impossible and maybe.
If maybe.

RK dances across the stage to the typewriter, doing pirouettes. She is much better than MK.

GC: *Trying to fix the typewriter.* Primitive technology! Who invented this thing?

Recently at the end of a reading, a man approached me with a smile. "We haven't met, but I was the one who loaned you the typewriter," he said. "That was a very sexy typewriter!" I responded. It was red and sleek and Italian. "Thank you so much!" I had borrowed this

typewriter to write public love letters in a bookstore to celebrate the launch of my first big book, one that talks a little about No. 1. Gold. This man worked at a publishing house that had rejected my book. His kindness helped reduce my grudge as well as the fact that time moves on. His sexy typewriter worked well, although I didn't recall that the letter L doubles for the number 1. Instead, I turned to exclamation points. Gabrie!!e Civi!

> *Gabrielle gets up & goes off stage. Rosa sits & speaks to and/ or types job letter:*
>
> **RK:** To Whom it May Concern:
> This letter is in application for the advertised position. I need a job, an activity daily or not for which I receive money and health insurance. I already have work—that to which I have devoted my life colon space space words movement silence stillness...

All of this is still true.

> **MK:** *Eating raw rice; after she begins eating the crunching sound is amplified, sounding not unlike a typewriter.*
>
> **RK:** Your (prompt?) attention to this matter is sincerely appreciated. As stated above, I already have work that pays in satisfaction, if not dollars. I need a job. Sincerely
>
> *RK continues dictating softly to the typewriter.*
>
> **MK:** *Stops eating the rice.* I like the littleness and hardness of it. (*Pause*).
> *MK pours the rice into her skirt.*
>
> **RK:** (*Leans over MK's shoulder*) So, if you're with someone, and that person loves you more than you love them. Is that intimacy? **Yes.** Is that a job? **No.** Is it work? **Yes.**
>
> *(exit MK and RK)*

GC: Halo

There was a girl telling a story when she needed to run.
There was a girl telling a story arms extended across the table.
There was a girl and a three foot piranha and *it was thiiis big*.
Your prompt attention to this matter is sincerely appreciated.
Have you ever loved someone so much and so hard,
you had to kill them from you? A dagger stabs into her
On the walk home. A deviled egg watches her
picking flowers, I always think daisies,
I always want roses, but it's really pansies, lilies,
or where I'm from erosion deeper surface under over
or a thick glade wet with coconuts, spears, bicycle horns.
I digress, she delights in her basket of flowers,
baked eggplant, he lifts his eyebrows.

I remember when GFC had to kill the idea of Rita Dove…

Ok, so we had Ovid's Metamorphoses and Kafka's "Metamorphosis" in the Hyperbolic mix, but what was the Rita Dove poem that GFC was connecting to here? I think it was "Persephone, Falling."

Yes, that's the one. And I still love Rita Dove, although my work is not as influenced anymore. (Or, at least it doesn't look that way).

RK: *(Interrupting)* Is that intimacy?

And somewhere was the Metamorphoses winding its way through the crowd? With García Lorca in the ether and Kafka and Kundera and fairy tales and shange's Liliane…

I just remembered that I was reading the Lais of Marie De France at the time and I think we had some pages of the lais also being passed around in the audience but can't say for sure. In any case, though I haven't thought of the lais in more than fifteen years, I can read the raw charge of them in the energy of this work, my own reckoning with Romance and the questions

of the literal and figurative, how a story asserts itself to be true.

GC: Yes!
He is more than a man, she is doing it for the other girls,
She is filling up for us, for you right now. We are actually
already...Ovid: "Dis saw her loved her, carried her away. /
Love leapt in such a hurry." She needed to run.
A split second, to turn, lamplight at first dusk,
she runs throws a ribbon turns into a river,
she runs throws a brush turns into a forest,
she runs throws her spectacles, reflecting pools.
Too late, she is hedging. He pulls you in.
She is captured. She lies, under duress, "she'd torn
the shoulders of her dress," "black tongues flutter."
Legendary leapt and *it was thiiis big*.

MK: *(MK rolls across the floor slowly —Hindu style)*
I should wake to a day of declarations. I would be
legislative in my manners.
I would say yes, I would say no.
If there weren't the tiny parts, the sharp tastes.
If there weren't bicycles that were red without tassels.
red without horns, red with no basket, red and no brakes.
Suppose thinking, speaking, feeling weren't perpetual
~~anxiety~~ *intensity*.
If it weren't disorder to be awake. Yes.
I can try this.

Blackout.
Three orange slides projected.
Lights fade up.

MK: French lesson: a. e. i. o. u.

Repeats the French vowels over and over with French pronunciation.
Repeats the vowels faster and faster until they become an incantation.

GC: Moi, j'ai appris le subjunctif. *[GC uses travailler in
sujunctif]*

Moi, j'ai presque oublié le subjunctif. Mais, je me rappelle bien l'espace de l'île Gorée, l'odeur des dictionnaires, le goût des pains au chocolat...

> *GC continues to speak in French, MK says the vowels slowly and then quickly as though they are an incantation. GC stops talking.*
>
> **MK:** Oui, je ne peux pas. Oui, je n'en veux pas.

Translation: Yes, I can't. Yes, I don't want it.

> Oui, je ne peux pas. Oui, je n'en veux pas. *(Pauses and goes over to GC leans into her ear and speaks)*
> a. e. i. o. u.
>
> *GC and MK walk offstage.*
>
> **GC:** *(From offstage)* Does this work? Or is it work?
>
> *RK comes onstage, folds a cloth, puts it on her head, then places the pail on her head and exaggeratedly walks around, swaying (like a distorted cakewalk) on the stage.*
>
> **RK:** Your prompt attention to this matter is sincerely appreciated.

[This space intentionally left blank.]

> **GC:** *(Comes on stage with MK. Points to RK and speaks to MK)* Are you being literal or metaphorical?
>
> **MK:** You say tomato. I say tomato. *(Pronounces it the same both times)*
>
> **RK:** *(Puts the bucket down)* Actually, we are already legendary.
>
> **MK:** Is literalizing the metaphor is a sign of psychosis?
>
> **RK:** Is this a job or is it work?
>
> **MK:** If I collapse the literal and the metaphoric is that a sign of psychosis?
>
> **RK:** Is this a job or is it work?

MK: Psychosis. Where I live – the yes and no unsplit, unseamed, unwound. Ravel is unravel. The Uruguayan who exists. I sucked the lemons in his yard and they were lovely and he does not exist.

RK: Is this a job or is it work?

MK: Potato. Potato. *(Pronounces it the same both times)*

RK: If this is a job does it cease to be work?

MK: Technology. Kill the metaphor.

RK and MK begin doing the mirror patty cake (ie. no contact).

The machine of exact memory is the machine of exact memory.

This is not the machine that we were speaking of, but we all have fond memories of "The Poetry Machine," a man *(Matvei Yankelevich)* inside of a refrigerator box who appeared at least one of the "Anti-Readings" sponsored by Ugly Duckling Press (and sadly, held no more). Those events included "pun star" contests and all manner of writing, typing, performance, and poetry. They were exhilarating and were inspiration.

RK: If this is a job does it cease to be work?

MK: Stupidity.

RK: If this is a job does it cease to be work?

MK: Mysticism. My heart star shattered for you. Listen. My heart. Star shattered.

RK: It's always work, but when is it a job?

MK: Mysticism. In my longing I would become as a tree. Should I be as a tree?

RK: It's always work, but when is it a job?

MK: Art. My heart which is like a metaphor, is furtive and shifty & cannot be mapped directly but is visible

in your oblique glance, like a star slowly pulsing that is like that a nocturnal tracery that is like the seahorse in birthing that is like the ache of all greening.

Or mostly it's a man holding an egg in his hands.

RK: It's always work, but when is it a job?

MK: Fascism. Fundamentalism. *(MK does a distorted cake walk dance as she says this and pronounces these words slowly and seductively)* The literalization of the metaphor

RK: This is our work. Should it also be a job?

MK: It's where I live. Further north. Paperclips and cheese slicers and sleighs. Cold places with the smallest parts lost in drifts of snow. And I could be a tree. Really. You must understand this.

RK: This is our work should it also be a job?

MK: Where I live. In the hinterlands, in Norden, as a tree, with the Uruguayan who did steal my red Chinese bicycle and who does or does not exist.

And if you have any heart at all you must attend carefully to language. There are no laws about understanding.

Recently I was sitting next to the artist and filmmaker Miriam Ghani at a performance and I asked if her current film project was fiction or documentary. She said it was both. I loved this answer as I have really become a person who prizes art that plays between fact and fiction. I think of myself as a writer of prose (fiction and non-fiction are not particularly meaningful distinctions in my work). I asked Miriam if the slipperiness between fact and fiction in her film was connected to its theme of Afghan politics. It goes further back, she said, to our folk tales. Arab folk tales begin, "There was and there was not..." Yes! I thought. Of course, and there must be other traces of this way of viewing reality and storytelling in all our histories.

RK: Is this work sincerely appreciated?

Blackout.
One blue slide projected.
Lights fade up.

Years later, Gabrielle asked me about the blue slides in this show. What was that, where did it come from, she asked. I was very clear about the blue and orange slides that punctuated the performance. I answer once again collapsing the literal and the metaphoric: the bright blue slides are where I come from.

Then almost any space was a space of possibility. This was desire and loss and a lot of hot air. Incomprehensible not that a gigantic balloon could whisk you to other worlds but that I had never been on one. Except maybe I had. Each book an atlas or almanac or grimoire. Each beckoning transformation. How I don't think I had read Anne Waldman's "Makeup on Empty Space" before this, but somehow, I was responding. How for sure I had read Jayne Cortez and admired her verve and relentless honesty and rhythm and powerful black-woman-writerness and how badly I wanted that. And how claiming it was trying it on and flaunting it and becoming.

GC: Fill the space with space. Fill the space with rice. Fill the space with laughter, with movement, with allusion, Pretense, pretension. With chicken bones.
Fill the space without flesh.
Fill the space with hot combs better than potato lie.
Fill the space with hot comb. Press. Molecular extinction.
Fill the space with overblown words: desire.
Fill the space obviously—with language.
Play. Repeat after me.
I am a rock star.

MK and RK repeat: I am a rock star.

GC: I am the Hale Bop streaking across the sky.

MK and RK: I am a glorious meteor streaking across

the sky.

GC: I am fucking amazing!

MK and RK: I am fucking amazing!

GC: Cosmos. Stop.

RK: There's no need to be vulgar!

(MK is dancing.)

GC: Once there was a boy who woke up
one morning turned into a bug.
This really happened in Detroit—
Steam rising from manholes in plumes on deserted streets.
We listen to techno going under the bridge over to Windsor.
It was somewhat astonishing being turned into a bug,
But when you go out to have fun, there's always sacrifice.
Madhu says: Pizzicato Five says, if you want to be a
groupie, you have to stay out until 5 in the morning.
We're a rock star, we're a bug, and it doesn't phase us at all.

ALL THREE repeat: We're a rock star, we're a bug,
and it doesn't phase us at all.

GC: Equation: we worked it out sideways (hyperbolic)
and scuttled ourselves right out the door. Well *actually*
we may... have... died. But it was just a symbol. See ya
suckers! *And it was thiis big.* And you walked into the
circus and you knew. These are my people. We are my
people. And there were slides and typewriters and lots
of wine (see you after the show) and I said to Iggy:
"Listen to me. We are recognizing your genius and you
need to recognize ours!" The story we were making—
making right now. Mom and Dad and Grete didn't like
the bug, but so what! We laughed, we cried. We used
tropes with good humor, in excess, in abandon. "In
lies, in lies." We were and we were not the bug. We laid
down the language for the future retelling. It was and
was not labor, elaboration. It is and is not exaggeration.
We are and are not true.

We are actually already legendary.

MK: I never learned the subjunctive.

RK: Is this a job or is this work?

GC: Beyond metamorphosis. This is now.

Actually, it is then. The elusive slip. Then and now. The present past. Our memories overlap but don't completely align. Multiple scripts confuse. How we wrote characters from memory, a Uruguayan with a bicycle, Iggy from the anti-reading, poor Gregor Samsa's sister Grete. How we made characters of ourselves, built our artistic characters, writing and dancing and playing. How we desired and longed for and materialized—flashing slides of blue light, typewriter clicks, hips winding under the weight of a pail. How I love this play! Now and then. How I love Gabrielle and Madhu and Rosa doing it then and doing it now.

So many of the phrases here have entered into my speech, my poems – I didn't realize that before re-reading the script.

RK: *(as RK speaks MK turns slowly and stretches up —swan like)* "And they took it as a confirmation of their good fortune and fine intentions when, at the end of the ride, Grete stood up first and stretched her young body."

Blackout.

END

vanishing

"Today? Tonight?
It waits. For me.

Sweet heart. Don't stop.
Breathe in. Breathe out"

–MELVIN DIXON
"Heartbeats"

rooms

*a n e m o n e

the black woman performance artist between windflower and sea.
moving through the tinny, post-metallic, into facing desire.
succulent thinking. an attempt at body. pleasure rebel how...

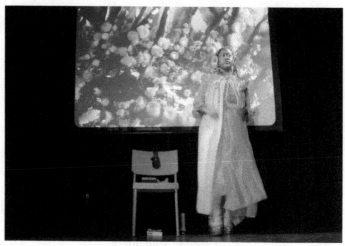

Photo credit: Sayge Carroll

 *a n e m o n e was created for Pleasure Rebel, Nastalie Bogira's groundbreaking series of New Queer Performance in Minneapolis. When Nastalie first invited me, I wasn't sure if I and my work quite belonged. Queer performance seemed most to describe work by those who directly identified as queer in public and political ways, and who often suffered discrimination for that reason. My own murky sexuality (most often described to myself *as a complete flop* or *a parade of humiliation and neglect*), separate from any precise sexual desire or attraction, seemed to not quite fit the bill. Moreover, I didn't want to take away an opportunity from an LGBT queer artist.

 Nastalie kindly responded that the queerness of Pleasure Rebel need not only apply to the declared identity of the artist but could also relate to the quality or approach of the work. They were interested in my performance practice and didn't

believe that hosting me in Pleasure Rebel would take away any vital opportunities. The series had already supported many self-described queer artists and would continue to support many more. Nastalie's expansive vision and their generosity in curation and production deserve a lot of credit for the existence of this piece. *a n e m o n e was made on some level because they opened up space for it to exist.

Continuing the explorations of love, race, and sexuality of my earlier work ("The Secret Garden (Closet)" (2002); "after Hieroglyphics" (2004); and heart on a sleeve (2006)), *a n e m o n e (2012) plays and displays moving in and through states of interiority and exteriority. In the first section, the audience watches me listening over headphones to a tape recording of myself reading a letter to my therapist about love. Only I can hear that amplified interior voice, but they can watch my body respond, see my hands start to move over my own body. Perhaps they think I'm responding to someone else's desire, but it's actually an attempt to withstand my own desire, to keep desiring myself. Looking back, this offers perhaps the best snapshot of my sexuality ever.

* a n e m o n e unfurls both girlish and cerebral. The work highlights my penchant for self-protection through the swaddling and unswaddling of my body. It showcases my romantic nature with fresh flowers and talk of love. It also reveals my deep, abiding sense of outsiderness. Here sexuality is mediated by headphones, the internet, and books. At the same time, moments erupt of unleashing —a turn of the body, an outburst of song, a repeated turn of phrase (big black dick), even frenzy at the end.

Throughout, the work mines liminality to sex, sexuality, love and queerness. Indeed, "the couples" mentioned in the piece, the positive models of love, are all queer: from my gay landlords, to my friends Sharon and Therese, to the Haitian poet Assotto Saint and his partner, Jan Holmgren. The invocation of Saint whose books are shamefully out of print remains one of my favorite aspects of the piece. Meant as a heartfelt homage, the incorporation of his words in my text and action, can hopefully

help keep his writing alive.

* a n e m o n e was a wonderful piece to make and perform. Perhaps because it happened at a rare time when I was actually in love (with a queer person) and making work within my own beautiful Fish House studio, the piece emerged as something lush and layered with possible momentum towards hope. There's a desire for transformation, for dissolution that never quite happens, or perhaps is just beginning.

A body into sea creature into flower.

*a n e m o n e - Gabrielle Civil

(threshold: search engine)

> *Track 1: Beez in the Trap - Nicki Minaj curtain opens.*
> *Slide 1 (already up): Black screen with the word "Anemone"*

Gabrielle stands puffy and swaddled in the space looking.

She holds up her flashlight and starts to survey the audience (she is looking for softness).

At the end of her search, she says: "but finding softness is a harder thing."

> *Track 1 stops. Slide 2: Sea anemones with electric kelp.*

(part one—the tinny)

She walks back, sets down her flashlight, picks up her tape recorder and presses play.

After a beat of hearing just the voice on the tape, *(...dear dr. depies...),* other music starts to play.

> *Track 2: Barely Bear-Dumb Type*

She proceeds to unravel, sheds up and through the red.
She puts on red gloves and headphones.
You can overhear the tinny resonating in her ears.

Photo credits: Sayge Carroll

With one gloved hand on the tape recorder, she moves the other gloved hand under her skirt, down between her legs. She begins to explore. What is she hearing? What is happening to her?

She stands up and turns off the tape.

Track 2 stops

She says: "and we are not the same."

Slide 3 with flaccid dick (sepia tone)

(part two—*the big black dick*)

She delivers a long speech about *the big black dick.*

Photo credit: Sayge Carroll

Big Black Dick Speech
it's harder than you might think
to find a flaccid black dick on the internet
sure, you can find plenty of erect black dicks,
hard, massive, gigantic even, humungous, well hung,
penetrating, poking, preening, engulfed in someone's mouth,
serving—well no: being serviced, served
but finding softness is a harder thing
the softness of the body...

WHAT HAPPENED TO ME TO MAKE ME THIS WAY?
i was trying to find this thing on the internet
this bell hooks quote—it was in one of her books
breaking bread, talking back, yearning,
one of the early ones and she was saying
black women always say they want to be treated right,
they say they want to be understood,
they say they want (*she sings*)
A MAN WITH SENSITIVITY A MAN LIKE
wait—that was Ralph Tresvant, the lead singer
of New Edition (before Johnny Gill) but
you probably don't know him
you know Bobby Brown or Chris Brown, right?
bell hooks said they say they want to be treated right
they say they want to be understood
but all they really want is *the big black dick...*
the big black dick—try typing in the phrase
big black dick in the internet and
see what comes up. Exactly.
the big black dick I asked him once—
WHAT DOES IT FEEL LIKE? WHEN IT'S IN ME
WHAT DOES IT FEEL LIKE? HE SAID—
YOU'RE JUST MAD THAT YOU DON'T
HAVE ONE OF YOUR OWN *the big black dick*
No—I am trying to understand feeling *the big black dick*
CAN YOU LOSE SOMETHING YOU'VE NEVER HAD?
I had a student—a lovely white Christian feminist
on her way to the marines—Praise Jesus! they could use her—
and I'm not being ironic, and neither was she—my student wrote
a knock-out paper on the poet Assotto Saint. Haitian-American,
black, gay, AIDS-activist lover from the 1980s. Assotto Saint,
according to my student, was a black feminist warrior.
She wrote about him and bell hooks and subverting
white hegemonic capitalist patriarchy and *the big black dick*
the big black dick—say it with me: *the big black dick*—
and it made me wonder:
how did she know? how did she know?
AND HOW TO TALK ABOUT THIS THING

THAT HAPPENS TO ME
WHEN YOU COME TOO CLOSE,
COME DEEP INSIDE ME
AND ENOUGH! - THIS THING I WANT TO SAY/
THIS THING I SAY I WANT /
THIS THING I DON'T SAY I AM LOOKING FOR
this softness another kind of being apparent
it becomes /maybe less a stand in than something else...
more and more a body the more you look at it
a field of flowers

Slide 4 black slide no words

(part 3 disambiguation)

She pulls the flowers from her head
(he loves me he loves me not) to make
 a secret garden. the flowers on a grave.

She sings:
you need a man / with /
 sens-i-tiv-i-ty / a man like

She delivers a speech about
Assotto Saint and the edge of desire.

Assotto Saint & The Edge of Desire
Search and search all you want,
there are no pictures of Assotto Saint
and his lover Jan Holmgren together on the internet.
To find this vision, you have to reach inside.
The two of them in the 1980s wearing assless chaps,
singing electroclash in their band Xotica.
His books are out-of-print but on page 197
you can find the lyrics of one their songs...
the chorus goes:

"touch is what i want
touch is what I need
touch me, be with me
everywhere"

(She rubs the faces of the two flowers down her cheeks.
She pulls them down her neck to her heart.)

HE ASKED: ARE THERE ANY COUPLES
THAT YOU ADMIRE?
touch is what i want

WELL, THERE'S MY LANDLORDS DAVE & TY...
touch is what I need

AND MY FRIENDS SHARON & THERESE...
 touch me, be with me

BUT A COUPLE everywhere
IN MINNESOTA COUPLES COUPLES EVERYWHERE
BUT A COUPLE WITH SOMEONE IN IT LIKE ME WELL

(She crosses over to the chair.
Pulls down her electric hair.
Takes off her drag queen red platform shoes.)

PLEASURE REBEL HOW?

(part 4 epitaph cocoon)

And again more a stand in / trying to explain
something both stemmed and flailing.
again the straight girl turning to the gay boys for love advice.
In *Risin to the Love We Need*, Assotto Saint wrote:
"to be dehumanized into a dick is far more damaging
than to be discriminated." Yes.

to be dehumanized by a dick?
And to be humanized by one?

HE ASKED ME:
"WHEN DID YOU DECIDE YOU WOULD NEVER
 LOVE ANYONE?
WHEN DID YOU DECIDE NO ONE WOULD EVER
 LOVE YOU?
Are you overhearing me?

(She gathers the red and cocoons herself.
She holds up the book and the flashlight.)

Photo credit: Sayge Carroll

as a girl at night when I was supposed to be asleep
I would get real cozy in my body and
make myself a cocoon under covers
and this is what I'd do:

(She pulls out the book and reads with the flashlight.)

not what you expected? Exactly.
By Assotto Saint from *Spells of a Voodoo Doll*.

"Epitaph

There's a grave in your heart
father holed
where over & over you lay
to bury yourself
through thirty years [thirty-seven years actually]
of fits furies & fangs
ground zero

* * *

here lives she
whose womb is a wound"

here lives he
whose words are submarine.
Assotto Saint.
Haitian American
black gay AIDS activist
out of print lover.

And I love him, and we are not the same.

(part five-anemone *(dissolution)*)

She moves to the floor, begins a slow body undulation.
She says: "from the flower to the sea..."

Photos: Sayge Carroll

Slide 5 blue-green anemone

when you look up *anemone*
in the internet encyclopedia
you find this word—*disambiguation.*

how to make sure that you find the thing you're looking for?
a bisexual flower in the buttercup family
a sea creature too private to tell

She delivers a riff loosely based on different types of anemones
found in the internet encyclopedia.

>*Anemone acutiloba - Sharp-lobed Anemone
>*Anemone afghanica
>*Anemone airei

but oh the undulation

>*Anemone alpina - Alpine Anemone
>*Anemone baicalensis - Baikal Anemone
>*Anemone blanda – Greek Windflower

her entire body a mouth

>*Anemone canadensis
>*Anemone caroliniana - Carolina Anemone
>*Anemone chinensis - Chinese Anemone

tentacles. extra sensory hair

>*Anemone coronaria – Poppy Anemone
>*Anemone cylindrica - Thimbleweed, Prairie Crocus,
>Candle Anemone

anemone assotto

>*Anemone deltoidea - Three-leaved Anemone,
>Columbian Windflower
>*Anemone hortensis - Broad-leaved Anemone
>*Anemone hupehensis – Chinese Anemone

pages splayed open in her hands

*Anemone lancifolia - Mountain Thimbleweed
*Anemone leveillei – Woodland Anemone

like a geode split open

*Anemone narcissiflora
*Anemone nemorosa
*Anemone occidentalis – Western Pasqueflower

easily raised from the seed

*Anemone oregana - Western Wood Anemone, Oregon Anemone
*Anemone parviflora - Small-flowered Anemone

perennial blooming

*Anemone quinquefolia – American Wood Anemone

in the search engine

*Anemone ranunculoides – Yellow Woodland Anemone

Track 3: Hidden Place - Björk

they will flower in may & june

*Anemone riparia - Riverbank Anemone
*Anemone rivularis – Riverside Windflower
*Anemone sylvestris – Snowdrop Windflower

the internal anatomy of anemones is quite complex

*Anemone thomsonii
*Anemone trifolia
*Anemone tuberosa - Desert Anemone, Tuber Anemone
*Anemone virginiana

and we are not the same.

Gabrielle is attempting

a state of dissolution,

a becoming anemone.

She is still moving...

curtain closes

What's Happening in There
a reflection by Sarah Hollows

From the Hive - an artistic collaboration between Gabrielle Civil and Ellen Marie Hinchcliffe - organized and presented *Girls in Their Bedrooms* on the evenings of May 29th and 30th at the PoppyCock ArtSpace in south Minneapolis. Each night included performance and installations by Michelle Be, Gabrielle Civil, Ellen Marie Hinchcliffe, Mankwe Ndosi, and Junauda Petrus. The following is a reflection on the opening night.

girls

read a homemade sign on a wooden gate

in
their
bedrooms

read another as I passed through the swinging doors to the front yard of the PoppyCock ArtSpace. From the front porch, I walked inside an open door and climbed one flight of stairs where I found a gathering in the hallway. The hallway, a bridge between universes.

Something about the bodies coming together between rooms reminded me of Kathleen Hanna, in the documentary *The Punk Singer,* talking about the creative power of girls and about her desire to reach out to all the other girls making/ thinking in their bedrooms by making/thinking in hers. They made me think of sisters and girlfriends clustering in hidden corners where hallways aren't just highways but mediated physical spaces wherein infinite translations occur.

Inside the first bedroom, a bright abstract floral quilt haphazardly made the bed; a stack of books piled high from the floor assembled titles into "a book poem;" stems of flowers lay scattered in loose array; colored pencils stood in an unopened box. In neon tubes of light, "negro sunshine" glowed from the

cover of a book and Vera Pavlova's paradoxical poem on desire and regret stuck to the wall. Tucked into the foot of the bed – a heating blanket bunched, unplugged.

"That's Gabrielle's room," said a voice in the hall, "she was just here, I don't know where she's gone off to now."

She hadn't left actually. I could see her just around the corner, inside the closet, with another group. Her expression was solemn but when our eyes met, Gabrielle moved out into the bedroom, smiled wide and exclaimed,

"The girl who wasn't snaaaaaaatched!"

(Later, the significance of this would hit me deep and send an aching crack through my bones but, in the moment, it was an endearing surprise.) We hugged each other hard as she held the 'a' in snatched like a song or a moan. I didn't understand but was aware that some sort of transition had occurred between the closet and the end of the bed where we now stood. I asked what was happening inside the room she had just emerged from, but we didn't talk much about it. She moved toward the bed and said that what was going on in that room was a different girl entirely. She said that *this* room was for the

LOUD AMERICAN girl,

but that I would need to check in with *that* girl, gesturing through a window in the bedroom/closet wall, later on. We piled onto her bed forgetting ourselves for a while, as if about to be absorbed into a slumber party but were quickly called up to the attic where performances were about to begin.

Across the hall was another bedroom housing the stairwell to the attic and an installation by Ellen Marie Hinchcliffe. The perimeter of the room had been circled with a thick line of what looked to be cornmeal, making/marking sacred space or ritual. This bedroom was quieter than the first and there was a stillness about it. From the ceiling, on translucent strands of what is commonly used to catch fish, loose, blank pages were hanging - maybe flying. They held each other in the air as if

waiting to be filled, containers for lost and forgotten memories, memories that ought to be forgotten, revelations that have not yet occurred, perhaps even prayers. My attention went to the floor where flower petals rested like rain, offering a delicate bed that would wrinkle and fade in time.

Up in the attic, sweaty, laughing, curious bodies leaned forward to absorb every detail, each one beginning its own translation of the texts. Liquor and laughter made thick, hot energy that competed with the air conditioner and fan. Ellen presented an altar to honor the memories of Maya Angelou and Paula Gunn Allen, and when she spoke their names I'd have sworn the room felt fuller. *An art letter* spoke of bedrooms as sites for creativity, yes, but also for restoration and healing. A silent video in black and white attempted to tell the truth while a story told another. A new kind of economy: red balloon, the ceramic bust of a young black girl, a bottle wrapped in sequins. To share a memory (a favorite *thing*) is not the same as to give it away.

It wasn't until intermission that I was able to return to Gabrielle's closet downstairs. It was dark, and, on the floor, there was a candle. A milk crate supported a thick stack of papers with either

the name of a girl typed out

or the phrase

"a girl who was snatched."

An article, "Nigeria: dozens of girls kidnapped" was posted on the wall (#BringBackOurGirls flashed in my mind and the marrow in my bones was heavy as lead remembering the LOUD AMERICAN girl and that window in the wall, how close I had been to this thing and how different it had felt). What happens when a girl's bedroom isn't safe, when what is precious cannot be protected there? *Girls in Their Bedrooms* I thought. In the body of a bedroom, the closet beats.

Back in the attic and sitting on the floor, Michelle Be unfolded papers from inside of an envelope as if unfolding a part of herself.

In no particular order, she began to read from the poems and streams of thought she had surrounded herself with, stopping as she sensed a resonance with the audience to weave the written word with an ever-evolving dialogue of ideas spoken out.

In Junauda Petrus's short video I saw the order of time collapse as thick smoke released from her lungs only to turn back around and repeat - a slow return and release played back over and in on itself as the phrase "be free" appeared over her face.

A challenge or a plea?

Amidst each piece was a seemingly intentional sense of being in process or unresolved. Mankwe Ndosi's improvised sounds/songs were a poetic manifestation of her statement, "There's something about always having the sounds around and never knowing the meaning." What are the sounds that surround us at every moment; what fragments of recognition are sparked when the words aren't what we understand? When a gesture or a cry, silence or repetition creates a space to enter into, even if what is there raises more questions than answers. What thresholds must we pass over or through in order to begin to understand? I saw Ellen's altar between the heads and shoulders of those sitting near the front, and the late, remarkable Maya Angelou's words sounded in my mind,

"A bird doesn't sing because it has an answer, it sings because it has a song."

From the Hive took me to that space that is both a time capsule and a cauldron of possibility. A place for memories to be made, recalled and desperately (tenderly) held onto, or carefully revised for survival. Where family is but set apart. The space where secrets are dealt with, revealed, embodied, protected, written, sung. Where rage, rest, and resistance weave strange fibers. Where the meanings of words are born and wrestled with, and sometimes not settled upon because bodies, because ideas, because questions don't always make the most sense with language attached.

Perhaps most of all, *Girls in Their Bedrooms* left me with the undeniable sense that there's something about doing and being together that helps us to reconcile existence with what we can't understand.

Girls in their Bedrooms: A Conversation
Gabrielle Civil & Ellen Marie Hinchcliffe

Ellen Marie Hinchcliffe & Gabrielle Civil at "Girls in Their Bedrooms"
/ Photo credit: Sayge Carroll

Gabrielle Civil (GFC): Maybe we should start with how "Girls in Their Bedrooms" came to be.

Ellen Marie Hinchcliffe (EMH): So my first memory: it was summer, and you stopped by one night and I was up in my bedroom and I had just started watching the Kathleen Hanna documentary.

GFC: *The Punk Singer.*

EMH: And you plunked down on my bed and watched it with me. And the thing that hit us that night was when she was talking about making the solo album, the *Julie Ruin* album. And she was talking about making it in her bedroom and thinking about all the other girls creating in their bedrooms. Which was a riot grrrl notion about girls in isolation, figuring out they weren't isolated and that there is all that creativity out there.

GFC: That is very riot grrrl but also very From the Hive and channeling creative energy. Also you were kind of down in the dumps that night and I had recently moved away and was back in town and you know you are really good friends with someone

when you show up and you are just like, "What are you watching? Scoot over." Then you are in their bed watching a movie on Netflix. That feeling of connection and intimacy was so nice.

Video still from "Art Letter (for Gabrielle Civil)"
/ Credit: Ellen Marie Hinchcliffe

And there was something about race in it too. I had just seen a show, one of many shows with some white people using some Nina Simone songs.

EMH: That's the other conversation we got into, about how often white people will pull music like that to use in their own work, including me and you were saying...

GFC: I want to go the other way. Nina Simone is a genius. And it was not so much that they [white people] shouldn't do it, but what about as a black woman if I used a riot grrrl song or *Julie Ruin* and flipped it. So that was in the back of my mind.

EMH: That's how the "Locus of Gold" video showed up as one of the projects we started working on and we used a *Julie Ruin* song and we were playing with the notion of that internal space, in your bedroom and all that creativity and then taking that out into the world, and in the film, it shows up as that gold thread that you are dancing with.

GFC: Something about "Locus of Gold" and "Girls in their Bedroom" that is important for us as artists to remember is that we had an idea and then we just did it!

EMH: I went to Joanne Fabrics, bought that shimmery gold ribbon and then came over with my camera and we just had the idea for internal/external and shot the video.

Video still from "Locus of Gold" by Ellen Marie Hinchcliffe

GFC: And we had also seen that artist at the Walker Art Center. Jim Hodges.

EMH: That's right we went to see him, and the space was cavernous and cold. But there were flowers and webs.

GFC: His work was beautiful.

EMH: And that really got us thinking about installation. And I had

this notion that I really wanted to hang blank pieces of paper from the ceiling with gold thread. So what was coming together was a night of performance, but installation was really alive. We looked into a gallery space, but it didn't work out and we were sitting way up on the third floor in your art space in The PoppyCock drinking wine, and all of sudden it was like what if we do it right here?

GFC: That was where things magically came together because there was a turnover at The PoppyCock and it was just two or three people living there and I was renting a bedroom and the attic art space for part of my three-month research term from Antioch College. So there were empty rooms and Josina really wanted to open up the space more for art.

"What Remains" installation by Ellen Marie Hinchcliffe / Photo credit: Sayge Carroll)

Video still from "Art Letter (for Gabrielle Civil)" / Credit: Ellen Marie Hinchcliffe

EMH: We went down to the kitchen and found Josina...

GFC: And she came up and we pitched it and she was like that sounds great! So it was re-imagining an art space. And speaking about that and thinking about the Walker, which in the Twin Cities can be this monolith, this fortress of ice and solitude.

EMH: Brick and aluminum.

GFC: And I go to the Walker quite often and have seen things that matter a lot to me but something about the big capital A, capital W Art World... and what I have been discussing with my students in Black Women and Performance class. There's this article by Freida High W. Tesfagiorgis ["In Search of a Discourse and Critique/s that Center the Art of Black Women Artists" (1993)] and she talks about an alternative notion of art worlds, how there are all these little art worlds coming together that are different than the big Capital A, capital W "Art World" that is really on some level just interested in perpetuating and justifying itself.

So we did go to the Walker and Jim Hodges inspired us which is a goal of the Walker—to be a catalyst for artists—but also, we can create our own art space and community where we are experimenting and really pushing our own artistry in different directions which is as valuable—and often more valuable—than what is happening on the big art scene.

That was really important coming out of some conversations I had just been in around the "Radical Presence" show coming to the Walker. And just the way community was being conceived in some of those conversations as opposed to the ways we were not conceiving it but activating it, mobilizing it, inviting it, creating it. That felt so nourishing and great and I want us to document that to remember for us and others: We Can Do That.

EMH: And the flip side of the Big AW is that Community Art gets put in tiny letters. And what "Girls in Their Bedrooms" speaks to is the depth of talent and skill and commitment of artists in the Twin Cities. We were able to pull this all together in less than a

month, maybe three weeks from conceiving to doing the show. And we could have curated ten times more amazing people. So having those connections and having those artists here doing interesting work and being available and then the flexibility because if we had conceived of this idea for an Art World venue, it might be a year from now if we could even get them interested. And that is something missed, something really alive about art when it comes together in this way. So there are these things stirring in us, there is the availability of space, then there is the depth of talent to pull from. Now I wish we had funding to pay those artists what they deserve. But we pulled that together and sold out both nights.
GFC: Yeah and on the dynamics of money, we laid out snacks and drinks and charged $5-10 because we wanted it to be affordable and we didn't really make $ but we didn't lose money either.

EMH: And yeah, we laid out the food and there was wine, and I believe a little bourbon.

GFC: A lot of bourbon!

EMH: It was a party as well.

GFC: And it wasn't conceived of as a money-maker but as something that would feed our souls and the souls of the people who came. I want to come back to the idea of community art as lowercase c, lowercase a. And between the big global art world and let's say an open mic at a coffee shop, how do we talk about what's in the middle? I feel like GITB was different with such a range of work and that we were all pushing ourselves. Even as we pulled the event together quickly, the ideas of the work were not slapped together.

EMH: And damn it was hot. It was summer in Minneapolis and it was urgent and intimate.

GFC: And I had just gone to a show recently also in a South Minneapolis house with Malia Burkhart and Miré Regulus. They were inside and outside the house. Miré even went across the street to Powderhorn Park and dug into the earth and laid her

body down. And there were the house shows through Bedlam with Molly van Avery and Harry Waters Jr. and so I was wondering about this kind of art space, house space, intimate space and linking the world inside houses to the world outdoors...

*Images from "My brown body, this I know"- Miré Regulus
/ Photos: Author's collection*

GFC: So the downside to all this, and what I know we talked about with Josina as well is it's a big old house and it was not accessible as a space to wheelchairs and I appreciated Ellen that you were honest about that in the PR stuff. Especially because after GITB, I was in Montreal performing at the [Hemispheric Institute's] Encuentro and I saw the most amazing performance by Barak adé Soleil and some other artists in the Disability Work Group where they showed up at a cabaret event that was not accessible, and they dragged themselves and their wheelchairs up the stairs. It was one of the most powerful performances I had ever seen. After that, I am going to always be more aware of accessibility. So it's hard because seeing and performing art in a

house was very rich for me, but most houses are not accessible in that way.

EMH: And yes, we put that on the PR to be honest about that, but, of course, that is not a solution. So the flipside to this style of spontaneous art is trying to cover your bases from a thoughtful place, not to cover your ass but to really think differently next time about that. There was an urgency and intimacy to the show that if the gallery space had come through would have been lost. But, yes, we both would think differently next time in terms of accessibility.

GFC: Let's come back to the idea of reclaiming the bedroom and intimate space. And to have a big sign on a house that says, "Girls in Their Bedrooms." And people think, sex show. But wait a minute. No. We are reclaiming that creative space for girls, and not just for girls but for all kinds of people who through their domestic/intimate spaces are creating other worlds and doing that in a house.

EMH: Let's say more about why it was called "Girls in Their Bedrooms." And how you have to fight against the instant external sexualizing of that and if there is sexuality here, it's coming from us, from me, not from the outside looking in.

GFC: To talk about you and your bedroom is not only about sex. Sex is there as part of creativity. And to say Girls is not to dismiss genderqueer or gender fluid people but to also say yes Girls, we were girls, honor girls. And that touches on the riot grrrl thing and also our own conversations and our desire to make *I Heart the Library* someday.

EMH: It will be made.

GFC: So if you are reading this, fund our film. And our girlhoods were both different and similar. Our desires to be creative, scribbling in notebooks, daydreaming, secrets, channeling a vision of a life, a world that you don't see around you and not wanting to speak it because if you do someone

might say, "You can't have that!" But you are busy building it and creating a framework for another way to be in the world. That for me is Girls in Their Bedrooms! Girls in the Universe! And so Girls is not solely about being a girl but is tapping into a kind of female energy that in many places is still not respected and cherished.

EMH: Makes me think of our Bedlam 10-Minute Play Festival piece we did a few years back that was our retelling of *The Outsiders* both book and film. And how we both had such a relationship to that story and both experienced desire for these bad boys in trouble and also a desire to be them.

Gabrielle Civil and Ellen Marie Hinchcliffe in "The Outsiders" /
Photo: Author's collection

And I think if someone came to "Girls in Their Bedrooms" expecting a shallow notion or essentialist notion of girl power they would be confused by what happened. And back to riot grrrl there was a time where reclaiming was super important. So "you throw like a girl" becomes a source of pride and we still need that reclaiming for Girlness but we also need to push that idea more, so it continues to be expansive and not shutting down who we are.

GFC: It can feel a little strange to be like "We did this thing and it was great!" But the reason I feel very thankful for this issue of *Aster(ix)* is because so many amazing things happen and go into the ether and I feel haunted by that especially in terms of black women's creativity and all the creativity that is not in the capital A capital W art world.

EMH: Just thinking of Michelle, Mankwe, Junauda, You and all the people in the audience as well that we know who are making work. The amount of strength and risk-taking and beauty in that room. It fed me. And I want to talk about isolation too. Because I have felt isolated as an artist. The time around getting the event together was so great. You, Josina, Mankwe, Reggie Prim and myself were all there working, talking, eating, having intense conversations about Beyoncé and art, and politics. Sayge Carroll stopped by and took pictures. So feeding. I need more. Sometimes you need to make what you lack. And you were just talking about being stuck in your studio and another person walked in and helped you get unstuck just by their presence. That's the power of audience.

GFC: Oh, yeah! Let's talk about the audience for "Girls in Their Bedrooms."

EMH: The first night the audience was predominantly white people. As a white woman that was interesting as I was reading about being a young, deeply political white woman and I felt a lot of head shaking of "Yes, I know what you are talking about" and a lot of laughter at the crazy and pitfalls of that.

GFC: It was super interesting to have the first night be almost all white audience members and the second night predominantly people of color and mostly African American people. And also the second night there were a lot more male-identified people.

EMH: And more elders the second night. And the second night when we evoked Maya Angelou at the beginning, who had just joined the ancestors, there was such a strong feeling in the room. And it was amazing how this elder, now ancestor,

Maya showed up as such girl energy and we opened one of her early memoirs and you read from it about being in a room with music and it was perfect.

GFC: Both audiences were great and showed what a wide range of communities we were pulling audience from. And I also like to think about audience as a way to push myself as an artist. So how do you cultivate an audience that can hold the energy for you but also push you? That is something we have talked about for years as artists and also as members of the audience. I think about Jean Ann Durades who was there. She would be the first to say, "Good job, but you know what, you can do better."

EMH: That is the gift of our friendship and collaboration: a lot of support but a pushing. There were many artists both nights in the audience that I respect and that does push you to bring your best, not to impress, but we owe that to each other as artists. And that trying and failing and trying some more is different than just the notion of self-expression. Finding your voice is important but you have to work at that voice. Certainly as a white woman, I have to be very diligent about my voice and what I am doing. And to support other white artists to think critically about those choices and not just express themselves without critical thought. Goes back to the beginning of this conversation and the ways in which white artists utilize black cultural expression in their work. Which is a huge conversation in its own right but always asking why. Not that you can't, but what are you doing? An audience full of powerful artists will not just sit back and say, "good for you," no matter what you do. You can't just open your journal and read how you feel. I'm sorry I am getting off track trying to feed Naima and talk.

GFC: No, you were right on target. But baby Naima is letting us know it's time to wrap it up. Ha! Still thinking about your baby and my installation about all the stolen girls from Nigeria and how that was activated—especially the second night—and about Maya Angelou makes me think about the connections between girls and ancestors and how it ended both nights with

Mankwe singing the ancestor song ["Breaths"] from Sweet Honey in the Rock.

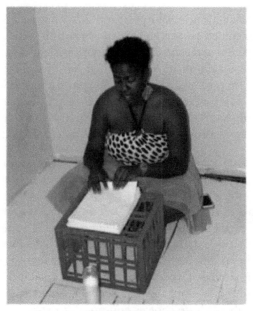

Image from "Say My Name (for 270 abducted Nigerian girls)"-Gabrielle Civil; Photo credit: Sayge Carroll

EMH: Yes and Maya who ended her life as an elder and a giant of society, but she starts as a girl and her story very much starts as a girl. And her intense, profound silence into voice and, not metaphorically, but her actual, extended silence by an act of sexual violence and then her voice! Survival, girlhood is a place of intensity and can be dangerous and that was what was powerful too about your installation because you don't have to have the western notion of a "room of one's own" to be creative. What you have to have is safety, a space to be yourself, whole. You could share a room with five people and be a girl in your bedroom as long as you have psychic space and physical, sexual autonomy. So we end on ancestors because they are

us, they were girls and they made the way. Not to martyr art because you shouldn't have to suffer but look what women and girls have done in the face of it all. Stay alive, stay creative.

GFC: Wordsworth said, "The child is the father of man," but the girl is the ancestor! So we were saying we celebrate creativity and we want every girl to be safe in her bedroom and in her life.

EMH: Yes.

From the Hive
(from my notebooks)

artistic process, <u>embodied experience</u>
artistic process: the body, waking up (to spring)

Like so much of our work together, over wine
this time in a corner near a fire in darkness
lovers nuzzling, amused by our chatter

sacred lovers, the spirit world
and creation stories...

Blackfoot Physics and Paula Gunn Allen
 ("thoughts are for the taking")
on our minds, in our hearts
and always your mother
resting in power, more like likely raising hell
 ("If I have to read one more fucking bad book
 in this fucking book club...")

And what we wanted to do in life and work.

And it was nice that you'd been reading Meredith Stricker's
Alphabet Theater which I'd given to you for your birthday
so many years ago

She too wrote of bees
their muzzles dripping with honey

You wrote of bee, pollen, corn, the yellow woman
with corn silk tassels

You talked about wanting to work in a new way
Wanting to trust poetry as a way of speaking, being in space
And I felt familiar there

Wanting to laugh
So afraid of the weight of the world, of creation

Both of us thinking
how much of the beautiful, terrible world we could hold

And me so scared to have another bad art experience,
to be bad in art, to not be good enough, to be too tired
to not have the lightness to make it good, to lose myself, to be lost

And so what had I been thinking about, reading, preparing for

body/ no body

W A K I N G U P

erotic energy => red kiss

The installation of two bodies, two ideas
The red kiss The bee on the flower
The black comb The honey comb

from emptiness to plenitude building

 simultaneity

 S H I M M E R

absurdity and pleasure

honey path, strand, tendril, comb, twist, helix
sacred desire

And waking up body, earth
And waking up into Spring

And voices singing, if need be or buzz

EMH puts on lipstick starts to read sacred text puts the book down
her mouth still is moving

GFC drinks a cup of honey mead listening, she starts to set down
yellow wooden cups, makes a little comb on the flower, a pattern of
connection

honey from bears squeeze honey into the mouth
And bear arrives in the picture, bear who has carried you

into the hive...
from the hive...

 hive = body
 hive = art

From the Hive

Created and Performed
by Gabrielle Civil and Ellen Marie Hinchcliffe

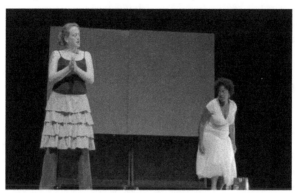

From the Hive, performane video still; Photo credit: author's collection

The first snatches of Radiohead's "Bloom"
begin to play and then fade.
Projection: a close up on a red flower unfurling into bloom.
Then sound of bees buzzing.

Lights up on E and G.
E wears black and pink. G wears yellow and white.
E kneads a chunk of multi-colored bits of paper in her hand,
allowing them to fall, spill down onto the stage.
G sits in a chair, body akimbo, hand on a hip,
her cheek out for the light, her right arm rising up
in a swell to press her palm to the side of her face.

Their pre-recorded voices resound.

G: It started with stories of origins
Blackfoot physics and Paula
thoughts are for the taking

E: Such strange news coming from all directions
like the shy woman who carries the water
the message is, survive

G: In your new journal with the plump robins in a pattern
on the cover, the language coming poetry now
You wrote—

E: Not like the news tells you to
but like the bee instructs in the flower
molten, gold, open

G: You wrote-- Beauty
as a way of walking
not as a way of looking.
You wrote—

G and E: What shimmers in body with body...

When all of the paper leaves her hands,
as these last lines enter the space,
E goes over to place a kiss on G's cheek.
E & G move their bodies, unfurl and arrive in space.

G: Hi Honey!
E: Hi.
G: Why does honey come in bears?
E: Because bears love honey.
G: Why doesn't it come in bees?
E: Because bees make honey.
G: But I think making is a form of love.
E: I think making is a form of love.

~ * ~

E:
Even now she thinks
rethinks, you could say consider

creates, reuses thoughts
we recycle them.
Again and again all is spinning
all is waiting, thoughts are for the taking,
thinking is a form of love.
Thinking is a form of love.
Thinking, like holding something up to the light
until it is shot through again with rainbows,
falls back across your body, immeasurable.

G:
What shimmers in body with body.
You told me a story about bear.
You said bear carried you.

E:
It was more like I made room for bear,
bear in my body and we walked together.

G:
Tasked with the body, we walk together.
Tasked with the body.
I'm not here.
A taste of sweetness.
A floating year.
Longing, Longing
The whole winter long
reading Dany Laferrière
A couple in an airport
An endless kiss
Riotous
in Port-au-Prince
in Minneapolis
"I wanna be your lover"
I don't want to be here
exiled from desire,
the red kiss.

The start of "Diagonals" by Stereolab kicks in and loops.
G and E dance! The dance opens into a moment of poetry.

G:
A poem by Lucille Clifton
"Out of Body" (in the voice of Mama)

G reads it all from the book called *Mercy*.
You should read this book and this poem.
For now, here are a few key lines.

"The words they fade
I sift towards other language
you must listen with your hands...

I am saying
I still love you...

I am trying to say from my mouth
but baby
there is no mouth."

E:
It builds and builds
this overwhelming need to call you
strongest on the full moon
and so I do.
And from that first cold sip of wine
from the first song
it all comes streaming through me
and I laugh so wildly
and I dance so hard
and I cry
I cry like a banshee
in the high place of the song
and the cry becomes a chant and
the chant becomes a body of light

and I spin and spin into
because I am your daughter
because you taught me how
because you let this be
because you let me be
because you join me
we always did know how to party Mama
in the sacred sense of the word
and we still do
because the shimmer in the body
is a light that does not go out.
the shimmer in the body
is a light that does not go out...

(an invitation for visitation, a dip into trance)

G and E repeat this phrase over and over
(and you can too)-
the shimmer
in the body
is a light
that does not go out...
the shimmer
in the body
is a light
that does not go out...
the shimmer in the body
is a light that does not go out...

Their bodies vibrate with the pulsation of these words.
E shakes. G jumps high into the air.

the shimmer in the body is a light

E throws colored confetti into the air.
She gathers it and creates a body on stage.
They lie in this body, one on top of the other.

They rise up: their bodies bridging one atop the other.
They roll and recover they rise up again.
They stand.

G: I say thinking is a form of love.
E: Making is a form of love.
G: Longing is a form of love.
E: Remembering is a form of love.
G: A taste of sweetness.
E: Can you hear them?

The sound of a hive of bees rises and falls.

"Gabrielle Civil: Ghostly Gestures
and Erotic Crackle"
by Sun Yung Shin

for *This Spectral Evidence*

Interview + New Work

Gabrielle Civil is a black woman poet, conceptual and performance artist, originally from Detroit, MI... I asked Gabrielle to share her visions and latest workings because she is an artist that has consistently inspired audiences through her glittering performances that are both ethereal and body-centric. In this conversation, she discusses some influences and how she is using the late Melvin Dixon's novel *Vanishing Rooms* in an upcoming performance in St. Paul Minnesota. Gabrielle and I held our conversation via a Google doc over the course of a few days in late June 2012.

Upcoming event: *Vanishing Rooms* is running Sat. July 28 at 8 PM and Sunday July 29 at 4 PM at the Fish House Studio–in the Dow Building at 2242 University Avenue Suite B14. St. Paul, MN.

SY: How does the word "visionary" or "haunted" apply to your work–whether past, present, or future?

GC: These two words speak to twin poles of my work. "Visionary" is my aim, where I want my work to go, how I want my work to seem from the vantage point of the future. This is the quality that I most admire in other artists: Marina Abramovic, William Pope.L, Jayne Cortez, Simone Leigh, Pina Bausch... So many people from the past and present working in different fields who inspire me. These artists have such compelling visions, indelible, strange and completely their own... That is what I want to generate, crack open, allow for myself and my work. "Haunted" is how my work often relates to the past. It is haunted by specters of racism, by questions of body,

by personal conversations and experiences, by images I've seen or books I've read. The word "haunted" is especially appropriate for what I'm working on in performance right now. Moe Lionel and I are collaborating on a new work inspired by Melvin Dixon's *Vanishing Rooms*. I can say that I have been haunted by that book (which is literally a ghost since it's now out of print.) The book has became a source, a catalyst to do something new with in it, in my body, in writing, in language and with someone else.

SY: I love that. The title of Melvin Dixon's novel, and from the little I read about it, reminded me of *Other Voices, Other Rooms* by Truman Capote and Baldwin's *Giovanni's Room*. Tell me more about how Dixon's book has been haunting you and what it opened up for you—how was this novel able to surprise you? What stones unturned within you / your aesthetic did it turn over? Tell me more about what Moe Lionel is bringing to the new work.

Cleis Press, 2001

GC: *Vanishing Rooms* is really an astonishing book. I first read it in my early 20s when I was living in NYC as a graduate student. I have such vivid memories of pulling it down from the shelf at the Jefferson Market Library on 6th Avenue, the one that looks

like a castle, and getting immediately sucked into this intense relationship between Ruella McPhee, a straight black woman dancer and Jesse Durand, a gay black dancer in 1975 New York. It's a book that's about impossible desire and art making and coming into one's own and all of these things were so important to me and continue to be. The novel is told in alternating chapters from 3 points of view: Ruella (who Jesse calls Rooms), Jesse and then a third character Lonny, who is the classic "troubled" white youth, a gaybasher who is actually closeted gay himself. So he represents a kind of violent, white masculinity that resonated with the some of the themes and stories in Moe Lionel's Naked Stages piece "in and out of the body."

Maybe it was because Ellen Marie Hinchcliffe and I were directing this work that I had the urge to pick up Dixon's novel again. But near the time when Moe's piece was about to premiere, I reread the book and right before I left Minnesota for the winter, I gave Moe the book with a letter about what it had meant to me and how I felt it was connected to his work. This started a rich correspondence between us about this book and at one point, we just decided that we needed to bring our conversations more directly into art-making. So along with the novel itself, our correspondence represents the source of the new work.

SY: Excellent. So I will wait for the performance itself before inundating you with more questions about that work. On another topic, how has landing in/spending time in Minnesota affected/influenced you as an artist and would audience members experience or see any of that in your work? Is any of it visible/audible? How do you negotiate what it means? Do you let it matter much? Does Minnesota haunt your work in any way? Has it changed for you since arriving–10 years ago?

GC: Those are all such rich questions. There's no doubt that coming to Minnesota made a tremendous difference in my development as an artist. From the start, I was engaged in various artistic communities–Cave Canem master classes and grant proposal panels for MRAC. I saw innovative work at the Walker that really stuck to me ("Memorandum" by Dumb Type and

the Yes! Yoko Ono show.) And I really became a performance artist here, largely because of the grant opportunities (Red Eye's Works-in-Progress, Naked Stages, grants from my job at St. Kate's) and the amazing interdisciplinary artists here who were fusing dance, poetry, monologues, installation, everything. I'm thinking of the impact of early Naked Stagers like Flávia Müller Medeiros and Mama Mosaic or Marcus Young's "Big Idea Store" at Intermedia when they had the Inside/ Out installation series. (Talk about spectral evidence, so much of this stuff is gone now and people may not ever have seen it...)

At the same time, it has been difficult for me to be Minnesota. I like street culture, the erotic crackle of people walking, talking, rubbing up against others on the day to day. I like mixing and mingling with people from all around the world. There's some diversity here, and I'm thankful for it, but it's nothing like New York City or Mexico City where I've been spent significant time over the last 4 or 5 years. Plus I hate the cold! So that's no joke. In order for me to have stayed in Minnesota, I've had to leave a lot. And that has certainly impacted my work in a number of ways. I've made a lot of work in other places: "Anacaona" in Puerto Rico, "ghost/gesture" in the Gambia and tons of pieces in Mexico (BRUSH, Muño, Despedida and more...). This has meant that people here in Minnesota don't always even have a chance to see my work and I don't think I've done the greatest job building and nurturing an audience here.

Also the pieces that I have made recently in Minnesota like "Tie Air" in 2009 at CIA or "anemone" the piece I did last month at Pleasure Rebel are often informed by a kind of restlessness. The work is haunted by questions of who I am and who I can be here in Minnesota as an artist and as a woman and how those things don't always feel like they fit.

In the 2011 Bedlam TenFest, Ellen Marie Hinchcliffe and I did a collaboration called "From the Hive." At one point in the piece I say:

Tasked with the body.
I'm not here.
A taste of sweetness.

A Floating Year.
Longing, longing
the whole winter long
reading Dany Laferrière.
A couple in an airport.
An endless kiss.
Riotous
in Port-au-Prince
in Minneapolis.
"I wanna be your lover"
I don't want to be here
but I am.
Exiled from desire.
The red kiss.

I think that says it all!

SY: And lastly, what do you need to take your work and life to the next stage, level, etc.?

GC: In terms of what I need to take my work and life to the next level, I'm like everyone everyone else. I need time, money, space, breath, invitations and opportunities, sweat and good luck. I think I do need to figure out my relationship to place—where I feel most inspired and supported. I'm not sure it's here. But I am also very thankful for the various communities that have fostered me here. And certainly for my friends and fellow artistic troublemakers. I leave a lot, but I also get welcomed back with open arms.

invite

someone

in

(_____) DOESN'T KNOW (_____) OWN BEAUTY
or *Vanishing Rooms*
[a partial dossier of love and performance]
written, compiled and survived
by Gabrielle Civil & Moe Lionel

(_____) Doesn't Know (_____) Own Beauty / Photo credit: Sayge Carroll

Dear Moe Lionel,

Leave it to you to ask for a letter.

In the archive of my life and art, our letters will stand as an important articulation of myself in love. Perhaps the only one, as I am very private about my love life. Even just a few minutes ago, after asking politely about your love life, to show you that I care, that I can be supportive, that I can be a good ex-girlfriend, although I didn't easily allow the non-ex term at the time, when you politely reciprocated, "So how is your love life?" I shouted, "I DON'T WANT TO TALK ABOUT IT." And it's true. I don't.

But there was a time when I wanted to talk about everything with you. When it felt like I could tell you anything and also that you actually would want to know. I'm so shy really. And I hate the idea of foisting myself on people. I hate anything that feels like that in personal relationships (which must be why in classic Freudian return of the repressed, I completely foist myself on people in performance art.).

Anyway, it does make sense that the test drive for this TSQ blackness submission would be letters, because the impulse to create *Vanishing Rooms* came out of our letters, that incredible euphoria of sharing of the self, of hopefulness, giddiness about the possibility of being known, that maybe someone would really want to know me, as that is what I still think love is, the desire and capacity and willingness to know someone else, what I called "an astral thread of magic and stars." And how much of that was related to letters, letters we were feverishly exchanging months before we became lovers and of course, always, always to books. Letters and books of the body, but also disembodied, the sphere of the bookish black girl.

In books, and maybe letters, anything can happen. A straight

black woman can have a love affair with a gay black man who also can love a white gay man who has been murdered and together there can be violence and mourning and sorrow and possibility... And reading that book in the little library that looks like a castle on 6th Avenue—the Avenue of the Americas! was the best kind of magic. I sat down and pored through it and it poured through me and it seemed like glimpsing the world I was trying to enter, something about art and dance and sexuality and breaking the boundaries of the kind of good black girl, black good girl I was forever trained to be.

And so then when EMH and I were directing "in and out of the body," which was so much about your family and violence and queerness and desire and maybe transness though you didn't want to name it, and just maybe too at the edges some other thing happening between you and me, as improbable as it was, as crazy sexy cool as I thought it might be, I knew that I wanted to give you this book, Melvin Dixon's *Vanishing Rooms* and that was the beginning. Of our correspondence. Of everything else too. Although I'm sure your narration would be different.

Mutual timing has never been our strong suit. As you like to remind me, you met me before I met you.

In any event, it made sense that in the middle of everything, our new romantic relationship, your three jobs and nursing school, and returning to date one of the people you loved before me while dating me, we would decide to make this performance work. Well it made no sense, because everything was overwhelming. But it happened! And I'm happy that we did this thing together. And I give you so many props for it because you were the one with the busier schedule and you made time for it, and it seems like you don't think I recognized the ways you made time for me, but I swear I thought I did.

And so it happened: _____ doesn't know _____ Me the nerdy black girl reader and you the violent gay white boy, animating the vision of the black gay male genius... the black/cis/man absent but omnipresent. Would we be Melvin Dixon's dream?

Would you like me better if I were a gay black man?

Or would you just want to fuck me more?

Forget I said that.

You said on the phone tonight we would be MLK's wet dream.
And I said maybe. And you pushed and asked, why maybe?
Of course, he would love that we have this connection. That
we are friends. But maybe I'm not as easy in that certainty, in
our current connection. Straightgay alliance, aka sassy black
best friend sidekick, was never my dream, so it's hard for me to
think it would be MLK's. Maybe—but you already know. Maybe
it's water under the bridge. Maybe improbably we got together
in the first place. Maybe predictably we broke up. Maybe
improbably we'll still manage to be close or at least will still
manage some kind of closeness and we can return to a level
of desire and capacity to know each other and let ourselves
be known that we had in my sweet and bittersweet memories.
Maybe I need to let it go and somehow not let you go... That's
me trying on hope. It will definitely take me some time. Maybe
I'll never write about our past relationship in this vulnerable
way again. (Sigh of relief for everyone.) Don't be ridiculous. I
am not a bad driver. Yes, it's time to move on.

Forgive me, Moe Lionel, something in me has become
undeniably brittle, perhaps annoyingly wry. I hate to be
vulnerable. It's such a quick route to sorrow. I hate
misunderstanding and being misunderstood. I've lost the
belief that you, that anyone, wants to hear how I feel or that
it will do anything but seem passive aggressive or petulant or
pathetic or angry black woman caught up in the past. That's
what this letter has become. Something preening in suffering.
And maybe that undercurrent of suffering would have made
my dance in *Vanishing Rooms* better. The image of the ladder
coming down over my upright black female body was striking,
but I never really nailed it. You were much stronger, slamming
red thin squares against the white walls. And there was power
in our doubled presence, the chalked lines around our figures,

reading over each other, mouthing words, and at the top, our bodies dancing together to Janet Jackson's "I Get So Lonely," a presage of future, in that moment something we shared, made together.

In the TSQ call, they say "We seek essays, poems, and artwork that contend with how and where transgender and Black meet, contradict, and interface as social and political categories of difference." Our performance, like our love affair, was a place where transgender and black met, contradicted and interfaced... It was neither alliance, nor friendship, as the characters in *Vanishing Rooms* were neither allied nor friends, but something else, another vector where love and pain could be measured and, in a rare, precious, improbable moment, could intersect and come to be known.

It was a beautiful, vanished thing. Like the novel, maybe it could feed other black/ trans/ dreamers at another time in another place. What do you think?

Thanks for the memories and for loving me and for making this piece, and hanging in there with me and for whatever will come.

I love you.
Gabrielle

[*Vanishing Rooms*: a 5-Paragraph Essay by Moe Lionel]

Introduction

I am telling you a story about skin.
What happens when you call a person a thing?
What happens when you call a body a place?
These questions haunt the pages of Melvin Dixon's 1991 novel *Vanishing Rooms*, which renders interlocking stories of grief, heartbreak, and violence through three alternating narrators. Dixon explores how race, class, sexuality, and gender become mapped on the body and in turn, entrenched in the architecture of intimacy.

Thesis

Dixon investigates the architecture of intimacy through the metaphor of rooms as place, person, and thing.

Body one open

I am telling you my story about skin.
rooms: the landscape of intimacy, (in)availability, and distance.
I'm not me.
Place.

Body two closed

I am telling you your story about skin.
Not a metaphor, quite literally: there is no room to contain us.
I'm this idea you have of me. I have always already failed.
Person.

Body three

I am telling me your story about skin.
I am not me. I am this idea I have of you.
Thing.

Conclusion
I am telling me my story about skin.

Restate thesis
Because people want to think they are afraid of a thing.
A thing is responsible for their pain so they make a person a thing.
The word that cannot be mentioned, of course, is love.

Gabrielle Civil **Moe Lionel**

**(_____) Doesn't Know
(_____) Own Beauty**

**a performance / installation
inspired by Melvin Dixon's 1991 novel
*Vanishing Rooms***

**July 28-July 29, 2012
Fish House Studio
St. Paul, MN**

Jesse

"…gashes like tracks all over Metro's belly and chest.
I could still see those gashes. They opened everywhere,
grooves of flesh and blood,
lips slobbering with kisses."

"I wouldn't let him smell it.
And I didn't have to dance that time, did I?
Like I'm dancing now that he's gone…"

Ruella

"He called me Rooms for short.
Rooms for all the spaces we created
where he could dance to several tunes at once, then rest."

"I wanted him to see me for who I was. A woman, yes.
A woman and not a room."

Lonny

"It's October, the season of yellow, copper, gray,
and red, real red.
The leaves are cut-off hands curling up like fists."

"I crossed the barricade and sat inside the chalk.
The glow was on me now. It *was* me.
I lay down in the shape of the dead man,
fitting my head, arms, and legs in place.
I was warm all over."

re: Vanishing Rooms

What happens when you call a person a thing?

I am telling you ____ story about skin.

Can you embrace someone you don't get?

Can you embrace someone you don't accept?

Can you embrace someone you don't get?

but there are two of us

_ _ G G _ _

Place. Person. Thing.

What does (fucking) invisible look like?

And, of course, the unmentioned word

~ * ~

Thanks to Ellen Marie Hinchcliffe, Sarah Hollows, Sayge Carroll & Josina Manu.

Special Thanks to Ty Neal for moves, grooves & keeping the 70s alive!

Tracks

"I Get So Lonely" - Janet Jackson

"Guilty" - First Choice

"I Feel Love" - Donna Summer

"Images" - Nina Simone

"When We're Dancing Slow and Close" – Prince

Promo video archived at http://vimeo.com/46145894

In memory of Melvin Dixon (1950-1992)

[performance]

(_____) Doesn't Know (_____) Own Beauty

or Vanishing Rooms

SCHEMA (7/26/12)

Threshold/ Installation
A hundred empty champagne flutes are set out
in the center of the performance space.
As spectators arrive, they see these flutes.
They also see us: MLN & GFC.
We grab fresh fruit, then recline before a video screen
where we lie down together slow and close and eat fruit
with our hands, juice dripping on our fingers.
A video begins to play.

Ty Video
On the video, Ty, a handsome, fifty-something
black man starts to dance to 70s disco.
Oh I feel love, I feel love,I feel love, I feel love, I feel reeeeeal love...
The music fades out and Ty starts to speak
of the glorious rooms of his youth.
"We had a good time," he says on the screen.
"Oh, they had everything. There were glory holes
and sex rooms and hot dancing and orgies and a FRUIT BAR!"

As Ty starts to speak, MLN & GFC get up
and begin to gather the glasses and move them
out of the space onto a white shelf.
GFC & MLN make the room vanish.

Duet 1 (I Get So Lonely)
janet begins to play. GFC and MLN duet:
dance solo first, then meet in middle.
The music falls out. MLN does push ups/ jerks off
/GFC does ballet 5 positions.

Book Opening
GFC reads from the start of Dixon's novel.
"Metro wasn't his real name, but I called him that. It was fall of 1975... The shock of the bright October sun made me blink so hard I missed a step and stumbled against him...We wobbled like two drunks, vying for balance."

Circle and Angry Kiss
MLN places first red lipstick marks on the body (his body)
GFC circles MLN, MLN grabs GFC, MLN and GFC angry kiss.
MLN taunts: "Wanna have some fun?"
MLN runs up ladder.

(_____) Doesn't Know (_____) Own Beauty/photo: Sayge Carroll

Leaves Fall
Above GFC, on the other side of the loft,
MLN cascades red paper leaves.

Textual Citation
GFC looks at him with his arms now empty.
GFC says: "He ain't never had a chance."

5 Paragraph Essay – Intro
MLN reads the intro to his
5-Paragraph Essay on *Vanishing Rooms.*
GFC puts on a pair of pink flesh colored tights.

fucking (invisible)
GFC delivers a monologue adapted from her
Poetic Essay on *Vanishing Rooms*
(the one she wrote the same time as his 5-paragraph essay
when she and MLN were ~~in love~~ developing the show).

[*Vanishing Rooms*: a Poetic Essay by Gabrielle Civil]
You could say I'm obsessed with sex.
In Melvin Dixon's Vanishing Rooms,
Jesse hooz black has sex with Metro hooz white.
Metro wants to have dirty sex with Jesse on the piers,
or up in Harlem but Jesse's not really feeling it
and one time Metro called Jesse a (_____)
while they were having sex and you know
Jesse wasn't feeling that at all
and so Jesse goes off to dance and meets Ruella
hooz also black but who really doesn't have much sex at all. [KNOCK]
Well at least we don't see it.
What does (fucking) invisible look like?
I'm not a pretty woman, *she says.*

In the meantime, Metro tries to come on to Lonny
hooz also white, but young, dumb and full of come and secretly in love
with another dumb white hood named Cuddles.
Names say something. / Cuddles is not to be fucked with.

Lonny is so fucked up by his attraction to Cuddles
that he fucking kills Metro-- I mean he mentions to Cuddles
and the gang that Metro is hanging around.
And Cuddles was like he must know you want to give it to him.
And Cuddles was like—we need to find him.
And Cuddles was like—we're gonna give it to that that (_____),
And the sex in what they did was completely invisible.
And that wasn't sex at all.

In the meantime,
Jesse is dancing with Ruella to Nina Simone.
Images. *(snap) *Doesn't Know* *(snap) *Own Beauty.*
An improvisation. A connection. It's unlikely but insistent.
A spark, red like the leaves. October is red man, red and mean.
And when the cops call Jesse to tell him what happened to Metro,
to ask him to come down and see the body,
Jesse calls Ruella to take him in.
Why does Jesse call Ruella when they've only just met?
She says: Come on over, honey, I've got plenty of room.
[MLN interjects:] He says: We danced. That's why.
And he does come over.
[MLN says:] And he thinks she's pretty.
And the way I read it—they have sex.
I mean they become lovers.
But in the book, it's hard to see.
(Fucking) invisible. To be fucking (invisible).

Duet 2 (Stretching—Our debate)
GFC & MLN spread out their legs in a V,
touch soles, hold hands, push, pull.
They are dancers warming up like Ruella & Jesse.
They debate whether or not the two were in love.
MLN turns away, GFC stretches up.

GFC Body / Room 1, Body 1
GFC starts drawing bodies in motion in chalk
on the stone floor—
she tells her story about why this book matters to her.
MLN makes a room with red masking tape all around her.
MLN reads Body Paragraph 1 from his 5-Paragraph Essay
on *Vanishing Rooms*.

Let's Play a Game / Hangman
MLN and GFC have this exchange:
/Let's play a game
/What kind of game?

/A game of skin
/In games of skin, I always lose.
/How do you play?
/With words. Give me a letter.
/L
/No
/O
/No
/V
/No
/It's not that kind of game. Give me a letter—
/You give me a letter/
 /I already did.

First Letter MLN -> GFC
MLN reads GFC his letter to her about *Vanishing Rooms*.

Dear Gabrielle,

How are you? I hope this letter finds you well. […]

On the plane from WA to MN, I read your letter again and started reading *Vanishing Rooms* again, getting absorbed by it. I just got to the bathhouse scene.

Intense! This book is one of the best I've read in a long time. The way he cracked open every characters' skin, exposing the heart, the way hatred can spread, how violence becomes defensive, protective, life-saving, life taking. How the webs of gender, race, and class are cast over desire and bodies. The possibility and the utter heartbreak.

I'm thinking of you reading this at 20 years old in New York. Do you know that Gabrielle still? I've been thinking of myself at different moments. How am I different? How am I the same? The first time I fell in love. The first time I realized I would be hated for how and who I loved, desired, fucked. Were these moments or slow realizations? Was the slowness part of the pain? I've been thinking about this in terms of my whiteness, masculinity and sexuality.

Whiteness—these steady aching lessons of whiteness that are centuries old, life long lessons unlearning and reckoning with white supremacist society one breath at a time now. Masculinity a body uncovered, my own. A secret broken \ over my skin. Hot to calm. Storm to light rain. Desire buried. And my sexuality—surface easy, knotted and twisted up in my hair, nails, teeth. Oh I love how books make me *feel* things.

I hope Mexico City is treating you well by the time you get this.

How's your heart, body, energy?
Thinking of you and missing you.
xox M

_ _ **G G** _ _

GFC writes xo in white chalk on the floor.
MLN lines up six hangman lines on the floor,
says there are two of us.
GFC writes G G on the third and fourth line.
She taps her pointed toe on the blanks that remain empty
and then writes GFC & MLN on the side.
(GFC does not write Ruella, Jesse, Lonny, Metro
although they are there.)
She says "You and Me"?

Hand / Fist

GFC & MLN take up each other's hands
and sniff each other's palms.

Room 2 / Body 2

MLN & GFC use red masking tape to build a room together.
MLN reads Body Paragraph 2 from his 5-Paragraph Essay
on *Vanishing Rooms*.

Chalk Outline

MLN traces his own body with white chalk.

Let's Play a Game / Tag

You're It.
They begin to play tag.
This game morphs into something else.

"Tell Me That Story Again"

With this prompt, they beg each other for stories,
surprise each other with topics,
share snippets about their lives
which moves them through the space...
They end up standing between two pillars.

Pillar Talk / Textual Evidence

GFC and MLN pick up two copies of *Vanishing Rooms* with
different covers.

They read passages, first one after another and then adding vocal improvisation.

Lipstick Gash (Desire & Hurt)
GFC marks MLN with the lipstick.
She says: *"Page 95: Because desire and hurt get mixed up here sometime."*

Body 3
MLN reads Body Paragraph 3 of his
5-Paragraph Essay on *Vanishing Rooms*.
halfway between the pillars and the studio sink.

Basin (Paradise Baths)
MLN goes to the studio sink and douses himself with water.
His body becomes wet and angry.
He picks up the red leaves that remain on the ground
and slams them against the far wall.

Red Leaves
GFC attempts to pat the leaves against MLN's skin.
MLN resists this soothing. Again he sticks red leaves on the wall.

(_____) Doesn't Know (_____) Own Beauty
Nina Simone's "Images" begins to play.
GFC does a dance with the ladder pulled down over her neck.
She picks red leaves, chews them up, spits them out.

Side By Side (Face Up/ Face Down)
MLN goes and lies face up on the chalk outline.
GFC goes and lies face down next to him.
She slides her hand up and cups his face.

Kicking the Leaves
MLN gets up and kicks the leaves away.
GFC gets up and kicks the leaves away.
The memory of the violence does not vanish,
but they open some space and make room..

Room 3

GFC and MLN take red up the red tape
and make the 3rd room.
MLN reads the Conclusion of his
5-Paragraph Essay on *Vanishing Rooms*.

Final Letter GFC -> MLN

GFC reads her letter to MLN about *Vanishing Rooms*.

Dear M. ---

Merry Christmas! I want to give you this book with a bit of an explanation because it is so loaded. Just look at the cover! Riding on the subway in New York City with it open in my hands, I could see my fellow passengers arch their eyebrows. Really Sis? What's on your mind?

The first time I read the book years ago, the cover was different. A triptych drawing of three characters in 1970s style. I was a young grad student at NYU and I lived in the heart of the West Village (the corner of Bleecker and Christopher Streets in a 6 floor walk up) and I was probably 21 or 22 years old and wanted so many things all at once. I wanted to be an artist. I wanted to write amazing poems. I wanted to be in love. I wanted to love. I wanted not to get my heart broken. I wanted not to need anyone. I wanted to be friends with everyone in the whole world. I wanted to be the life of the party. I wanted to be able to be alone (a strange goal as in key ways I'd always been alone – so I guess I wanted to be able to accept that I would be alone and learn how to make the best of it and flourish.)...

One day at the Jefferson Market Library, I pulled down this book *Vanishing Rooms* and immediately tore into it. There was a black woman dancer and she was in NY with dreams and somehow that was what I latched onto from the start. And oh! The love that dare not speaks its name. In my early adulthood, sexuality belonged to gay men. They were the only ones allowed to have it and explore it. And there she was having a dalliance (a relationship) with this gay man and somehow he loved her (although not how she wanted him to) and what the hell could anybody do with a relationship like that?

It was a book that affected me deeply even as I realize now that I didn't understand a lot of it then (and still may not) and also that what is important to me about the book shifts depending on what's going on for me in my life…

Anyway, this book is not light. It's intense and about gender and race and sexuality and love and friendship and all the things we talked about over beer and fish and chips for me and beer

and baby back ribs for you.

If you have a chance to read it, let me know what you think (about how men dance – and the difference between men and boys.)

<div style="text-align: right">

Love + Kisses
Gabrielle

</div>

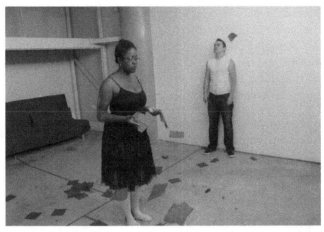

(_____) Doesn't Know (_____) Own Beauty / Photo: Sayge Carroll

[GFC & MLN partially restate thesis.]

The Unmentioned Word
GFC & MLN say:
"And of course, the unmentioned word"

Duet 3 (When We're Dancing Slow & Close)
GFC & MLN dance through the rooms.

m nortonwestbrook
Fri, Jan 8, 2016 at 8:21 PM
To: Gabrielle Civil

Dear Gabrielle,

Thank you for the letter.

I used to respond to your letters line by line, sometimes word
by word. I wanted to be precise. To make sure you knew I was
listening (reading) you. Maybe I thought something different
then, something different about structured self disclosure,
intimacy, and the potential for being known and understood.
I am not doing that here the line by line practice. And in
general, I've let that go.

To be clear though, I feel more committed to seeing you,
feeling you, knowing you. But I hope I better understand
that love is what is required in that, not precision unto itself.
Though surely love itself can be a precise act.

It saddens me that you can share less with me now that we are
friends and not lovers. And I am being precise there. I think
we are better friends now that we are not lovers. And I can
accept that. Ironically, it feels like a grandiose gesture of love
to accept your intermittent distance.

And it's interesting. I've never felt that I could or would want
to tell someone everything. First off, I have some question as
to whether that is possible. But also in my family structure, it
was best and safest to keep your most tender parts to yourself.
Surely no one would want them (my transsexuality). Surely
no one would know what to do with them (my transsexuality
again and also my visceral desires: drip the wax, hold my
breath, think of inappropriate men). Surely I would not
be better understood and I did not wish to sacrifice my
confidants (my tender parts). So as you know, I'm reticent to
relent to offer those tender parts with abandon.

As I write this, it reminds me of a salient and pronounced and stark difference between skin color (and its web to race) and physical embodiment of sex footnote/not asterisk: I mean both the fucking kind and the flesh variety and I am not going to star asterisk here because you know I don't believe in that (and its gnarled bite into gender). This isn't a Gender Studies (no more Women's Studies it offends the white college student) class, this is our correspondence so obviously skin color and physical sex, not the same, duh. Not the same in terms of how they map to the body, duh. Not the same in terms of how they map to America and racism and transphobia and homophobia, duh. Homer Simpson will be my guest lecturer next week. Back to this salient and pronounced and stark difference... how whiteness encases my most tender spots, literally, the physical skin, a weird cocoon that's real and stays for a lifetime and people just sort of ignore me. I'm not talking about being visible. It's not the late 1990s and I don't care. I can't possibly being making sense now.

Of course, there is dissonance in the read and expression (how have I already forgotten that white woman who said she was black and then people started talking about trans-racial (Rachel Dolezal, I remembered upon rereading this paragraph) and I thought that's the thing about getting older. People take the ideas and realities that are most important to you and make a mess. A bigger mess than I made. It's past tense. I'm out of my 20s. I'm a gay white man. No one is paying close attention to my every move. No one notices that I sit to pee. No one notices that the bulge in my pants is pure matter of force, the cock of the hips, the slump of the denim. No one notices and no one notices. Homophobia kills the family and transsexual men's fear of the bathroom (shut up faggot, don't look at my dick. crushed red paper. the way that white boy fucked or did he get fucked drunk. the white boy who lost it in that book. i can't remember names either. LONNY!!!!!).

That performance sits with me still.

I digress, Holden.

I've always felt too gay for you. A failure at heterosexual romance (you're the only person who I have ever attempted). A man to be your true self with and begrudge my company of other gays (men and the otherly gendered milieu).

I never wanted the girl in the postcard. And as you said, that's not when I first met you. I met you and my body was a blur though frankly in moments I've worried my body didn't register as desirable and in turn, there was no memory. I was a late game desire. A second look.

Those questions we asked in the piece still haunt me. Can you love someone you don't understand? Can you understand someone you don't love?

And you're right. I don't know about MLK. I was being flippant. But something I can say about the Gay Straight Alliance. I dropped out once I started having gay sex. I mean that's true. In high school, I stopped going. I could say more but I'll leave it at that.

I know we likely do not agree about this, but I like our GSA. I like that I don't want to drop out. I like that the straight cis black girl and the gay trans white boy fucked and fell in love. I liked that we went to prom and the mean white boys called us _ _ gg _ _ and the nerdy lightskinned black teacher said we loved each other despite gender and we spiked the punch and laughed and laughed. And under the bleachers, we whispered. We knew. I didn't desire you despite. I desired you because. Because you were you: dark skin, smart hands, full hips that could work my cock to spasm, thick middle for my pasty white boy hands to grip, your hot mind, the books you keep on your shelf, the teddy bears you never tell anybody about. And you held me close and told me you forgot that they meant the gender thing about me too, forgot that they'd made my body an object a white outline with blood marks as scars on their medical slides.

I like being in the GSA where that happened.

One of the smartest things you've ever said to me is that there are some things other people give us, that we cannot do on our own. And the flip side of that, there are certain people who can and cannot give us certain things.

We have something special and precious. I know that in my bones.

I haven't said much about the actual book, but I think you get my point.

I love you. This is astral.

xo m

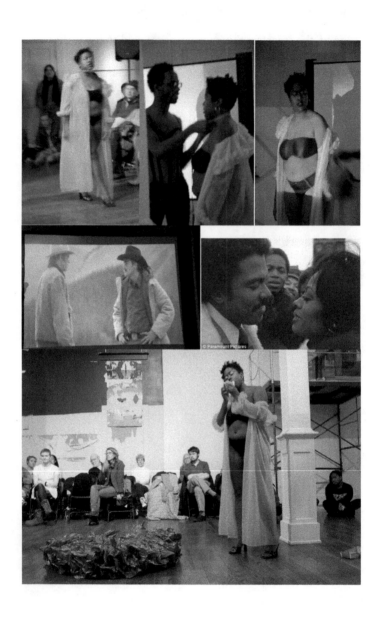

GABRIELLE CIVIL

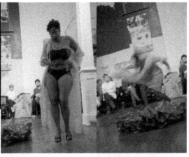
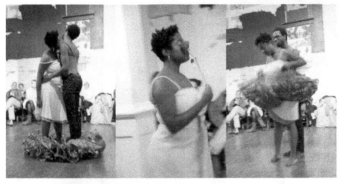
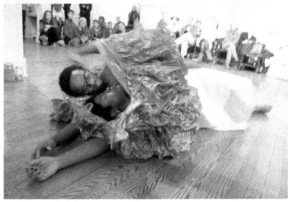

(first comes love)
... and then
Performance featuring Nicolas Daily
Photos: Dennie Eagleson

DROP EVERYTHING AND READ

BEAR WITNESS TO QTPOC BRILLIANCE

Queer & Trans Artists of Color Volume 2
Interviews by Nia King, edited by Elena Rose

When the apocalypse arrives as revolution or colony collapse, when electricity fizzles and we're all by the fire trying to rebuild culture, I'll be glad to have Nia King's *Queer & Trans Artists of Color* books nearby. Filled with intelligence and insight, these books offer practical examples of marginalized people creating and transforming culture, making art against the odds. The first volume *Queer & Trans Artists of Color: Stories of Some of Our Lives* (2014) included interviews with 16 artists, including Janet Mock, Ryka Aoki, Julio Salgado, and Leah Lakshmi Piepzna-Samarasinha. Recently, *Queer & Trans Artists of Color Volume 2* (2016) hit the stands. In her foreword, Piepzna-Samarasinha declares: "just think about the fucking importance and audacity of saying: 'Volume 2.' So much of the time, in publishing, QTPOC [queer trans people of color] are told we're lucky if we get one volume, or half a volume... Fuck that. We deserve an encyclopedia of us... We deserve to have a rich, deep archive of brilliant complexity." Indeed.

Volume 2 expands into that "rich, deep archive." Following the model of the first volume, it features 16 interviews that King selected from her podcast, *We Want the Airwaves*. A self-described "mixed-race queer art activist," King conducts interviews knowledgeably as a QTPOC artist herself. Curious, warm and direct, she even knows some of her subjects socially. Conversations are rich, free-wheeling and candid. And it's wonderful how often the word "*[laughs]*" appears on the page. King and editor Elena Rose have also continued placing artist biographies at the end of the book, so each interview arrives without context or clear indication of the artist's race, gender, or artistic practice. While this can be disorienting, or produce an

insider vs. outsider vibe (you mean you don't know so-and-so already?), this decision allows each artist to reveal his/ her/ hir/ their individual story in response to King's questions without reader preconceptions.

The artists themselves vary tremendously across race, ethnicity, age, sexual orientation, gender identity, ability, education, profession, and artistic practice. Their artistic disciplines span performance, painting, software, games, textiles, literature, theory, music, and film. Often active in more than one form, the QTPOC artists here don't deny dire realities of systemic oppression, still they claim their own power. "How many other trans Latinas have PhDs?" media artist micha cárdenas muses. "Oh, maybe I am the first one that survived this long."

In her introduction, King recognizes the rampant violence against people of color and LGBTQ people as a context for this book. She also declares: "This book doesn't matter just because we are being murdered in the street. It matters because the artists in this book are fucking brilliant and you need to know about them... I want straight and white people to know what we are up against. I want queer and trans people of color to know that our lives are possible. That we have a future." To this end, the book documents and celebrates QTPOC survival and artistic success. It serves as an access point into community for burgeoning/ self-discovering QTPOC artists. It defies stereotypes, informs, and decenters straight and white people. It highlights the variety and multiplicity of QTPOC artistic communities, as well as the diversity of QTPOC artistic experiences. Most importantly, it allows everyone across all categories to "bear witness to QTPOC brilliance."

Conversations with Juba Kalamka, co-founder of homo-hop group Deep Dickollective, and Cherry Galette, co-founder/ director of Mangos with Chili, preserve the legacy of those legendary QTPOC performance troupes. Interviews with painter Grace Rosario Perkins, poet/ performer Amir Rabiyah, artist / filmmaker Tina Takemoto, and literature professor/ visual artist Ajuan Mance highlight how queer artists

can recover, reclaim and transform personal, racial and cultural history. Weaver Indira Allegra explains using textiles to protest police violence. Poet Trish Salah breaks down issue-based vs. identity-based organizing. And more. Every interview is worth reading. Other scintillating artists include Elena Rose, Mimi Thi Nguyen, Martín Sorrondeguy, Lexi Adsit, Mattie Brice and Kiley May. Other discussion topics include gentrification, mental and physical health care, biphobia, resistance, and the need to recognize more voices within queer communities (something this book itself achieves).

One of the best parts of this book is how honestly the artists speak about money. In her acknowledgments, King even writes: "I'd like to thank the voters of Oakland for raising the minimum wage in 2014 so I only had to work one job while writing this book instead of two." While this public support helped, it matters that *Volume 2* was produced through wage labor and crowdfunding outside of the academic and publishing mainstream. This hard, urgent work, like so much QTPOC artistic and cultural work, was clearly a labor of love. Now that this book exists in the world, artists, teachers, librarians, arts activists, and organizers should make sure to support it. This book should be bought, taught, reviewed, discussed, and shared long into the future. As storyteller May says: "After we're long gone, all that's left of us are our stories that we leave behind." This book, these stories, will bring light and heat.

Call & Response

"We have resisted continued devaluation by countering
the stereotypes about us that prevail in white supremacist
capitalist patriarchy by decolonizing our minds... asserting
our understanding of our own experience. In a revolutionary
manner, black women have utilized mass media (writing, film,
video, art, etc.) to offer radically different images of ourselves.
These actions have been an intervention."

—BELL HOOKS
Sisters of the Yam

Call & Response: Experiments in Joy

~ * ~

"Without a discourse of their own, Black women artists remain fixed in the trajectory of displacement, hardly moving beyond the defensive posture of merely responding to their objectification and misrepresentation by others."

–FREIDA HIGH W. TESFAGIORGIS,
"In Search of a Discourse and Critique/s that Center the Art of Black Women Artists"

~ * ~

Call & Response was born from an astral e-mail exchange with the then President of Antioch College, Mark Roosevelt, who was checking in with me about a job offer. At the time, I had been securely ensconced as an Associate Professor of English, Women's Studies and Critical Studies of Race & Ethnicity at a small, predominantly women's college in the Upper Midwest. I had worked there for thirteen years and had been tenured for six. I had not initially been seeking a new job, had not done a full search on the job market, but I had grown restless in the snowy heartland. I was seeking new ways to grow as an artist and teacher. I wanted—and still want—to become a better and better-known artist.

So when my friend Miré Regulus sent me the Performance job listing for Antioch out of the blue, my heart welled up. Here was an opportunity to align my extensive artistic practice and community teaching as a Black feminist performance artist with my professional identity. This position would be to build and lead an undergraduate Performance program with the notion of Performance as interdisciplinary and deliberately linked to Visual Arts and Media Arts. The position would allow me to test and develop my pedagogical ideas about experimental performance and consider key questions of performance art practice within a liberal arts context. More importantly, the

job could shake me up, challenge me, and push me to put my money where my mouth is.

At the same time, accepting a job at Antioch would mean venturing into the cornfields, living in a tiny town (Yellow Springs, OH, pop. 3734) far from the dynamic art centers that had been my lifeblood (New York, Minneapolis, Mexico City). The thought excited and unnerved me. That spring of 2013, I had interviewed and received a job offer from Antioch, then asked for a week to decide whether or not to make the leap. During that time, Mark sent me a message, the exact words of which have been wiped away with the rest of the e-mail correspondence from my old life. It went something like:

> "Dear Gabrielle,
> I always think that March will be warm, but today again is cold and rainy. But then I thought, maybe something good will happen today. Maybe Gabrielle will write me about coming to Antioch."

To that, I responded something like:

> "Dear Mark,
> I have been dreaming about the cornfields... My biggest fear of coming to Antioch College is losing my context, the people, places, things, situations that allow me and my work to make sense. One thing that would help allay that fear would be a festival of Black women and performance at Antioch College, an opportunity to bring Black women performers together from around the country, presenting and sharing work with each other and Antioch students. This would be magical."

Although the possibility of a Black women's performance festival had long been percolating in my mind—indeed Rosamond S. King, Wura-Natasha Ogunji and I had tossed it around separately at various times— I had no idea that I would propose this idea until I did. The flash of insight to write this to Mark that day can only be described as a gift from God, although others could as easily thank the universe, killer instinct, or #blackgirlmagic.

Call & Response Artist Show & Tell (July 2014) / Photo credit: Dennie Eagleson

To my surprise and delight, Mark immediately responded:

> "This is the best e-mail I think I have ever received. Let me ask around and see if we can actually make this happen…"

Mark's instant enthusiasm helped convince me to give Antioch a try. Because I proposed this idea at a key moment and the institution agreed to support it, the Call & Response symposium of Black Women & Performance took place at Antioch College. May more such miracles come to pass.

The seven lead artists of Call & Response were (from left to right) Awilda Rodríguez Lora from San Juan, Puerto Rico; Rosamond S. King from Brooklyn, NY; Wura-Natasha Ogunji then based in both Austin, Texas and Lagos, Nigeria, now fully relocated to Lagos; Miré Regulus from Minneapolis; Kenyatta A. C. Hinkle from Los Angeles; myself Gabrielle Civil, project organizer, newly relocated to Yellow Springs, OH; and, Duriel E. Harris from Chicago. Our practice represented a full gamut of performance from multi-media performance art, live art actions, performance installation, theater, dance, music, conceptual art, spoken word, poetry, and more. Moreover, each artist had significant experience with more than one performance form. We also had various diasporic connections

to Africa and the Caribbean and represented a range of ages, academic backgrounds, sexual orientations, familial situations, gender experiences, languages spoken, and more. Even more significantly, none of the artists, myself included, had met all of the other ones. While many of us ran in the same circles or had heard each other's names, the symposium became an opportunity to build community as Black women performers and make new artistic connections.

The structure of the project was innovative and historic.

In Summer 2014, seven Black women performers—with different relationships to the words "Black," "woman" and "performance"—came together at Antioch College in Yellow Springs, Ohio from seven different cities to create and announce a Call, a collective prompt for artistic action. A month later, the seven artists reconvened to share their Responses to the Call with each other and the Antioch community.

To my knowledge, there had never been a gathering of Black women artists focused on process. Too often, artists, activists, scholars gather together, share what they've already made, hit it off, connect, spark ideas for collaboration, and then never see each other again. Call & Response scheduled time for conversation, collaboration, going home to make work, and then coming back a month later to premiere this work before a knowledgeable audience. This structure allowed us space to generate ideas and then manifest them.

In our July session (July 18-22, 2014), we introduced ourselves to each other and the community. Each artist brought an object, a writing prompt, and an embodied exercise to do together. We had closed group sessions where we talked about our lives and our work. We visited the Herndon Art Gallery on campus. Many of us took walks in the Yellow Springs Women's Garden or in the Glen Helen nature preserve. Some strolled down our Main Street and had coffee at the Underdog Café. With students, we ate meals, visited classes, and conducted a public roundtable about our work. With faculty, students, staff, and local African-American residents, we attended a community potluck in our honor organized by history professor Kevin

McGruder. Our Saturday night evening of Artist Presentations drew a crowd of over a hundred people (quite significant in a school whose student population was about two hundred) and even attracted local hero Dave Chappelle to the audience. This marked the first public event in our re-opened Foundry Theater and helped put the Antioch Performance Program on the map. All of this activity undergirded our main artistic task: to produce the Call, the collective prompt for artistic action that would articulate our ideas about art-making and would catalyze our new performances.

It took us hours of writing, moving and talking to come up with the Call. Again, we didn't all know each other beforehand and had certainly never collaborated before on a document. We brainstormed questions and gestures. We quibbled over semantics. We laughed. One of my sharpest memories was when Wura asked us one day, what would it mean for us to look at our own work separate from or beyond the lenses of our multiple oppressions? What would it mean to create work from there? No direct line existed from these questions to the final composition of the Call, but these questions cracked open something crucial for me. Here was our chance to create our own discourse as Black women artists. We could now respond to the world on our own terms. What would move us forward in our own practice? What would it mean for us as Black women artists to claim joy?

As centuries of blues songs, novels, poems, plays can attest, joy is not a simple thing for Black women. We were not interested in denying history. Instead, we wanted to claim new space for our imaginations and actions. To evoke joy for ourselves felt unexpected and courageous. For me, it felt both daunting and liberating. On Tuesday Afternoon, July 22, in a dynamic live performance at the Antioch Community Meeting, we made our announcement.

The Call was to conduct "Experiments in Joy."

Call & Response Artists Announce the Call:
Experiments in Joy

From Lagos and Austin, Los Angeles, Louisville,
Minneapolis, Chicago, Brooklyn, Seoul, Pétionville, the
Arkansas Delta, Horseshoe Mountain, Busan, Detroit, New
York City, Kentifrica, Puerto Rico, Beirut, Mexico City,
Banjul, The Gambia and Yellow Springs, OH, we arrived
to participate in Call & Response, an innovative dynamic
of black women and performance at Antioch College.
We are a diverse group of seven black women artists with
different relationships to the words "black," "women" and
"performance." For five days, we shared stories and forged
a process. We debated privilege, agency and forgiveness.
We worked, played, laughed, sang, presented work and
considered what we are all called to do.

> What is the urgency of our invention?
> How can we engage in collective imagining?
> How does our work change when we create
> from a place of freedom?
> What is irresistible to us?
> Are you available to yourself and to your calling?
> How can we negotiate invisibility
> and hyper-visibility in productive ways?
> How do we undefine the defined?
> How can we sharpen our awareness of energy and
> rhythm in the body?
> How can we make art that manifests change
> for a more socially just world?
> How can we move through or without fear?
> How can we sustainably care for and be accountable
> to ourselves and one another?
> How can we achieve radical openness?
> How can we claim joy?

In response, we call you to conduct experiments in joy

This call invites you to play, explore, investigate and create: performance, poems, drawings, desserts, long walks, spirited discussions, textiles, hairstyles, dance, research—make it funky—cooking, music, maps, apps, structures, sounds, movements, games, artifacts, political actions, adornment, manifestations, encounters, new intentions, letters, photographs, or anything else— surprise yourself! Here's how to do it:

1. Tell the truth
2. Make something new
3. Invite someone in
4. Document
5. Repeat

This process can be collective or individual, a single event or daily practice. Reasons to respond include: to participate in an artistic community; to connect to the enduring legacy of black women artists; to experiment; to play; to find new sources of joy; to confront obstacles to your joy; to learn how to inhabit joy while embattled; to make new work; to transform the work you're already doing; to interact in new ways; to heal. We don't have all the answers and we don't always agree on the answers we have. We do know the conversation is urgent. Join us. Respond to the Call.

Gabrielle Civil, Duriel E. Harris, Kenyatta A. C. Hinkle, Rosamond S. King, Wura-Natasha Ogunji, Miré Regulus, Awilda Rodríguez Lora

~ * ~

The August session of Call and Response (August 22-24, 2014) became the "Experiments in Joy" performance festival. This event included a community performance workshop on the theme; another potluck in honor of the artists at the home of local professor Jocelyn Robinson (with a hot tub!); a short film festival with offerings by Junauda Petrus, Autumn Knight, Ada Pinkston, Catron Booker, Ellen Marie Hinchcliffe, Marco Villalobos, Steve Bognar and Julia Reichert as well as Antioch students Teddy Piersen and Cristian Perez; an original performance score by Chloë Bass; and, additional live performances at our Saturday night event by local vocalist Vernetta Willett & DJ Basim Blunt from WYSO's late night program "Behind the Groove."

The main attraction of the festival, of course, was the premiere of our artist Responses. Our work ranged tremendously in form, style, content and duration. We had slotted another Saturday night evening of presentations, but festival performances happened the entire weekend from Friday night through Sunday morning. On Friday night, Kenyatta convened a panel "KENTIFRICA IS OR KENTIFRICA AIN'T?" where Antioch students, faculty and community members presented their research on Kentifrica, her contested geography/ merged consciousness of Kentucky and West Africa. Kenyatta also collaborated with Antioch Chef Isaac DeLamatre Saturday afternoon to serve Kentifrican dinner to Antioch students and community members before our evening event.

Saturday afternoon, Rosamond also sat for hours in the Performance Atrium of the Foundry Theater for her performance installation "Leave It Behind." In this work, she created an opportunity for audience members to "leave behind" tiny physical pieces of themselves (fingernails, skin flakes, cheek swabs, blood) representing a thought or experience they wanted to eschew. Rosamond took down their stories, what they wanted to leave behind and why, and tweeted aspects of them in real time. Also in the atrium on Saturday afternoon, Miré created automatic poetry in public for her piece "*My brown*

body, this I know". She wrote line after line on large sheets of paper. She also embarked onto other parts of the campus to dig into the earth with a shovel and write words with colored sand into the excavated space. Saturday afternoon also found Wura working with Antioch students to paint with abandon in her *"Paint Like a Man!"*.

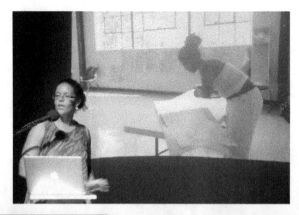

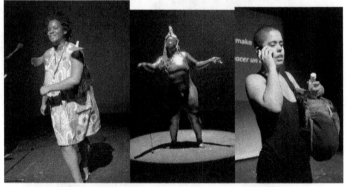

*At the August Experiments in Joy Festival: Nicolas Daily serving as
emcee; Wura-Natasha Ogunji auctioning paintings; Miré Regulus;
Duriel E. Harris / DJ Buddha hyping the party;
Kenyatta A. C. Hinkle; Rosamond S. King in "Tiny Winey";
at the July Show & Tell: Awilda Rodríguez Lora / All photos: Dennie Eagleson*

At the Saturday evening event, Miré showed a slide show of the work she had just done that afternoon and activated "*My brown body, this I know*" as a call and response choral poem. In one of the most raucous and uproarious events of the night, Wura auctioned off the fresh canvasses from "*Paint Like a Man!*". Kenyatta took the stage to thank the entire community for their embrace of Kentifrica. Awilda surprised the crowd by announcing that her twelve-hour durational performance would start at ten o'clock that night after the evening presentations were over. She would stay in the smaller experimental theater in the Foundry Theater amongst feminist books, videos, markers and paper and brainstorm on the nature of "La Mujer Maravilla" or Wonder Woman. With the assistance of anyone who came to visit, talk and dance with her, she would experiment with creation in real time. She would perform her results on Sunday morning in the Glen Helen nature preserve. Her work became a gorgeous display.

Three true premieres took place at our Saturday event. My performance art work "_____ is the thing with feathers" incorporated music, movement, text and projections to explore joy. Wearing one of Kenyatta's Kentifrican headdresses, Rosamond performed her unforgettable dance "Tiny Winey", exposing some Antiochians to the Trinidadian *wind* for the first time. Finally, Duriel took the notion of dance to the next level. As her alter-ego Shawn a.k.a. DJ Buddha from her show *Thingification,* she performed a live DJ set that brought almost a hundred people to their feet in a rambunctious dance party.

None of this work existed before July.

Inspired by the Call, we were also deeply inspired by each other and the process. From July to August, through conversations and play, live painting and writing, collecting of physical artifacts, dining and dancing, artists and audiences alike experienced the real-time process of black women's performance work as well as its ostensible final products. Process truly became product. Call & Response itself became an Experiment in Joy.

This was especially true for the administration of Antioch College. In the midst of significant fundraising and budget constraints, the College supported this initiative, particularly costly as artists came not once, but twice to campus. The College paid for all artist airfare and opened a campus guest

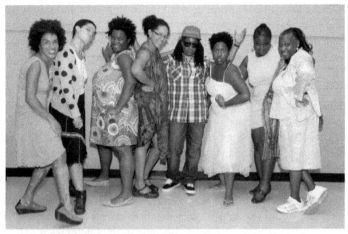

Call & Response artists with Vernetta Willett at August festival /
Photo: Dennie Eagleson

house to lodge visiting artists. Our budget covered purchase of discounted tickets to the excellent, locally sourced dining hall for meals. Each artist also received a small honorarium. This generous investment was a wise one—and not just relative to my employment. Call & Response charged the energy of the Antioch campus with joy! Literally, the term "joy" became part of the campus vocabulary for the summer. Students started conducting their own experiments in joy. Resident Advisors in the dorms brought up joy in weekly meetings. People expressed joy by smiling and laughing more. At a recently re-opened school that at that point, ran year round, where everyone works very hard, and where each day seems like a bid for survival, this option to claim joy was a life-saver.

The symposium also highlighted the power of experiential education, a hallmark of Antioch education. Call & Response artists played a major role in my two classes that term. In July, Awilda introduced my PERF 104 Presence of the Performer students to the improvisation practice "Passing Through" and all of the students and artists practiced this form together. In August, PERF 104 student Austin Miller also served as Awilda's assistant during her durational work. For twelve hours, he never left the theater except to get the artist coffee. He told

me recently that the experience changed his life.

Call & Response was even more integral to my PERF 360 Advanced Topics in Performance: Black Women and Performance class. The seven smart, hard-working students of this class, Ciana Ayenu, Sam Benac, Hannah Craig, IdaLease Cummings, Jane Foreman, Amelia Gonzalez, and Avigail Najjar connected traditional academic research with real world artistic experiences throughout the term. Mining the intersections of Black women's performance in theater, popular culture and visual art, we read Alice Childress' short play *Wine in the Wilderness*, Ruth Feldman's *What It Means to Be Free: Black Women Entertainers and the Civil Rights Movement*, theoretical texts by Darby English, Coco Fusco and Nicole Fleetwood, poetry by Kate Rushin, and articles on the notorious Donelle Woolford affair. A special touchstone for our work became Freida High W. Tesfagiorgis' classic essay "In Search of a Discourse and Critique/s that Center the Art of Black Women Artists" as we kept coming back to her term "trajectory of displacement." What would it mean to put black women's work at the center of discourse and critique? What would it mean to respond to something other than "objectification and misrepresentation"? Call & Response made that happen.

Black Women & Performance students read the CVs of all the artists and explored our websites. They wrote and delivered introductions for us during our July artist presentations. They facilitated and came up with questions for our public roundtable. In July, they joined with other students to recreate Wura's performance "Sweep" on the Antioch campus. In August, they served as artist assistants, helped gather materials for the works, and de facto helped produce the festival. PERF 360 students also played key roles in *"Paint Like a Man!"*, "Leave it Behind" and "KENTIFRICA IS OR KENTIFRICA AIN'T?". This deep interaction allowed for true experiential learning, lived experiences of black women's performance and community building through art.

Student interaction also allowed for other wonderful convergences. Sunday afternoon in July, PERF 360 student Ciana Ayenu brought out hula hoops for the Call & Response artists

and introduced us to the slack line on campus. The next thing you knew, we were all running, hula-hooping, balancing on the line, laughing, experiencing joy. While the support of the College was generous, it was still relatively small for all the visiting artists accomplished on campus (artist presentation, collaboration on the Call, class visits, open studio, public workshop, premiere of new work, etc). But none of the artists came for the money. This playing together, this connecting with each other, with students and the community, was the purpose of our convening. We didn't come for a song. We came to sing together.

The mention of song is intentional as the structure and title of Call & Response drew from the signature dynamic of African-American performance expression. The symposium allowed black women artists to perform and embody the call and response pattern featured in everything from slave spirituals to contemporary sermons, from classic novels like Ralph Ellison's *Invisible Man* and Toni Morrison's *Beloved* to jazz and blues. Naming the event Call & Response connected our innovative convening in performance to Black diasporic heritage and tradition. At the same time, on the level of content, we could make whatever work we wanted. Whether it be gender expectations in art making, cooking, DJing, the myth of Wonder Woman, the hidden nature of the earth, we could explore whatever moved us.

Call & Response became the framework of our context.

Within that context, we could be free...

How an institution attracts Black women artists can be different than what it does to keep them there. As the day-to-day responsibilities of academic work have at times stressed me out and brought me down, I am proud to have been a part of Call & Response and deeply grateful to have had a chance to guest edit a special issue on *Experiments in Joy* in *Obsidian: Literature & Arts in the African Diaspora*. We enter into the academy to make a living and to make a difference. Events like Call & Response and journals like *Obsidian* offer artistic inspiration, emotional solace, and community support to help us brave, reclaim and experiment with joy.

"The Call that we crafted was to conduct 'Experiments in Joy.'
This has become a transformative life practice."
—Gabrielle Civil

"Experiments in Joy: Antioch & Beyond," 2018 Commencement Speech,
Antioch College, Yellow Springs, OH, June 2018

"Experiments in Joy: Women Writers of Color on Collaboration," Associated
Writing Programs (AWP) Conference, Tampa, FL, March 2018

"Experiments in Joy: Here, There & Everywhere," Goddard College MFA
in Interdisciplinary Arts Spring Residency Webinar, Feb. 2018

"Experiments in Joy: Intersecting Art & Identity," Keynote Address, Moore
Undergraduate Research Apprentice Program, University of North
Carolina-Chapel Hill, July 2017

"Experiments in Joy: New Visions" University of Minnesota-Duluth,
Duluth, MN, April 2017

"Experiments in Joy: Intersecting Blackness..." Keynote Address,
Black Intersections: Resistance, Pride & Liberation conference,
Claremont Colleges, Claremont, CA, April 2017 =>

"Experiments in Joy: Recharging our Culture," Lecture for the Liberal Arts
Mission, St. Catherine University, St. Paul, MN, March 2017

"Experiments in Joy: Transformation Now!" Pratt Institute, Brooklyn, NY,
Feb. 2017

"Experiments in Joy: Art / Action Post-11/9," English Department
Colloquium Series, St. Catherine University, St. Paul, MN, Dec. 2016

"Experiments in Joy: Art Action Now," FRED Talk, Culture / Shift,
USDAC / RAC Convening on Community Arts, Cultural Policy &
Social Justice, St. Louis, MO, Nov. 2016

"Experiments in Joy: Art Education & Social Justice," Keynote Address,
Art Educators of Minnesota Conference, Minneapolis, MN, Nov. 2016

"The Experiment: A Master Class," Combined MFA/ BFA classes, Jack Kerouac
School of Disembodied Poetics, Naropa University, Boulder, CO, Sept. 2016

"Experiments in Joy: Call & Response at Antioch College," Network
of Ensemble Theaters Symposium: Intersection: Ensembles &
Universities, Chicago, IL, May 2016

"Experiments in Joy: Black Feminist Performance Art (in) Practice,"
Women's Art Institute Lecture, St. Paul, MN, June 2015

"Experiments in Joy: Black Feminist Performance Art (in) Practice,"
Wolfe Institute Brooklyn College Undergraduate Series, April 2015

Experiments in Joy: Intersecting Blackness

~ * ~

*(For greatest effect, read the following text aloud. Feel free to stand up
and bring it into your body. Invite friends. Do it together.
Look up the artists and check out the images. Enjoy!)*

~ * ~

Good afternoon, everybody. How's everybody doing?

So it's Sunday morning, and this kind of convening for me is like church. Can we get a hmmm? Hmm hmmm, here we are at Black Intersections, hmm.

And in the spirit of church and the spirit of fellowship, turn around and say hello, good morning. Good morning! I think many of you may already know each other, but if there's someone that you don't know, then make sure you introduce yourself. Say hi. Hi!

It is really such a delight for me to be here at the final event of this inaugural conference, Black Intersections: Resistance, Pride & Liberation at the Claremont University Consortium. My goal here today will be to harness, gather the energy of this final conference event, and put it through my own prism as a black feminist performance artist. Hopefully this will give you some inspiration and renewed energy in your own work as you move forward from here. How does that sound?

What is the urgency of our invention?

How can we engage in collective imagining?

How can we claim joy?

The title of my talk today is "Experiments in Joy: Intersecting Blackness."

Somehow in your seat, either with your own hands, or if you have the consent of those around you, find a way to intersect blackness. Now make it a little bigger so others can really see it. Great.

Starting with a nod to ancestors, I want to start with this image. Is there anyone here that knows what this image is? Any Haitians in the house? Okay. So you might know. This image is a *lwa*, or a vèvè, a spirit drawing in Haitian religious tradition.

We are not going to do a religious ceremony right now, so you don't have to get nervous, in case you feel like, uh-oh, what is Gabrielle about to get us into? Although I do really believe that talking about art, talking about community, talking about liberation is a religious experience, this will not be formal ceremony. Still, with a nod to ancestors, I want to begin with this *lwa* for Papa Legba, a traditional start for ceremony, because it represents the spirit of the crossroads.

I want to start here to suggest that we, in this moment, in this country, are at a crossroads. We have to decide who we are, who we want to be, what we are doing, and what we want to do. We have to bring that spirit of the crossroads into our body.

We have to be ready.

And in that spirit, I want to share something with you. Some of you maybe saw me do this in the libation ceremony we had in front of the library the other day. It is a gesture of armoring and protection for us here at the crossroad. I'll show it to you first and then invite you to do it with me.

We pull strength down from our ancestors…
We pull energy up from our ancestors…
We press ourselves further down into the ground…
And we take power from each other
and bring it to ourselves…

So I invite you, if you are willing and able, to stand
and join in this gathering of energy.
Or feel free to join where you sit…

> We pull down energy from our ancestors.
> And then we pull up energy from our ancestors.
> And then we ground ourselves down into this earth.
> And then we pull from the power of each other
> and bring it to ourselves.
> Oh, doesn't that feel good?
> Yes, if you feel a little tingly, that's all right.
> Take it if you need it.
> And what we just did there was our first experiment in joy.

The title "Experiments in Joy" comes from a really incredible project that I had the honor of organizing at Antioch College in 2014; that project was Call and Response, a convening of black women and performance. Really, more than a convening, it was a *dynamic* of black women in performance, because the structure of the project was to bring people together to meet not once, but twice.

We were seven artists, seven black women performers, with different relationships to the words "black," "women," and "performance." Here, I want to bring the names of these amazing artists into the space. We were Awilda Rodríguez Lora; Rosamond S. King; Wura-Natasha Ogunji; Miré Regulus; Kenyatta A.C. Hinkle, Duriel E. Harris and me, holding it down. In this group, you had dancers, poets, theater makers, actors, performance artists, and everyone did more than one thing. People had different relationships to the African diaspora, to the Caribbean and Africa; people had different sexualities; people had different gender understandings, identifications. Some people were parents. Some people were queer. So you had a very diverse group of people all still within this prism of black women performers. And through a process of developing questions (*How does our work change when we create from a place of freedom? What is irresistible to us? Are you available to yourself and to your calling?*), we developed a Call to conduct experiments in joy…

When you think about joy, what kind of things do you think about? I'm just curious.

>>Sprinklers.
>>Laughter.
>>Laughter, what else?
>>Happiness.
>>Free brunch.
>>Quiche.

Yes! What we were interested in doing as black women artists, black feminist performers, black people in the world, was reclaiming this notion of joy, but really doing that within the context of our specific experience and understanding.

What does joy mean for us, and what are the expectations on us as black women performers, as black people in society, as feminist artists? What is the work we most want to make? What would it mean for *us* to create from a place of freedom? Could this be a way to create or build or make more freedom by trying to discover or claim that place? This was at the heart of our Call to conduct experiments in joy. And this was our method for how to do it.

Number one, why don't we say it together? I'm a big believer that when you put language in your body, something magical happens.

Number one...

Tell the truth.

Here's something else for us to say together.

BLACK LIVES MATTER

All right, so when we are talking about telling the truth, this is one thing that immediately comes to mind. Black Lives Matter. Remember that this started with three people in a conversation, one person trying to console the others. And she did that by telling the truth in the face of a world intent on denying that truth. These three words say, you know what, even if George Zimmerman gets off, even if Trayvon Martin was murdered, even if Rekia Boyd, even if Mike Brown, even if Sandra Bland, even as these people have become ancestors, while they were alive, **their lives mattered**—and while we are alive, **our lives matter.**

That's the truth.

Now, what about the complexity of the way that we live our lives? What about the truths of our lives that are harder to put into three strong words. How do we live our black lives? How do we connect to material and spiritual realms?

Going even deeper: what are the things that we know, and how do we come to know them? How does our knowledge of the truth grow as we move from birth to death? And, dear friends, if we are talking about the truth, what are the things that we honestly or truthfully don't know? What are the unknowns in our lives? Or what about things that we know but don't know how we know them? Intuition, epigenetics, ancestral memory? How can we tell the truth about that?

Living World

Death Birth

Spirit World

This image presents a Bakongo cosmogram, a West African cosmological spiritual system that shows our movement from birth to death, from our ancestors and back to them again. Here again, we see the crossroads, just like we saw in the vèvè before. And I think about diaspora and how knowledge moves and spreads and gets adapted and changed and preserved. I love this image so much! I want to connect it too with ideas from a workshop I took with John Muse and Mason Rosenthal called "Making is Thinking." Believe it or not, they used the language of Donald Rumsfield to help us think about performance making. Can you believe it?

Look again at the Bakongo Cosmogram.

Known Unknown Known Known

Unknown Unknown Unknown Known

What if up here above the line is what is known? What if below the line is unknown? What if in the movement from life to death, we have our certainties, our known knowns, but

we also have things we didn't even know we knew... How can we discover those things? How can we tell those truths? What about aspects of the world that we know we don't know? What might it mean to talk about that? Even more dangerous, what about the things we don't even realize we don't know? How can we access a space of truth where this all intersects? For me, this is the heart of education and of performance practice...

Step 2: Make something new. *(Let's say it together.)*

As people, as artists, we receive all of this knowledge, all of these schematics, about the world. And many of them are beautiful. Look at this color wheel. And here we have this incredible artist and architect, Amanda Williams, who decides to make her own "color (ed) theory." She takes the colors of things within her own community and creates a color pattern from that. So you have Ultra sheen, pink oil moisturizer, Harold's chicken, currency exchange, Flaming Red Hots and Newport squares. These become her color patterns. She gets them mixed as paint and, living in Chicago, she goes into a neighborhood with boarded up buildings and paints the entire exterior of an abandoned house in a color from her "color (ed)" theory palette. Flaming Hot. Crown Royal purple, etcetera.

Just imagine, you're walking in the neighborhood where you see boarded up houses every day and then, boom, all of a sudden something new thing that is there. It's the same house but now transformed. This change maybe does something different for each person who sees it. But in any case, this artist has intersected imagination with identity and art. And I would argue that this is activism.

Invite someone in. *(All together.)*

Let's come back to the body for a minute here. A lot of the work that I do—all of the work that I do, actually—is embodied work. And it hinges and depends on a sense of presence. My ability to be here in this space and time with you. And your ability ideally to be present in this space and time with me and with each other. What does it mean to be present? Let's practice that.

Find a partner, and make sure that you are comfortable.

We are going to do a very simple live art performance exercise. All you have to do is look into the eyes of your partner and allow your partner to look into your eyes for two minutes. That's right, two minutes. You're lucky, in my classes, sometimes we do it for five.

During the two minutes we are not going to talk. Ideally, be across from your partner and, in the bestcase scenario, unencumber your arms. I know some people want to clench their hands or their fingers, but get loose, people. Get loose.

Now everyone, take a deep breath.

Close your eyes. Reset yourself now. Understand that your goal is not to stare someone into the ground. Your goal is not to be super protected and kind of look elsewhere or pretend like you are looking but not really look. All you have to do, dear friends, is be present and look and let someone be present and look into your eyes. You might want to giggle or smile. That's okay. Just let whatever happens, happens. And you will do it in silence.

Begin...

All right. Take a minute and just touch base with your partner.

Okay. I'm nosey. What just happened?...

What kinds of experiences did you just have?

>>We thought it was very awkward but after a while it was okay.
>>We just kept laughing.
>>I could focus easier on her left side, but her right side was intense.
>>We played the blinking game. That made it less awkward.

>>All of a sudden there is some awareness or sense...
>>Awesome! So much happened. And, again, thinking about the theme of our gathering, think about how being present with another person can offer a rich opportunity of intersection. Think about movement work, and liberation, and

ask yourself, if you can't be with people, how are you going to move with people? How are you going to build with people? If you can't be present with them or you are not open to them—but wait—let me dial myself back too. Because there are reasons why we can't walk around with complete unprotectedness in this society. There are reasons why we arrive with our armors and we need to have alertness and recognize who or what is going on. That is for our protection.

Still, if we are trying to move, if we are trying to build, we have to practice being present with each other, the same way that in the freedom movement they practiced sitting down at the lunch counter knowing at least some of what was going to happen there. They practiced. So if we are going to intersect art and identity, imagination and activism, we are going to have to practice. Invite someone in.

So in the spirit of inviting others in, I want to let in the energy of other black performance artists who inspire my work. To start, here's a quote from Valerie Cassel Oliver, who organized a fantastic exhibit called "Radical Presence: Black Performance in Contemporary Art":

> "Performance art by black visual artists distinguishes itself by
> moving away from the stage and into the theater of the
> everyday and the ordinary. It is often temporal and engages
> visual elements, whether documents or objects. It is rooted in
> spectacle and... occupies the liminal space between black eccentricity
> and bodacious behavior, between political protest and social
> criticism."

Now, here are some images.

Adrian Piper, walking down the street with a sign that says: "Wet Paint." Dread Scott invoking the Memphis sanitation workers' strike of 1968, but instead of carrying a sign that says: "I Am a Man," his sign says "I Am Not a Man."

Pope.L puts on a Superman suit and crawls from one tip of Manhattan all the way up to the other end.

Finally, this is one of my favorites. I think this artist, Nona Faustine, identifies as a visual artist and photographer. I'm not

sure that she identifies as a performance artist. But this is a self-portrait and I think of this very much as a performance. She stands here naked wearing only white shoes right on Wall Street in Manhattan. She makes clear the undeniable fact of her black female body. And I just love the title of this piece: "From Her Body Sprang the Greatest Wealth." Think about ancestors.

Invite someone in.

And then document. One of the reasons why it's so important to me to have books about my performance art practice is because I am so haunted by the black women artists, performers, dancers, thinkers, whose body of work has been destroyed and lost to time. I remember them and take inspiration from them too. That inspiration leads to the last step in an experiment in joy.

Repeat.

Tell the Truth. Make Something New. Invite Someone In. Document. Repeat.

Where can we find joy in the black feminist tradition? In the work of Gwendolyn Brooks and ntozake shange and so many more. Lucille Clifton maybe says it best when she says: "Won't you celebrate with me... / that everyday something has tried to kill me / and has failed to." This is the heart of an experiment in joy. At the intersection of art and identity, activism and imagination, this is the urgency of celebration.

This is the expansive realm of blackness, ancestors and spirit.

This is the crossroads.

Are you ready?

Thank you very much.

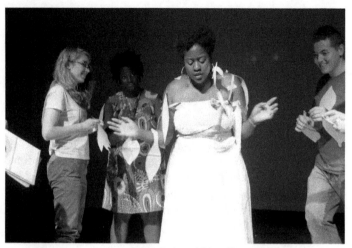

_____ is the thing with feathers / Photo: Dennie Eagleson

~ * ~

what was irresistible to me? how could i claim joy? after recalling the capture of the chibok school girls in the first half of our convening, i wanted to respond in release. not a forgetting, but an alchemizing, a coming together of various materials, and a letting go. some actors have described how scrupulous preparation allows them to be spontaneous and organic in performance. I wanted to make the transition, mark the pivot from external understanding to internal consciousness, from intellect into the body. i needed ancestors to help me. i needed ritual and history and the blues and suitcases and scissors and poetry. i needed a yellow rubber chicken and red masking tape and an audience willing to join me. a flight of fancy into black feminist consciousness, this was my experiment in joy.

_____ is the thing with feathers

premiered at the Experiments in Joy Performance Festival
Call & Response: Black Women & Performance at Antioch College

Installation
A red and yellow plastic rug.
A yellow suitcase full of paper upstage
with a red roll of masking tape stuck through the handle.
A yellow and red rubber chicken downstage.
A video projection looming large above:
a black and white drawing
of a black woman with scars.

Overture
"Ode to Joy" from Beethoven's Symphony No. 9 in D Minor,
Op 125 starts to play and continues to play throughout the
next sequence.

Vèvè Chicken Threshold
I walk through the aisles with the rubber chicken,
stirring it into space—stirring up voodoo ritual
and new world culture
The crowd starts to apprehend "the thing without feathers"...

Chicken Fusion
I pull out the roll of red tape
 and let the expanse spread between my hands.
I tape the rubber chicken to my body
and let it circle and circle around my body.
Red tape holds the rubber chicken in place around my waist.

Red Tape Scars
Once the rubber chicken is secure, I make red tape scars.
I tear off small pieces of red tape and press them all over my body.
Beethoven starts to fade.

Into Blackness

The slide changes.
A video projection appears with the title of this work:
"_____ is the thing with feathers"
I say: "And what does it mean to be without feathers?"
I wait two beats and then the slide changes again to black.
The backdrop remains black for the rest of the show.

Into the Paper

I say: "So when I came to Yellow Springs,
I brought approximately a million boxes
and bags and suitcases of paper."
I open up the yellow suitcase,
set and spread out stacks of paper.

"Years ago, when I was trying to become myself,
I would gather all this, black women's poems, plays, essays,
and I would hoard it and cherish it and keep it close.

This was before the internet.
And when someone gave you a copy
of an article about black women's dreaming,
you held onto it for dear life.
You carried it with you wherever you went
because you weren't sure if you lost it,
you would ever be able to find these words again."

I move the papers through my hands.
I make designs of the stacks of paper on the stage.
The paper is black women's paper, black women's dreaming.

"What is the urgency of our invention?
How can we undefine the defined?
What is irresistible to us?
And what if we can let go, transform the past
and turn it into something new?"

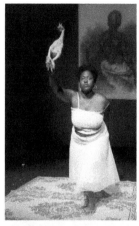
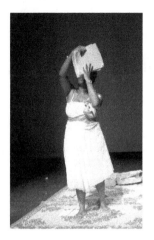

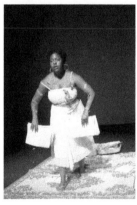

Photos: Dennie Eagleson

Feathers
I reach into the yellow suitcase
and find a pair of red-handled scissors.
I cut a feather from black women's paper.
I tape that feather to my body.

There are more scissors in the suitcase.
I walk out into the crowd and hand scissors to people.
I invite them to come and make feathers from the stacks of paper,
to tape those feathers onto my body, onto themselves and
each other.

is the thing with feathers

And when it seems like we are almost ready for flight,
I say: "_____ *is the thing with feathers.*
And what is the _____?"
Hope! a poetry reader calls.
"Ah someone knows their Emily D!
Okay, but here and now we're in the experiment
so what else can _____ be?"
The crowd calls out new possibilities.
Memory! Love! Letting go!

I encourage the cacophony of sound,
And as the space fills with words,
like feathers rustling in space.
I return to the suitcase and roll out a long runway
made of this black woman's paper.
Longer than my arms, I find two long wings
made of black women's paper.

Joy!

Bettye Levette's song "Joy" fades in.
It starts soft and gets louder and louder.

I say: "This is the runway. This is the landing strip.
I have my feathers. Now these are my wings."

I take my place at the end of the runway.
I prepare my arms with undulation.
I prepare my legs with dance.

My red tape scars and my yellow and red rubber chicken
are still there but are now engulfed by this paper.

I run. I jump. I use my wings made of words.
I shout out the word "Joy!" each time I rise in air.
I fly.

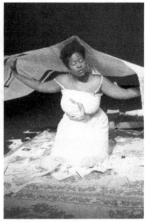

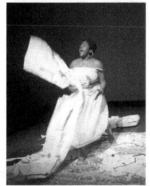

Photos: Dennie Eagleson

breaking the frame

And who will join this standing up
and the ones who stood without sweet company
will sing and sing
back into the mountains and
if necessary
even under the sea

we are the ones we have been waiting for

<div align="right">

–JUNE JORDAN
"Poem for South African Women"

</div>

Dear Miss Lily,

We arrived at the farmhouse at night, Lewis and me, without shadows in starlight, the night before the new moon. It was my first time in South Carolina and it started as a blur, a hatchback laden with provisions, frog bellows and rustling boughs. We came in haste, escaping family drama, you know how it is. White people. You knew them, not these exact white people but their kin. Rich great granddaddy Graydon who hired you to cook. Lily Cook, you were called. Without knowing, I heard that and wondered, was that really your name?

We woke up to situations. No water, a busted water heater, a dishwasher that needed to be replaced. Workmen and trucks and a dog that refused to stop barking. Loud defensive growls that broke into my sleep. Upon waking, I learned that my task was to clean. The family was planning a big party to celebrate the upcoming eclipse when the moon would overlap the sun. The farmhouse hadn't been used in months--maybe some rooms not in years—and so we needed to wash and sweep. Miss Lily, I could have been salty about this. Why a black woman gotta come down South Carolina and immediately be set to clean? I'm an *intellectual*, an *artiste*. Did I go to all that school to come South for that?

My own mother's eyebrow would lift in the air. Since when was I too good to hold a broom? Stay cheerful, pitch in, and avoid thinking about the racial implications. What sweeping could reveal. A clearing out and passing through this place, the country place of my friend Lewis' ancestors. Miss Lily, I think you would have gotten a kick out of him. How he flummoxes his family. Yes ma'am, I mean sir. Ladies—and gentlemen. A double take. A white boy, well really neither boy nor girl, but he'll settle for boy, making them all rethink family, what they think they know.

What do I know? In the wide wooden hall between the front door and the back screened-in porch stands a massive wall of framed photos, generations of family glory. Smiling antique babies, pale and gleaming. In a crib. In a high chair

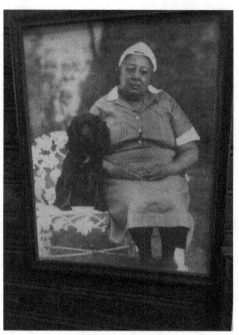

Miss Lily Alexander/photo: taken by author,
McCrory family collection

sitting at the table. In a captain's hat with a life vest. Brothers and sisters and maybe cousins on a sofa in a row lined up by height. In ruffles and short pants. School pictures in four square collage frames. Cheesing it up at the camera. Grownups too. In formal dresses with long gloves. In a hilarious grandma reindeer hat. Enlarged, shaking hands. Standing serious before an impressive ship. Posing pretty as a debutante or bride. On a fishing trip showing off a massive haul. By a barn door, in a trucker hat, patting the nose of a foal. Sitting pensive on a rock next to bare trees. In black and white and in color. White power. And before I looked closely at the corridor, the specific white people in frames, I see you. Zero in like a laser beam, or better put, your picture eclipsed everything else.

Near the far-left corner, in the center of the adorable cherubs, the smiling deb, the white woman and the ship, you

sit on a white metal bench, made of ornamented white flowers, clad in clean uniform, white collar, white cuffs, pinned white hat, hands almost folded in your lap, Next to you, of course, right at your shoulder, is a fluffy black dog. Wow, these people and their fucking dogs. These Graydons, McCrorys, Wallaces. I haven't been acquainted long and already, I've met Baca, Ripley, Taco, and heard about Beausiphus. Yipping, drooling, barking, defending, leashed or unleashed with fierce love.

"Who is this?" I ask Lewis' Aunt Margie (pronounced with a hard G). "That's Lily Cook. She worked for the family for years. Really, she was like one of the family."

Oh, sweet Jesus. Oh Audre Lorde. Like one of the family. Really? I was polite, Miss Lily, I didn't roll my eyes. Because it's true, I don't know you or this family of theirs. I kept looking, looked deeper, heart-looking more for you.

> *What were you like, Miss Lily?*
> *Lily of the valley?*
> *Lily perfume?*
> *Lily of the Bible?*
> *Not lily white.*
> *Were you lily-like?*
> *Did you like that dog, Miss Lily?*
> *Was she in fact your dog?*
> *Did you pull her close*
> *and confide your secret thoughts?*
> *Was she the kitchen dog that ate your scraps?*
> *Was your cooking even better than I imagine?*
> *Was she Paw Paw's, old man Graydon's dog?*
> *Was she begging to enter the frame to share your light?*
> *Did she eclipse you in the family affections?*
> *Were the two of you seen as the same?*
> *Was the picture a gathering of favorite pets?*
> *Is that question impertinent?*
> *Am I speaking out of turn?*
> *I'm sorry, Miss Lily. I really want to know:*
> *What did you think of this family?*

Were you aggrieved or cheerful at your service?
Did you think of the kitchen as your home?
Did you like this family?
Were you like this family?
Were they like your family in any way?
Did you have daughters or sons or children
who were neither daughters nor sons or both?
Who were your siblings and cousins?
How often did you see them?
Are there many pictures of you?
Were you alone?
Did you get to sit alone?
Were you proud of your uniform,
how hard and well you worked?
Would you be proud to have your picture
here on the family wall?
Did you belong?
Do you cook up their own sense of belonging,
the story they want to tell about who they are?
How did you feel when granddaddy Mac
the developer tore down your house?
Did you add an extra pinch of salt?
Did they even know you?
Did they know you better than I ever will?
Did you hate it that they called you Lily Cook
when your name was Lily Alexander?
Or did you take it Lily Cook as a fact,
a title of pride, an armor or disguise?

A punctum. Last week, my friend Amy used this word in an e-mail to me and I was too lazy to look it up, but it seemed like a sign when I saw it again this morning while reading some poems on the screened-in porch, right next to where your picture hangs. The poet Carolina Ebeid, whom I met in Colorado, borrowed the word from this French guy Roland Barthes who says the *punctum* "is the object/ image within a photograph that leaps out and punctures the viewer: 'the

accident which pricks, bruises me.'"

Miss Lily, what are the odds that I would read this word--*punctum!*--right as I was thinking of you? Your picture on the family wall, next to the dog, the horses and houses. That picture pricked and bruised me. Loved and claimed, remembered and misnamed. Lily Cook, an imperative as much as a nickname. An articulation of power and a shame, at least for them.

In an interview a few days ago, Lewis recorded his 95-year-old grandmother, the Graydon girl you knew as Sarah, saying: "That's just the way it is. It's like with the blacks and the servants back when I was growing up. That's just the way it was. But the problem was we didn't think anything of it--bad. We just were totally indifferent. Didn't even know the servants' last names. We called Lily, Lily Cook but her name was Lily Alexander."

Miss Lily, at least she remembers your name. At least she's getting a glimpse of something. But this isn't about her. It's about you and me, my cheeky desire to claim you, to be claimed by you too. I see your picture and cherish you among my ancestors.

We may say some ancestors are given and others are chosen, but sometimes ancestors choose you. I feel chosen by you Miss Lily Alexander, your reminder, your welcome. How you showed me that I am always and never a stranger in this house, and that I can be so, like you, with diligence and grace. How you hold the space, remind me of mysteries and radiate a gorgeous blackness, a new moon, an eclipse to block out the omnipotence of the sun.

Love,
Gabrielle

Hand Written Notes

A month has passed since *hand written note(s)...*

A month of massacre and memorial circles, Ramadan prayers for Orlando, Queers against Islamophobia, new vigils in Charleston for the church dead, shapeshifting, Brexit, a high yellow prettyboy spitting truth to power—who knew?—on BET, color drama, stars and stripes, commencement marches, poetry picnics, tall tiger lilies, unexpected rain, and fireworks so loud and so long in Detroit that my mother couldn't sleep for anger.

And now, an eclipse of more grief, more heartbreak... Bombings in Baghdad on high holy days. The unjustifiable murders of Alton Sterling and Philando Castile. The misdirected mayhem against officers in Dallas, Texas along with the slander of peaceful protestors. In the wake of such unbridled evil, what to say about a movement festival?

Why talk about something like this at all?

Perhaps because events like this, to paraphrase Alice Walker, can offer ways forward with a broken heart. It took nearly a year to materialize *hand written note(s)*; a month later, my experience feels indelible. I want to write back and maintain the correspondence. I need to remember the energy of healing exploration right now. This feels in line with a key festival aim "to support artists before and beyond the actual event or performance," which is to say then and now and always. I write with this in mind my heart.

inviting / corresponding

This is the truth: it made absolutely no sense for me to come to the Spring 2016 Movement Research Festival. I am not white or thin or particularly young. I am not a downtown dancer. I didn't know any of the curators or performers. I don't live in New York City. I don't even live on the East Coast. Instead, I was in the last weeks of a job in the lonely Midwest where I had just served notice (a hand written note, indeed). My urgent need was to take time to get myself together—recover from deep physical and emotional pain, regroup my art practice, and

reshape my life. This plan was in the works, but not for the week of June 6. I still had classes to teach, papers to grade, boxes to pack, and, yes, money to save.

Yet, when I tried to delete the message, I couldn't. It was just a generic post from an e-blast. Still something made me keep it bold in my inbox. Perhaps the words: *space, healing, lasting action.* The exquisite sea blue and ethereal lines on the portal of the festival website. The loveliness of Ayano Nelson's design. The scrawls and doodles. The key words of the curatorial statement: *self-care, history, rest, celebration, old medicine, and inner ceremony.* And the line that rang through me like a bell (hooks circa *Sisters of the Yam*): *"Grieving, getting stuck, and finding new ways to move through it."*

What is the shape of an invitation?

How to engage (in) correspondence?

At Mei Ann Teo and Laley Lippard's session on "open spaces" at the 2016 NET conference in Chicago, a wise person in my small group talked about the pre-work required for people to want to enter a space. Predominantly white organizations wondering about their homogeneity often misunderstand this, as do straight, cis, able-bodied and middle and upper class ones. My students and I talk about this too relative to live performance. Just because you say you want people to do something, i.e. you "invite" them into your action, doesn't mean that they will do it. What signals are you really sending? How grounded, how expansive, how urgent, how earnest, how thoughtful, how deep, how credible is your invitation? It has to be heart-felt, cross-checked, and irresistible for others to want to bother.

Even then, it's a risk.

For me, likely the oldest, blackest, fattest, clumsiest person in the room, the festival could be a deep, micro- or macro-aggressive bust. So before coming to *hand written note(s)*, I pored over all the materials, workshop titles and descriptions, participant bios and websites. I did this out of deep loneliness and deep hope for connection, but also as a measure of psychic security.

When I saw the promise of black people, queer people,

people of color, trans people, women, artists, and teachers poised to engage and name (unnaming/ renaming) key aspects of themselves as a part of everybody's central work of self and community care, I accepted the invitation. I didn't know what would actually come to pass. I didn't expect it to be perfect. Rather the possibility of some correspondence, some similarity and expression in exchange, meant that I had to try.

addressing/ enveloping/ enclosing
In La MaMa Great Jones Studio 6, I take 3 workshops one after the other: Marissa Perel's "Rename and Unbody: Somatic Awareness and Language for Who and What We Are," Ni'Ja Whitson's "Being a Body Out Loud: Trans-Indigenous and Political Practices for Artists and Activists seeking radical moves in their work, art, lives," and mayfield brooks' "Rupture: Improvising In The Break." These workshops together cost a total of $12. I feel very lucky to be there.

At the start of all 3 sessions, we say our names.

In my notebook, I write each one down in order in the shape of our circle.

(1) Marissa /Kosta / Josie / Awilda / Gabrielle / Keiko / Elliott / devynn / Coco /Amelia / Juliette / Kat / Randy / David

(2) Ni'Ja / Awilda / Gabrielle / Maura / Marissa / Kosta / Judah/ Victoria/ Josie ///
(a cosmos of ancestors)

(3) mayfield / Gabrielle / Kosta / nyx / Maura / Josie / Randy / Rachel / Bex

I may never see these people again, but I mark and hold them.

I appreciate and know them like folks you only see late night at the club.

We create and enter sacred space together.

~ * ~

Funnily enough, I almost didn't go to Marissa Perel's workshop. Would suppositions about the body alienate or segregate me? Would I be the only black person in the room? Would I be too fearful and shut down for somatic awareness? I signed up, telling myself that if it felt wrong in the morning, I wouldn't have to go. I woke up before the alarm with a gust of wind in my chest. It was hope. To my delight when I arrived, my friend Awilda from Puerto Rico was already there. Like me, she had decided to try all 3 workshops as well. It was a day of coincidences and continuities of community.

Marissa's workshop was a good call. I am brave. In our introductions, when she asks about injuries, I mention having a broken heart. It was my first time ever saying that out loud. Later in the session, I make a major discovery. For months, I have been highly functional and *deeply disassociated*. Trying to return to my body is deeply necessary and deeply painful. Marissa stresses that integration isn't always the goal. How can we be present in our brokenness or fragmentation? What do we need that is most impossible? How can we make the unknown a home?

These questions offer crucial somatic grounding for Ni'Ja's workshop. All along Ni'Ja (preferred pronoun: they) has been my magnet. I had never met them, but their title had made me gasp. Their workshop description had made my heart keen and flutter. I read it and reworked my class syllabus and got on a plane. I was not disappointed.

In real time, we activate the technology of the circle, resurface our contact with the earth to re/connect with ancestors. We generate an enclosure of energy in the room that radiates, permeates, and envelops us all...

At one point, while I was trying to channel my maternal grandmother, my paternal grandfather shows up. This is especially amazing because he died when my father was two. Who are you? I ask. Who do you think? he answers. I'm the one that made all this possible for you! Sweat pours, clear snot falls from my nose, and tears run down my face. Sopping and streaming, I stumble to the bathroom. Standing in front of the paper towel dispenser, I can't figure out how it works. I can only go back, lie down wet and surrender.

In our discussion, Kosta mentions that people he didn't know had shown up for him. Inside, I knew. Some of my ancestors had dropped by to check him out. This was confirmed later in mayfield's workshop when near the end of his solo, Kosta picked up a stray piece of paper and placed it on the wall. He withdrew his hand and it remained there pressed. That piece of paper held my name.

The ancestor energy of Ni'Ja's workshop is a cocoon and a sheath. Ni'Ja tells us that warrior practice is healing practice. This seems crucial, but I'm not sure I understand. I fear how protected I've become around my heart. This protectedness seems connected to numbness and my state of disassociation. They clarify that it's not about being guarded. Rather, we need to be *armored*, taking on tools to be ready for the psychic warfare against us all around us. This resonates again in the wake of Orlando, Baghdad, Baton Rouge, and Falcon Heights, MN.

mayfield's workshop offers radical openness, intimacy and trust, the release of the head into another's hands while rising up and folding back down into the ground. We stretch and massage each other's bodies. We bobble our heads across the room, practice falling and getting up. This reminds me of the movement practice of SNCC protesters in the freedom movement, of Lénablou's *bigidi*, the stumble dance of Guadeloupe, how to swerve and catch yourself, rising and falling. This is armor and pleasure too. We laugh and wail and speak in tongues. We become an improvised, improvising *corps*.

~ * ~

I may never see some of these people again, but I love them. I mark and hold them. They mark me and hold me too. At a key moment when I start to feel afraid and unworthy of touch, Rachel pulls me into the dance. nyx twirls me into a duet. On a break, Josie shares bits of her dark chocolate with Awilda, nyx and me. She tells us that she and Kosta are from New Zealand. They are dismayed by what they see in America. They're trying to get a grip on this side of the world. Me too. devynn mentions my broken heart in their festival writing and

I feel seen, heard, and remembered.

I think about how fugitive communities can form in a dance class or workshop. The workshops become an enclosure within the festival's "porous enclosure for caring, rest, silence and celebration." How beautiful it is when that enclosure can be heterogeneous and non-normative. How different it is when the wisdom of the space, when the bodies in the room emerge from black and brown bloodlines. nyx talked about this in mayfield's workshop and Maura wrote about this in her festival writing. This was a powerful thing for me as well.

The presence of these bloodlines brought me to the festival in the first place. Moreover, it mattered to everyone, that our brown bodies were there. Together we were all part of a synthesis of energy that would address, enclose and envelop, overlap and fuse queer / somatic/ black/ ancestral/ knowledge/ movement/ healing / laughter / pain.

rewiring/ forwarding

My friend Purvi comes with me to Enclosures at The Chocolate Factory. We have our marked-up copies of Sylvia Federici, Fred Moten, and badass Audre Lorde. My festival experience so far has been extraordinary and to use Ni'Ja Whitson's word, I feel *armored*, prepared, and what in Detroit we used to call "geeked!" I can't wait to engage and hopefully embody these texts with new people.

I stop short when we get to the space. My apologies if I missed it somehow, but it seems completely physically inaccessible. There is no handicapped ramp to enter the space and, more intense, it seems to lack an elevator. The only way up to the bright, warm discussion area and Liliana Dirks-Goodman's lovely houses is a set of steep, rickety stairs. The only way down to the restroom is those stairs plus another flight.

As a person who has performed in multiple inaccessible spaces, I'm not trying to get up on a high horse. Rather, my recent reading on disability aesthetics and especially my talks with brilliant queer black disabled dancer Barak adé Soleil have made me more aware. Barak's recent, gorgeous performance "The Politics of Space" with Mikel Patrick Avery and Nikki

Patin investigated these questions: "Who is welcomed? Who is deserving? Who is allowed?" I think again about the shape and quality of invitations, the nature of community inclusion.

Tobin Seibers writes: "Aesthetics tracks the sensations that some bodies feel in the presence of other bodies." Which bodies are present? Why and how? What is the default dance community? movement research community? reading and responding community? How can we anticipate better the disabled dancers, readers, responders who would roll up in wheelchairs or stroll up with their devices if they were allowed more access?

I make this note, then climb up the rickety stairs. Randy Reyes greets us with a rose and a hand written note. I recognize Randy from the workshops and feel close to him, although I don't know him at all. I'll come to feel this way later about Jonathan Gonzalez and lily bo shapiro from this very event and the next night's revels, although I know them even less, having never danced in a room with them. This feeling of closeness comes again from the intimacy of sharing moving/ reading/ writing/ healing space. It has to do with being present in the room together. This is why we have to get as many folks in there as possible.

Presence can happen in many ways. Sarah Maxfield sent the notes and roses in her stead when she unexpectedly had to bow out. Her presence became these presents for us, sumptuous bunches of orange, yellow, and lavender roses. It was great to be greeted with a gift, something special and personalized ("To: You / From: Me"). I felt welcome, as if my presence, my being there, was really valued. The curators' opening statements also extended this feeling and I loved the acknowledgment of our presence on occupied, indigenous land.

The presence (absence) and roles of various community members were a big part of the readings and the evening's overall dynamic of responding. Federici and Moten ask us: who does what kind of labor where? Lorde models creative vision as poetry as liberation. At the same time, why do the performers mainly move while the discussants mainly speak? Have we been hard-wired to perform in this way? Is there a way to rewire the dynamic?

The event cracks open when Rihanna's "Work" comes on and we all dance and later when the performers enter into the circle and speak. How can we keep flipping our scripts, replay our roles differently? Holding a rose close to his face, one black man asked about fugitivity: "What are you actually running from? What are you really trying to avoid?" The flip side of the questions: what are you trying to build? The you is me and us. I left with a lot on my mind.

The next morning, my friend Zetta and I walk together in Prospect Park. She is not a performer and is horrified when I describe the practice of authentic movement in Marissa's workshop. What do you mean you have to move with your eyes closed while someone is looking at you? That sounds like a nightmare. I try to explain that you are not there to entertain the person and the person is not there to judge you, but rather that person is there to witness you, hold your energy, and keep you safe in the room. *Hmmm*, she remains skeptical.

It reminds me that however much I think of myself as an outsider, particularly in the downtown New York dance world, I am still inside the room. I am able-bodied in key (although not all) ways, a mover, a performer, a talker, and a person able to hold the gaze. My festival invitation came to me by wire, not as a hand written note. But still it came. I was on that Movement Research e-list; I can bring other folks into the fold. How can we rewire our networks and forward our invitations even more? How can somatic healing, interdisciplinary connections of reading, writing, moving and making connect with even more people?

I give Zetta the beautiful hand written note from Enclosures. Later, she posts this on FaceBook:

"I can feel a migraine coming on but I'm so grateful for this morning's walk in Prospect Park with Gabrielle Civil! She passed along this note from a fellow woman performance artist, which is just what I needed to hear today since I feel myself sliding into a period of deep reflection: "I wanted to be with you tonight. I am not there. I sent this. In my place. It is a moment—a breath suspended between inhale and exhale. Life and death. Held in your hand. Inside your shoes, there is skin

on the soles of your feet. Inside your feet, there is blood in the marrow of your bones. The work you are doing is enough. You are enough. <3"

My forwarding this note and Zetta's posting it online allowed the festival to cross from one world into another. Beyond the initial moment, Sarah Maxfield's words offer widened enclosure around movement research. Hand written note(s) can still offer beauty and solace in these terrible times.

I offer thanks for this note, for the rose and real talk of Enclosures, the brilliant performances there and the next day, the workshops, and overall for the three full days of festival events that nourished, inspired and challenged me. I offer special thanks to Aretha Aoki, Elliott Jenetopulos, Eleanor Smith, and Tara Aisha Willis for all their hard work. I am an honored witness of their authentic movement(s). I especially appreciate them letting me, a virtual stranger, share my verbose thoughts as festival writing. Often folks work hard and don't receive much feedback, so hopefully these thoughts can feed the archive and serve too as a thank you note to them.

they came in shimmying...

They came in shimmying, conjuring, undulating. Black women elders in black, different shapes, different sizes, different hues, different hair. They came in with claps, with a drummer behind them, shaking and rattling, snapping and soothing. They stepped onto the stage, stood behind music stands, and started to intone. Caledonia & Millie. Streetcar & dining table. ntozake & Toussaint. Blues & jazz. Seed and infinity. Welcome to St. Louis. Welcome to the new world—post-11/9—and just like the old one... *Don't worry, baby. We got you.*

Not church, but something like it. And boy did I need it. As a black feminist poet, conceptual and performance artist, as a liberal arts professor with a Ph.D., as a queer-friendly child of an immigrant, the 2016 election was ROUGH. The nasty, divisive, acrimonious campaign season was ROUGH. Right now is ROUGH. Rough meaning scary, poisonous, destructive, a real bummer for real.

Let me be clear, the world wasn't perfect on 11/7/16 or the morning of 11/ 8. Extra-judicial killings of black people had raged for years. Water protectors were already being intimidated at Standing Rock. Right here, the state of Minnesota continued to have the highest achievement gap of white and non-white students in the nation. Things were not peachy keen.

Still, I woke up on 11/9, not knowing where I was or whom I could trust. I woke up on 11/9 questioning my belief in the vision of this country or my capacity to participate in it. I woke up on11/9 with deep reservations about the possibility for racial harmony, sharp questions about whiteness, and new insights about white supremacy. Generally, a warm, fuzzy person—I'm a Libra for godsakes, I love to hug—and I felt my body clench, my jaw set. I was unsettled, disturbed, upset, disappointed, angry, sad, afraid, and chilled to the bone. My sense of the national body, the political body, my own black feminist body, was beyond alarmed. What would happen to my dreams while I had to watch my back? What would happen to my neighbors? What would happen to this world?

And then, they came in shimmying, conjuring, undulating.

Black women elders in black, different shapes, different sizes, different hues, different hair. Not church, but something like it—the opening ceremony of Culture / Shift 2016, a convening of the people-powered United States Department of Arts & Culture. Note: this is not a federal agency, but a network of artists, activists, and organizers dedicated to cultural agency in our communities. A week after the election, I was there—and so were they. These black women elders welcoming me there.

Their bodies were not clenched, their jaws were not set. They flowed, they swayed, they grooved. And this reminded me of something deep and true. In the apocalyptic cataclysm of the 2016 Presidential Election, my older black people have been real chill, rock steady, unphased, righteous, ready, and maybe a little amused. While I was curled up in a ball the morning after, they were like: *Really baby, where did you think you lived?* Not in a cruel way. They were the ones who taught me to dream, to connect, to excel. Not in a delusional way either. They recognize the tenacity of racism, xenophobia, and misogyny. They also recognize their own tenacity. They embody it. As source and resource, that tenacity becomes my own.

They came in shimmying. They beckon for me to shimmy too. Elections are important, politics are important, but justice is bigger than both of them. Art is too. And so, the movement of these black women elders moves me. Post 11/9 is the time for art and action, art in action. This is the time not just to stand for justice, resistance and solidarity, but to shimmy for it. This is our moment to become who we are most meant to be. This becomes an experiment in joy.

Breaking the Frame

How can we mobilize art in new ways?
How can we flip the script and disrupt the discourse?
How can we subvert expectations and stimulate change?

After years of high profile, extra-judicial killings of black
people, I am struck by how much action and reaction
seemed to follow a strict script.

State Violence —> Non-Indictment —>
Outcry/ Demonstration —> GreaterMilitarization —>
Protest / Vigil —> Reset/ Do It All Again.

This script has framed the nature of our work as artists and the
nature of our lives as citizens. This frame needs to be broken.

At the same time, our artistic responses are often equally
rote: the same songs sung the same way / the same elegies
/ the same murals to the fallen / the same candlelit orations
/ the same frustration and helplessness. As a black feminist
performance artist, as a grieving citizen, I crave more.

I believe deeply in the power of experimental art and artistic
experiments to transform consciousness and communities.
To this end, I want to break the frame: reconsider the forms,
sites, materials, practices, and audiences of our work; rethink
which art for which people when and where, how and why.

Right now, post-election, in the era of 45, the need to break
the frame has become even more clear. In a nation as divided
and dangerous as this one is now, we need artists more than
ever to witness, console, listen, disrupt, commiserate, dream,
and tell the truth.

While others discussed policy, self-care, language justice, and
other worthy topics at the final session of Culture/ Shift in
Saint Louis, Steve and I started cooking as artists.

If "Breaking the Frame" were a medicine show,
what acts would we want? Which artists and activists
offer compelling models (Bill T. Jones, Dread Scott, Coco Fusco...)?
Which kinds of art have been ignored?
How could we be proactive instead of reactive?
How could we zoom in on particular aspects
of the social political script and blow them up?
What specific actions could we imagine?

How about instead of a march, we had a person on a treadmill,
going and going and never getting anywhere? And what if that
treadmill were on wheels and a person were singing protest
songs into a megaphone into that person's face? Or instead of
hashtags for the slain, what if we hashtagged ourselves, the
living, and all those living in the audience, all those performing
on stage? What if we hashtagged our ancestors? What if the
talking heads in our community were literally giant puppet
heads? What if we featured a duet with actual police?

As we started riffing, the sweet adrenaline of creativity started
to surge. Some of our ideas excited me and some scared me.
Some were brilliant, some were crackpot. Some will materialize
and some will never see the light of day. It didn't matter.

My body started to sway. My heart and mind started
unclenching. I was breathing, laughing, scribbling, visioning,
moving. It was the best I had felt since 11/9. The process
was deeply medicinal. I had just met Steve that weekend, but
he became my comrade, my community. Art dreaming with
him helped remind me of my truth, my capabilities, and my
values. Our exploration of artistic possibilities helped me break
the frame of post-election despair. The actual score holds
potential for surprise and new manifestation. May you too
find inspiration, balm, and camaraderie here.

Breaking the Frame

A score by Gabrielle Civil & Stephen Houldsworth

1. Mark the Frame

2. Identify the Tropes

3. Queer the Frame / Play =>
DO SOMETHING DIFFERENT
(tone * medium * materials)

4. Discover Something
CREATE SOMETHING PROACTIVE

5. Reflect – Perform – Discuss
(In solidarity/ Enjoy)

--November 19, 2016

dear you,

years ago, i made myself a sign in space,
a bright shield of bravado.

here, take it.

okay, it's not a billboard or your name in lights,
just a page from my book,

but i really want you to have it.

grab some colored markers and scratch
out what's not you. scrawl in what's not there.

tell the truth. make it work for you.
better yet, play.

flip it over and fill in the blanks.
pull out your scissors and cut into this book.

don't get too precious. cut it out.
or tear it. tear into it. you can tear it up too.

make something new.
a souvenir or a life preserver.

it's yours if you want it.
invite someone in.

send me a selfie when you're done.

xo gab

I am a maker of:

poems / performance art/ plays / conceptual art / works on paper / art books / installations / projections / pictures / videos / essays/ articles / meditations / stories / hybrid texts/ letters / long rapturous e-mails / process pieces / novels/ grant proposals/ schemes / translations/ dances /daydreams / ideas

document

Aesthetic Crossings
(for Michelle Naka Pierce)

* 1 *

Maybe it's because of my many years in the Twin Cities...
Maybe it's because I've often been the only, or almost only
black face in the crowd at a particular poetry reading...
But here's what I've noticed: if you go to a poetry reading in
Minneapolis, the people in the audience look like relatives of
the reader.
"Innovative" language poets get "innovative" language-y crowds.
Spoken word poets get spoken word crowds
(notably younger and browner).
NPR poets get crowds proudly sporting their NPR bags.
And hipsters, of course, get hipsters.

This is not just a matter of taste,
but rather a self-selected social stratification,
a claiming and perpetuating of intellectualized social space.

I want to crack open this space.
Or rather, I want to inhabit, fill and layer it in different ways.

This is my utopia.
This is not easy.
In fact, it is quite difficult.

* 2 *

In the Language & Thinking program at Bard College,
I would often teach Charles Bernstein's short essay, "The
Difficult Poem."
This essay always amused me with its deadpan voice and
its diagnosis of difficult poetry "symptoms" such as "high
syntactic, grammatical, or intellectual activity level; elevated

linguistic intensity; textual irregularities; initial withdrawal (poem not immediately available); poor adaptability (poem unsuitable for use in love letters, memorial commemoration, etc.); sensory overload; or negative mood."

Yes, formally experimental or syntactically fragmented work is "difficult" and still (or perhaps therefore) worth reading and teaching. But the description of difficulty as related only to high intellectual activity or "innovative" style is deeply limiting. It discounts very real social and aesthetic difficulties connected with encountering different subjectivities and experience manifested in and through poems.

As Audre Lorde writes in "Poetry is Not a Luxury," true poetry is "the revelation or distillation, of experience, not the sterile word play that, too often, the white fathers distorted the word poetry to mean—in order to cover their desperate wish for imagination without insight." Recognizing revelation, comprehending distillation and reckoning with insight is another, equal kind of poetic difficulty.

(Just there in Lorde's sentence, some may have difficulty with the phrase "white fathers." Although not syntactically elevated, it may still cause a different set of symptoms such as bristling, brow furrowing, anxiety, sweat or, in other readers, unexpected grins and exhalation.)

As Bernstein suggests: "The difficulty you are having with the poem may suggest that there is a problem not with you the reader or with the poem but with the relation between you and the poem." And that relation is, of course, social, economic, political, historical, national, regional, racial, gendered, classed, sexually oriented and depends greatly on who you are.

For example, for many teachers and practitioners of "innovative" poetry, Lucille Clifton is actually more difficult than Gertrude Stein. They can't "relate" or deal with the body in "the lost baby poem;" the operation of race, gender, or motherhood; the social location from which she writes and the social location it might imply for them as readers; how her poems bring readers into her subjectivity, but also make them aware of their own separate, socially-located subjectivity. Some might say Clifton's

poems aren't "challenging" enough or that her syntax isn't surprising, but what they're really saying is "I don't want to talk about this work," "I don't know how to talk about this work," "I don't know what to say," "I'm not comfortable," "This isn't my kind of poetry" (or perhaps "This isn't my kind of person"). This, at least, has been my observation.

I want my students to embrace the difficulty of poetry—all kinds of difficulty in all kinds of poems. Both Gertrude Stein and Lucille Clifton are or can be difficult depending on who you are, where you're from and what kind of training you've received in reading poetry.

Both poets deserve to be read (along with Bernstein and Lorde). Reading both in the same class helps us read each one, the other (and each other).

* 3 *

Back to my utopia.
I call it an aesthetic crossing.

In my classes, racially, ethnically and aesthetically
diverse poets arrive together:
 they hang out, float and claim common space.
They offer and represent a wide range of possibilities for
 what poetry is and can be; for who poets are and can be;
 and for who my students are and can be.

* 4 *

My friend Michelle Naka Pierce, who taught with me at Bard, asked me which two texts best represented aesthetic crossing in my pedagogy. My clear choice is *100 Best Loved Poems* edited by Philip Smith and the *Norton Anthology of Postmodern American Poetry* edited by Paul Hoover.

Both touchstones of my Intro to Creative Writing Class, the two books couldn't be more different. The first book is slim, short and cheap—$3 new in a Dover Thrift edition but easily found for 99¢. It features key canonical figures in the English

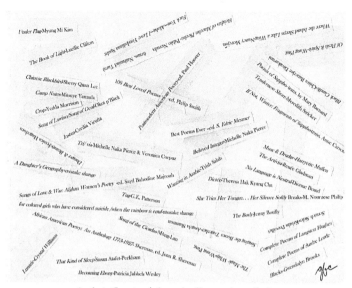

Aesthetic Crossings/photo of collage, author collection

language poetry tradition: Shakespeare, Donne, Milton, Keats, Frost, etc. (It has only 4 women and no people of color, but who's counting.)

The second book is huge, three times the size of the first, long, expensive—$25 new—still canonical (published by Norton) but far more contemporary, "innovative" and experimental. This book offers work by Paul Blackburn, Allen Ginsberg, Alice Notley, Maureen Owen and Amiri Baraka amongst others. For many of my students, both of these books are difficult.

I teach these books together.

When we are working on poetry, students are assigned readings from both books, usually grouped thematically. Here are some examples from the syllabus:

Sept. 5 happy birthday!

"A Birthday"-Christina Rosetti (in class)*..................................BLP 71
"Often I Am Permitted to Return to a Meadow,"....................PAP 36
"Songs of Another"-Robert Duncan.."40
"The Marvelous Land of Inhibitions"-Lorenzo Thomas............"447
"Swallow the Lake"-Clarence Major.."339

Oct. 15 more family poems /poet-in-residence Crystal Williams

Nov. 18 flora & fauna

As you can see, different weeks offer a different balance of different poetic eras and styles. Along with the two core texts, I am also still offering handouts, using whole collections and maximizing class visits from visiting poets.

They are encouraged to read everything—and the best students do—but they are responsible for doing detailed journal entries with "remarks" and "sparks" on two texts of their choice (although texts with asterisks are mandatory).

The journal responses are structured to allow for both the critical and the creative.

Remarks offer commentary on the poem, what the student notices about its form, style, content and impact, how the poem works or doesn't work. (Notice, I don't ask them to summarize what the poem "means.")

Sparks are bits of new writing inspired by the experience of reading the poem. Students don't have to explain why or how they got to the spark. It could have been the poem's theme, a

specific word or something too internal and alchemical to trace. All that matters is that students are catalyzed into new writing. Students often develop these sparks into more polished works that are circulated and discussed in class.

In this way, my students also use writing to build their poetry reading and writing skills at the crossroads of different aesthetic styles—i.e. different linguistic configurations, social locations, poetic occasions and canonical positions.

At and in the aesthetic crossing, students come to grasp and appreciate poetry better overall.

This opens the possibility of new and better relations with many different kinds of poems. They can better configure themselves as poetry readers and writers, prepared and entitled to enter any poetic space—on the page and in the world.

* 5 *

I want to open up new space
for students and for poets and for poetry.
I want new and eclectic audiences.
(I want to not be the only black face in the crowd.)
I want there not to be an only [] at a poetry reading.
I want to help generate readers of poetry
—and not just advocates of a particular style.
I want my students to be fearless and open.
I want them to reckon with the difficulty of poetry,
both relative to aesthetic innovation
and to the claiming and crossing of social locations.
I want to develop and offer strategies
for dynamic, creative poetry reading and teaching.
I want my students to understand
that if they are willing to be open and work hard,
they can receive incredible insight and access
to different worlds of poetry.
I want my students to encounter poetry all together.
I want my students to know that it all belongs to them.

... hewn and forged...

How can books armor and heal us?
How can we read to each other, read each other better?

My 3-hour, durational performance art work "...*hewn and forged...*" explored and activated these questions. Created for the Salt Lake City Performance Art Festival at the downtown City Library on September 30 and October 1, 2016, the work incorporated one hundred de-accessioned books, five thousand pennies, my body and voice as a black feminist performance artist, and the game presence of a family crowd. The work aimed to help me move through heartbreak and honor how books have helped me process grief.

This is my heart. These are my friends.

These lines opened the work and punctuated key performance actions. At the start, I stepped into a giant heart fashioned out of books, outlined with pennies, then invited everyone to choose a book of their own.

Take a friend and make friends with your friend.
Make your friend make friends with the space.
Make friends with other friends.

People pressed books against the windows and chairs, against other books in other people's hands. Then we would play, read aloud, tell stories, strike poses inspired by words on the page, and mouth words in silence.

...hewn and forged... / Photos: N. Rich

Over time, as people continued picking up books, the dull gleam of another heart became perceptible. This was a heart fashioned out of pennies that had been hidden underneath the books. Under the direction of children, we made a river of pennies, a currency of wishes. People walked on this river while others read blessings to them from books.

> *Who here needs a blessing? Come forward. Pick a friend.*
> *A blessing is both a wound and a gift.*
> *Where do you hurt? Place your friend where you hurt.*
> *And we here, place all our power into our friends and*
> *send that energy out to bless and heal.*

For two days, I worked with books for hours, holding them in my hands, making friends with them and with people who held them. The work was improvisation, live happening, and alchemical activation of self and community. By the end, we were hewn from those books and forged together.

"...hewn & forged..." by Julien Blundell

When it began, the slow snake of the bass clarinet rose through a hiss of cymbals. Dancing in wavy extensions of her body, Gabrielle Civil circled a pile of books and pennies in the center of the stage-room. She picked up a book—*Social Sciences*—and, with it caressed to her chest, danced over to the audience and handed it off.

This was the beginning of the lecture-ritual-story-performance (let's call it a presentation, in its traditional and medical references) of Gabrielle Civil's "Against Oblivion" (which is not the title but makes a perfect stand-in for the memory of the evening). Her presentation ranged in modes, from dancing and musical accompaniment, to slide-show images and text, to poetry and ritualized audience participation. Each mode surrounded and elaborated on the first words Civil spoke, placing books down in different corners of the room: "This is my heart. These are my friends."

As the presentation progressed, the conception of the "book" became mythic, came to include in its references the human soul, individuality, and community. Civil made it sacred:

> "A book on the shelf has pinched her finger.
> Diane Duane. A book, the medicine.
> The barrage of names. A spell A spell
> All the things naming can do
> (spreading the pennies blood-copper
> pennies "and it was all blood and it was
> all breaking")
> To defy oblivion — to accept the past and
> transform it. To make that book."

But there was also an offering. So Civil told of her struggle to realize her book (her heart, her friend), and the forces acting against the book were the same as those that act against the liberation of humanity, and more specifically the liberation of African Americans from systematic oppression. Kevin Young's conception of the "Shadow Book" haunted the stage. The

Shadow Book occurs in three manifestations:

1. The Lost Book. What was written and has disappeared.
2. The Removed Book. Censured or lost, parts of this book are missing.
3. The book that was never written. "Books the world didn't want to exist."

For the African-American writer, the Shadow Book often falls within this third category. As life is denied, literature is denied existence. However, the Shadow Book, Civil stressed, is not the failure of the writer. It is the forces of oppression. "It is not your loss. It is a loss for all of us." How do we carry the unwritten, the unbound book of loss, that which incurs, inflicts?: "A blessing is a wound and a gift." Then, as spell, as solidification, the audience was called to name as many reasons as possible that keep a book from existence while Civil tore pages out of a paperback romance picked up from the stage display. The naming took on a physical presence, and scattered about the room lay the pages of "oblivion's shadow." To defy oblivion. To accept the past and transform it. To make that book.

At the heart of the presentation is the mantra: Books save lives. They are a project against oblivion. They are a ritual and an alchemical activation of the unwritten book/soul in you. They are both "a refuge, a possibility."

To conclude the presentation Civil organized a circle in the center of the room, both convocation and invocation. Calling on all of our future books. "It was never about the book, it was about everything."

DROPEVERYTHINGANDREAD

Antígona González – SARA URIBE (TRANS. JOHN PLUECKER)

At a time when the discourse of "bad hombres" and "building a wall" has poisoned US society, Mexican writer Sara Uribe's *Antígona González* emerges as an antidote and prescription. A brilliant meditation on the wages of violence in contemporary Mexican society, the text takes up the classical figure of Antigone to speak out, remember, and reclaim the dead:

> Me llamo Antígona González y busco entre los
> muertos el cadáver de mi hermano.

> My name is Antígona González and I am searching
> among the dead for the corpse of my brother.

Translated with aplomb by John Pluecker, the text arrives in a fine bilingual edition, and was longlisted for the 2017 Best Translated Book Award. Like Claudia Rankine's *Citizen*, *Antígona González* can be read as a lyric essay or series of prose poems and fragments. Originally commissioned by actress and director Sandra Muñoz in 2012 for premiere in northern Mexico, it is also a subtle performance text.

In Sophocles' original play, Antigone seeks a proper burial for her brother Polynices, in defiance of her uncle King Creon's decree. Here, Antígona González (identified as Sandra Muñoz, Sara Uribe, and others) still operates in defiance of the state, but she has no body to bury. Instead, she remembers her brother Tadeo, and this memory must serve as a hedge against oblivion:

> Tadeo... te pienso todos los días, porque a
> veces creo que si te olvido, un solo día bastará para que
> te desvanezcas.

> Tadeo... I think of you every day,
> because sometimes I think if I forget you, just one day

would suffice for you to vanish.

Throughout the text, memory operates as an urgent holding place, a site of both bittersweet nostalgia and urgent personal/political resistance. Ultimately, memory mobilizes action as the individual becomes collective:

Vine a San Fernando a buscar a mi hermano.
Vine a San Fernando a buscar a mi padre.
Vine a San Fernando a buscar a mi marido.
Vine a San Fernando a buscar a mi hijo.
Vine con los demás por los cuerpos de nos nuestros.

I came to San Fernando to search for my brother.
I came to San Fernando to search for my father.
I came to San Fernando to search for my husband.
I came to San Fernando to search for my son.
I came with the others for the bodies of our people.

Working in the style of documentary poetics, Uribe comes to report on an entire landscape of violence. She incorporates language from news bulletins, blogs, e-letters, and first-person accounts to link the personal and systemic and to showcase the lost and found:

Ciudad Altamirano, Guerrero. 22 de abril
encontraron a tres jóvenes
ejecutados, justo en las faldas de un cerro.

Ciudad Altamirano, Guerrero. April 22.
three youths were found
executed at the base of a mountain.

Her project encompasses documentation and reclamation, not just of those lost, but also the people who loved them:

No quería ser una Antígona

 pero me tocó.

> I didn't want to be an Antigone
>
> > but it happened to me.

This powerful sentence appeared posthumously in the journals of Columbian activist Diana Gómez, who also called herself Antígona Gómez. These words demonstrate how the identity of Antigone, truth teller and seeker of justice, is not an aspiration, but a tragic consequence.

The timeliness and timelessness of *Antigone* becomes another facet of Uribe's text. As revealed in a copious notes section, Uribe references famous Latin American productions of the play and weaves in fragments from Judith Butler's *Antigone's Claim: Kinship Between Life and Death*, María Zambrano's *La tumba de Antígona* [*Antigone's Tomb*], Marguerite Yourcenar's *Fires*, and more. In his excellent afterword, Pluecker also discusses his integration of various English translations of *Antigone* to mirror Uribe's praxis.

Pluecker writes: "Translation allows both for difference to continue to exist and for us to work alongside each other as neighbors, people deeply implicated in a shared story." This ethic of recognition and cooperation models the work of the U.S. reader and reinforces the overall message of *Antígona González*:

> No, Tadeo, *yo no he nacido para compartir el odio.* Yo
> lo que deseo es lo imposible: que pare ya la guerra;
> que construyamos juntos, cada quien desde su sitio,
> formas dignas de vivir; y que los corruptos...
> pudieran estar en mis zapatos, en los zapatos de
> todas sus víctimas aunque fuera unos segundos.

> No, Tadeo, *I wasn't born to share in hatred.* What I want
> is the impossible: for the war to stop now; for us--for
> each of us wherever we find ourselves--together to
> build ways to live with dignity; and for the corrupt...
> to be in my shoes, the shoes of
> all their victims, even if only for a few seconds.

May these powerful words be part of our cure, in the United States, in Mexico and beyond.

Touch/ Don't Touch

I'm on my knees, a plump, black woman in black from head to toe, with blue-black lipstick almost kissing the microphone. My thick, black, curly, natural hair is bobby-pinned flat on both sides, leaving my hair Afro fabulous in the front and back. I stick my hair in the face of a smiling, bearded white man in glasses, sitting cross-legged on the floor. *Y'all have heard Solange's "A Place at the Table," right?* Yeah! the crowd screams. *Y'all have heard "Don't Touch My Hair"?* Yeah! *Well, TOUCH MY HAIR.* Gasp. The crowd shifts. What?! *C'mon. Come on. Touch my hair.* I'm bending over and crawling, I'm leaning and entering the white man's space.

Go ahead.
Touch it.
Nervous laughter.
Touch it. Touch it. Touch it.
I'm hissing now in the microphone.
I'm pressing my body flush against his chest.
You know you want to...
He's laughing and squirming. His eyes are closed.
I can almost see the tears forming on the other side of
 his eyelids.
Just doooooo it. Just doooooooooo it.
I'm crooning. My head is almost in his lap.
His body almost vibrates from my presence.
His hands haven't moved.
Nothing else can happen until you touch it. Do it right now.
Finally, the poor guy taps my enticing, fuzzy crown.
HOW DARE YOU!
I scramble away from him and rise to my feet.
YOU TOUCHED MY HAIR?!
The crowd roars.
WHY DID YOU DO THAT?
He mumbles something about white privilege.
You better go back and listen to some Solange.
The performance/ reading continues.

~ * ~

When I took the stage at that bar, an impish frisson of delight tickled through me. Ostensibly a literary reading, with my help, it became something else. I moved the crowd around, pressed my pelvis against the wall in a display of "fat black performance art." Hissing, crawling and confronting the audience felt elicit, mischievous, and wonderful. Bossing, demanding, cajoling, changing my mind, blurring the space between humor and threat, us and them, felt delicious and life-preserving. Who gets to run the space? Who gets to be surprising? Who gets to be bad?

In my early days as a performance artist, I was plagued by the question of who got to do what. As a nice girl, a first-generation middle class black poet, what space did I have for risk, surprise, or perversity? My job was to be smart and well-mannered, and most especially *good*, which is to say follow whatever the rules of blackness said was right. It is this goodness that got me. Performance art liberated me from all that, the scripts that predetermined exactly what was happening or was supposed to happen, exactly what I was supposed to think, say and do, and how both powerless and angry I would feel about it.

This moment, at the AWP Lit Up CCM mega-reading at the Black Squirrel bar in D.C., illustrates one of my favorite aspects of being a black feminist performance artist: the opportunity to shift the balance between what is expected of me—as a plump, dark-skinned, natural haired black woman in America—and what I will actually do.

Touch / Don't Touch/
Photo: Michael Seidlinger

~ * ~

My entire life as a black woman, I have been entangled in hair discourse, folks teasing out the follicles, trying to retwist the locks. How white enslavers categorized black hair grades on charts to purport Negroid inhumanity. How debates raged in the 1960s, pitting "righteous, natural" black women against "boujie, hot-combed" ones. How braids and hair weaves incorporated the synthetic into both Afrocentric and corporate looks.Corn row, conk, press and curl, Jheri curl, French twist, high top fade. This is not an exhaustive list.

In "Self Portrait of the Artist as Ungrateful Black Writer," Saeed Jones brings up this hair anecdote at a toxic, highbrow literary party: "You've grown out your hair," the poet said, the

ice in his cocktail catching light. "Now I'm going to do that racist thing where I touch your hair," he said as he reached for my afro. His fingers tested the texture of my hair, the way you might squeeze a bath sponge." Yes, still this, in 2017. Interesting too, the poet knows that he's not supposed to touch the black man's hair and does it anyway.

Where does such license come from?

To touch a black person's hair without permission, and even to ask to touch it, is sloppy and gauche. This has been true for decades. So, when Phoebe Robinson's book *You Can't Touch My Hair: And Other Things I Still Have to Explain* came out, I groaned. Really in 2017? Really, Solange? We're still talking about this? As racist microaggressions and cluelessness persist along with endemic state violence and systemic oppression, yes, I guess we still have to.

~ * ~

At a performance art workshop in Mexico, a beautiful Afro-Latina college student asked me how I dealt with some of our classmates touching my hair. I asked her if people were coming and touching her hair without her consent and let her know in no uncertain terms that I thought that wasn't cool. She said she knew that and she had been letting them know. But on a personal level, she wanted to know how I *felt* about it.

It was my turn to take a minute and shift. In this workshop, folks had been gazing into each other's eyes, speaking in different languages, getting naked. What did it mean that I had barely noticed people touching my hair? Outside of the US, had I let my guard down? Or had I just taken it as par for the course, a small price to pay for border crossing? Had I felt a special level of trust in that context? Maybe all of the above? Her question sparked guilt at my lack of vigilance. Had I been letting my people down, letting the adversary in? Letting them touch me without penalty? What kind of role model was I being for this young woman? I too had been subjected to blithe, unthinking white people asking to touch my hair and

had felt objectified and angry, thrust into the pernicious choice between being a mammy or killjoy. Do I really think that's okay? Of course not. But at that workshop, I felt great pleasure at being seen and touched, especially when so often in the US I feel bereft and undesirable.

~ * ~

And yet. The perverse craving. Let's change it up. Surprise. Maybe I'm neither the mammy nor the killjoy. Maybe I'm both, a queen and a thot, a poet and a Ph.D. Maybe I can be strong, make you laugh, make you uncomfortable, make you feel ashamed, make you acknowledge your desire. Maybe I am histrionic, enraged, the angry black woman. Maybe I'm a temptress, a succubus. Maybe I contain multitudes. Maybe I'm your next girlfriend. Maybe I'm just messing with you because I can. Maybe sometimes I do want it. Maybe I do want your hands on my body, but I want to control it. Maybe I don't want to be scripted. Maybe I don't want anyone to tell me what the hell to do or how to feel. Maybe under white supremacy, I can't take that too far. Maybe it still bounces back, my armor, an aura of power and protection. Maybe this is breaking the frame. Or trying to. Maybe this is the balance of black feminist performance art, tipping the scales of identity, history and art.

playlist

Are your hearts open?

Are you clearing the path?

Where is this happening?

Is it easy to find?

Are there ramps for wheel chairs?

What are the on-ramps to this experience?

Who are your guides?

What are your questions?

What are you working with? Why?

Are you grounded?

Are you asking folks to sit on the ground?

Are there chairs for folks who might need them?

Does the bus line go there?

Is sound amplified?

Is there on-site interpretation?

Are you listening to each other?

Are your ears to the ground?

Who do you want to be there? Why?

How are you inviting them?

For real, what's the invitation?

What's the access? What's the candy?

Why should they stay?

What world are you building?

How are you transmitting information?

Are elders welcome?

Can kids come?

If so, what should parents know?

Is childcare available?

Are you offering a sliding scale?

Are you getting paid? If so, from whom?

Is there fair division of labor?

Who is in charge of what?

Are there touchstones to hold?

Is there designated space to catch your breath?

Are you drinking enough water?

Are there appropriate bathrooms?

Is WIFI available?

What's the passcode?

Where are your objects?

Have you spent time handling them?

Do you know how you'll activate them?

Do you have a program?
Is it printed (with some in large font)
or projected or recorded?

What's the pre-show music?

Who's greeting folks at the door?

Do you have an exit plan for when it's over?

Who is holding your energy?

Are you holding each other's energy?

Are you excited? a little scared, but exhilarated?

Do you take a moment each night
to look at each other and breathe together?

Do you run through the whole thing
at top speed just to feel the flow?

Do you allow for disagreement?

Do you have ways to work it out?

Do you make up ways to play?

Did you remember thank you notes and gifts?

Are you ready to experiment?

Are you open to joy?

Experiments in Joy

A SWERVE
A Decade Old Apology-Jane Blocker. Re: A Decade Old Apology

SHAPESHIFTING
Opening Up Space for Global Black Girls—with Zetta Elliott.
Discipline and Knowledge: Teaching at a Maximum-Security Prison

~~BLACK OUT~~ ██████████——**fall out**. Black Swans
(meditations on ballet). Behind the Orange Door—with Rosamond
S. King. Book Review: *"The Great Camouflage: Writings of Dissent
(1941-1945)*-Suzanne Césaire. Introducing Rita Dove

FLASHBACKS
Hyperbolic—(No. 1. Gold) with Madhu H. Kaza & Rosamond S. King

VANISHING ROOMS
* a n e m o n e . What's Happening in There-Sarah Hollows.
Girls in Their Bedrooms—(From the Hive)—with Ellen Marie
Hinchcliffe. From the Hive —with Ellen Marie Hinchcliffe. Ghostly
Gesture & Erotic Crackle—with Sun Yung Shin. (_____)
Doesn't Know (_____) Own Beauty (or *Vanishing Rooms*)—
with Moe Lionel. photo collage from and then... Bear Witness
to QTPOC Brilliance on *Queer & Trans Artists of Color Volume 2*:
Interviews by Nia King, ed. Elena Rose

CALL & RESPONSE
Call & Response: Experiments in Joy. The Call for Experiments in
Joy—(Call & Response Ensemble)—with Duriel E. Harris, Kenyatta
A. C. Hinkle, Rosamond S. King, Wura-Natasha Ogunji, Miré
Regulus & Awilda Rodríguez Lora. Experiments in Joy: Intersecting
Blackness. "_____ is the thing with feathers"

BREAKING THE FRAME
Dear Miss Lily. Hand Written Notes... they came in shimmying...
Breaking the Frame. Activation (A Sign in Space). Aesthetic Crossings
...hewn and forged... hewn & forged... by Julien Blundell. Book

Review: *Antígona González* by Sara Uribe. Touch / Don't Touch

PLAYLIST
Performance Checklist. Table of Contents. Production History. Publications. 10 Books for X in J. Acknowledgments & Thanks

Production History
Hyperbolic with Madhu H. Kaza & Rosamond S. King (No. 1. Gold), American Living Room Festival, HERE, New York, NY, August 2002

"Anacaona," by Gabrielle Civil & "..." by Rosamond. S. King in *hipotéticas*, a performance art event, *detrás de la puerta china*, University of Puerto Rico, Río Piedras, Puerto Rico, July 2003

"Sucking Teeth" with Rosamond S. King (3 min. short), premiered at R. S.V. P: work / play / process), No. 1. Gold event, Center for Independent Artists, Minneapolis, MN, Jan. 2006 and included in "New World Creole: Latin American Film Shorts" (curated by Juan Caceres), Labotanica Art Space, April 2010

"Introducing Rita Dove" introduction delivered for Rita Dove at her reading as the Inaugural Bonnie Jean Kelly & Joan Kelly Distinguished Scholar-In-Residence, St. Catherine University, O'Shaughnessy Auditorium, March 4, 2009

"From the Hive," with Ellen Marie Hinchcliffe, Bedlam TenFest, Capri Theater, Minneapolis, MN, May 2011

BLACK OUT WHITE WASH ——**fall out**. premiered as a performance lecture in the Violence & Community Symposium at the Jack Kerouac School of Disembodied Poetics at Naropa University, organized by Bhanu Kapil & Michelle Naka Pierce, May 2012.

"* a n e m o n e," Pleasure Rebel series, curated by Nastalie Bogira, Bryant-Lake Bowl Theater, Minneapolis, MN, May 2012

"____ doesn't know____ own beauty" with Moe Lionel, Fish House Studio, St. Paul, MN, July 2012

"and then..." featuring Nicolas Daily, Currencies performance event, Herndon Gallery, Antioch College, Feb. 2014

"Girls in their Bedrooms: installations, video & performance,"
From the Hive, with Ellen Marie Hinchcliffe, PoppyCock ArtSpace,
Minneapolis, MN, May 2014

"Say My Name" (an action for 270 abducted Nigerian Girls),"
premiered at Girls in their Bedrooms, Minneapolis, MN, May 2014,
reprised at Antioch College, Call & Response, July 2014
and many times since around the world

"Call & Response," a dynamic of Black Women & Performance,
curated and organized by Gabrielle Civil featuring Gabrielle Civil,
Duriel E. Harris, Kenyatta A.C. Hinkle, Rosamond S. King, Wura-
Natasha Ogunji, Miré Regulus and Awilda Rodríguez Lora, Antioch
College, Yellow Springs, OH, July & August 2014

"_____ is the thing with feathers," Call & Response, a dynamic
of black women and performance, Antioch College, Yellow Springs,
OH, August 2014

"... hewn & forged..." site-specific action, Salt Lake City
Performance Art Festival, Featured Performer, Salt Lake City, UT,
September-October 2016

"... hewn & forged... (Alchemical Activation against the Shadow
Book)," Jack Kerouac School of Disembodied Poetics, Visiting
Writer Series, Naropa University, Boulder, CO, Oct. 2016

"Experiments in Joy: Intersecting Blackness...", Keynote Address,
Black Intersections: Resistance, Pride & Liberation conference,
Claremont Colleges, Claremont, CA, April 2017

Publications
"Opening Up Space for Global Black Girls: A Dialogue between
Gabrielle Civil & Zetta Elliott," Departures in Critical Qualitative
Research Special Issue: Saving Our Lives, Hear Our Truths:
Exploring the Theory, Praxis, and Creativity of Black Girlhood
Studies," Fall 2017

"Discipline & Punish: On Teaching in a Maximum-Security Prison,"
Colleagues, St. Catherine University, Winter 2012

BLACK OUT WHITE WASH fall out, Something on Paper,
Journal of the Jack Kerouac School of Disembodied Poetics,
Inaugural Issue, Winter 2013

Black Swans (meditations on ballet), *Dancing While Black*, inaugural issue, Winter 2019

"Behind the Orange Door—Gabrielle Civil & Rosamond S. King in Collaboration," with Rosamond S. King, *Small Axe* 52, Caribbean Women Artists Special Issue, vol. 21, no. 1, March 2017

"The Great Camouflage: Writings of Dissent (1941-1945)"-Suzanne Césaire," book review, *Rain Taxi*, Vol. 18, No.1, (#69), Spring 2013

* a n e m o n e, *MAI: Journal of Feminism and Visual Culture,* Issue 2: Sexualities, Fall 2018

"Something's Going on in There" by Sarah Hollows, reprinted from *"Girls in Their Bedrooms:* Creativity in Intimate Spaces" issue, *Aster(ix) Journal*, Spring 2015

"Girls in Their Bedrooms" originally published as "From the Hive: A Conversation," with Ellen Marie Hinchcliffe, *"Girls in Their Bedrooms:* Creativity in Intimate Spaces" issue, *Aster(ix) Journal*, Spring 2015

"Gabrielle Civil: Ghostly Gestures And Erotic Crackle" in *This Spectral Evidence* by Sun Yung Shin, June 21, 2012 thisspectralevidence.wordpress.com/category/gabrielle-civil/

"Bear Witness to QTPOC Brilliance," book review of *Queer & Trans Artists of Color, Volume 2* interviews by Nia King, ed. Elena Rose, *Aster(ix)*, June 2017

"Call & Response: Experiments in Joy: An Introduction," *Obsidian: Literature & Arts in the African Diaspora*, volume 41.1-2, March 2016

The Call for Experiments in Joy, Call & Response ensemble, *Obsidian: Literature & Arts in the African Diaspora*, volume 41.1-2, March 2016

"_____ is the thing with feathers," *Obsidian: Literature & Arts in the African Diaspora*, volume 41.1-2, March 2016

"hand written note(s): before & beyond," 2016 Movement Research Festival Blog, July 2016

"they came in shimmying..." a reminder of ancestors in *Walk Towards It: An anthology of urgent writing, lists to remember, love letters to carry with you for inauguration day January 20th, 2017 and beyond.* ed. Ellen Marie

Hinchcliffe, From the Hive dissemination, January 2017

"Breaking the Frame" as "Remedios: Breaking the Frame: Dreaming into the Urgent Now," *Aster(ix)* on-line, Jan. 2017

".... hewn and forged..." *Emergency Index Vol. 6.*, ed. Sophia Cleary, Katie Gaydos and Yelena Gluzman, Brooklyn, NY: Ugly Duckling Presse, 2017

"... hewn and forged..." (lecture performance video), *Something on Paper*, Issue 5, 2018. somethingonpaper.org/issue-5/civil/

... hewn & forged...-Julien Blundell reprinted from the Jack Kerouac School of Disembodied Poetics at Naropa University Blog, November 3, 2016

"Antígona González"-Sara Uribe (trans. John Pluecker)," *Rain Taxi*, on-line edition, November 2017

"Aesthetic Crossings ," *The Difficulty with Poetry: Opacity and Implication in the New and Old*, 2016 Bard Poetry Conference Anthology, Bard College, April 2016

"Hyperbolic," Rosamond S. King, Gabrielle Civil, & Madhu H. Kaza, *BathHouse Journal*, Issue 17 Collaborations, Winter 2018

"Touch/ Don't Touch," *Art 21*, Balance Issue, guest editor Lewis Wallace, April 2017

10 Books with Psychic & Heartfelt Connections and / or Inspiring Impact on the Book You Are Reading Right Now

A House of My Own by Sandra Cisneros
Create Dangerously by Edwidge Danticat
How Phenomena Appear to Unfold by Leslie Scalapino
Uncollected Texts by Carolee Schneeman
Museum by Rita Dove
Life Doesn't Frighten Me poem by Maya Angelou,
with illustrations by Jean-Michel Basquiat
Uneasy Dancer by Betye Saar
Something about the Conditions for a Good Collaboration by Giancarlo Norese
Eiko & Koma: Time Is Not Even, Space Is Not Empty ed. Joan Rothfuss
Out of Order, Out of Sight, volumes I & II by Adrian Piper

Notes

The letters in "Opening Up Space for Global Black Girls" were conceptualized and written in Brooklyn, NY, Boston, MA, South Hadley, MA, Miami, FL, Port-of-Spain, Trinidad, Detroit, MI, and Yellow Springs, OH between February and March 2016. The authors thank the editors of the *DCQR* special issue on Black Girlhood Studies, Chamara Jewel Kwakye, Dominique C. Hill, and Durrell M. Callier, for creating the occasion to have this dialogue.

The prison mentioned in "Discipline & Punish: On Teaching in a Maximum Security Prison," was Eastern Maximum Security Correctional Facility in Napanoch, NY. There I taught Language & Thinking in the Bard Prison Initiative in Summer 2011. It was an honor to teach those brilliant students. May they continue to radiate power and gain liberation. To donate to BPI, go to: bpi.bard.edu/support/

(The summer Madhu and I taught for BPI at nearby prisons, we roomed together in a small cottage in upstate New York. One day, a massive storm hit that to flood the entire Hudson River valley and we had to take cover with others in our small cabin community. I promised myself that if we got through the storm--i.e. if we didn't die--I would get an artist studio. That was the start of the Fish House Studio, where I built * a n e m o n e, where Ellen Marie

Hinchcliffe launched her book *Fierce Shimmer*, where Moe Lionel and I created, rehearsed and performed *Vanishing Rooms* (and had sex more than once), and where I finished my book *Swallow the Fish*. I loved that place so much.)

"Behind the Orange Door" mentions my performance *Anacaona*, a work grounded in my Caribbean heritage. More writing about this work along with its performance text can be found in *Sargasso: Journal of Caribbean Theater and Performance*, Special Issue 2004-2005. I removed this writing, along with commentary about *"whisper* (the index of suns)," another important early work, from the original manuscript of *Swallow the Fish* to wrangle the page count. I remain deeply haunted by this self-inflicted excision. My next books, translating Haitian poet Jacqueline Beaugé-Rosier and addressing my performance art in the Caribbean and Africa will flesh out this part of my art/life/work. I promise.

"Girls in Their Bedrooms" was the subject of a special issue of *Aster(ix)* in Spring 2015, guest-edited by me and Ellen Marie Hinchcliffe. This volume includes documentation and texts by other artists at the event.

Collaborative writing with Moe Lionel about our performance "____ doesn't know____ own beauty" was originally compiled to submit for the *TSQ* special issue related to blackness. Our submission was rejected.

Call & Response" was the subject of a special issue of *Obsidian: Literature & Arts in the African Diaspora*, volume 41.1-2, March 2016, guest-edited by me. This volume includes documentation and texts by other Call & Response artists as well as submitted work inspired by the Call for Experiments in Joy.

To see members of the Call & Response ensemble discuss Experiments in Joy at the Network of Ensemble Theaters May 2016 conference, you can go to: www.youtube.com/watch?v=k-vzG4KVdpA. For more discussion of the project, check out: "The Experiment: Master Class at Naropa University," *Something on Paper*, Issue 5, 2018. somthingonpaper.org/issue-5/investigations-civil/

You can also see Duriel E. Harris' writing on the project on the Poetry Foundation's Harriet Blog at poetry foundation.org/

harriet/2016/08/serious-play/ and catch Awilda Rodríguez Lora's joyful experiments at #*Bailartodoslosdias* on Instagram.

The repurposing of Donald Rumsfeld's "known knowns" was introduced to me in "Making is Thinking: Lightning Rod Special & Haverford College," a workshop conducted by John Muse and Mason Rosenthal at the Network of Ensemble Theaters: Intersection // ensembles + universities conference, Chicago, IL, May 2016. The conceptual connection to the Haitian vèvè and the Bakongo cosmogram is my own.

"Dear Miss Lily" was written during the first Solina writing residency with Lewis Wallace at Mac's Acres in Blythewood, South Carolina in August 2017 right before the solar eclipse.

"The formulation "11/9" in *they came in shimmying* was inspired by Carlton Turner's use of it in his opening plenary keynote "Art, Truth & Healing: Practicing Radical Love" at the USDAC conference Culture / Shift in 2016.

The score "Breaking the Frame" emerged from an Open Space Technology session facilitated by Adam Horowitz at the end of the USDAC conference Culture/ Shift in 2016.

Images from *"...hewn and forged..."* appeared in "Write It in Fire: Tributes to Michelle Cliff," special on-line section of *Love | Hope | Community: Sexualities and Social Justice in the Caribbean,* a joint project of Caribbean IRN (International Resource Network) and *Sargasso: Journal of Caribbean Literature, Language, and Culture, April 2017.*

This book is a performance. This book is an archive. This book is an underground mixtape. Part of an evolving chronicle of performance body, it features the presence of many brilliant people: writers, performers, dancers, poets, artists. Look them up and be dazzled by their greatness.

Acknowledgments & Thanks

Thanks to all my family, friends, teachers, students, and collaborators and to all of the editors of all the journals who published prior versions of these texts.

To St. Catherine University, Bard Prison Initiative, Antioch College, Naropa University, Denison University, and the California Institute for the Arts for employment and undergirding support.

To Josina Manu Maltzman, Eleanor Savage, Amy Hamlin, and Mankwe Ndosi for friendship and art/ life in the Twin Cities.

To Rafael Cervantes & Dina Gavrilos, Sharon Doherty & Therese Cain, David Naugle & Ty Neal (star of the Vanishing Rooms video) for being wonderful couples and wonderful people in Minnesota.

To Purvi Shah, Eléna Rivera and lily bo shapiro for love and hospitality in New York City.

To Jeremy Braddock and Ira Dworkin for staying rad and staying in touch.

To Catron Booker for keeping the candle burning in Mexico.

To Barak adé Soleil for modeling artistic strength and ferocity.

To Michael Abdou, Greg Bullard, and Eric Leigh for good company and old time's sake.

To Michelle Naka Pierce, J'Lyn Chapman, and Bhanu Kapil for great opportunities at Naropa.

To Paloma Glover, Anna Martine Whitehead, Syniva Whitney & nyx zierhut for being rad black movers and for dancing with me. To Ni'Ja Whitson for blessing me with sage.

To Stacy Szymaszek and Miguel Gutierrez for a magical evening at the St. Mark's Poetry Project.

To Sarah Hollows & Kris Mason for No-$uch-Goods, a performance house party in New Orleans.

To Aisha Sabatini Sloan, Hannah Ensor, Donald Harrison, and Laura Edith Sutherland in Michigan.

To Tisa Bryant, Allison Yasukawa, Douglas Kearney, and Andrea Fontenot for the warm CalArts welcome.

To Eva Yaa Santewaa and Thomas DeFrantz for feedback on "Black Swans."

To Mark Roosevelt for saying yes to Call & Response. To Nicolas Daily and Kevin McGruder for being the Call & Response street team. To Michael Casselli for deep tech and Jocelyn Robinson for the hot tub.

To Lewis Wallace, Sam Worley, Raewyn Martyn, Deanne Bell, Emily Steinmetz, Louise Smith, and Charles Fairbanks for kindness, hijinks, and cheap beer in the cornfields.

To Vernetta Willett for raising us up with amazing voice and spirit at the Experiments in Joy Festival. Rest in Power. You will be missed.

To Tom Manley for keeping it going and to the Antioch Class of 2018 for allowing me to bring Experiments in Joy to their commencement.

To the amazing Antioch students in Black Women & Performance: Ciana Ayenu, Sam Benac, Hannah Craig, IdaLease Cummings, Jane Foreman, Amelia Gonzalez, and Avigail Najjar and the performance majors: Seán Allen, Cole Gentry, Selena Loomis-Amrhein, and Fleet Simons. We cracked open worlds.

To Nastalie Bogira, Kristina Lenzi, Dennie Eagleson, Nicolas Daily, Michelle Naka Pierce, and Lewis Wallace for soliciting my work and including me in their art schemes.

To Cody Knacke for his transcription of the "Experiments in Joy: Intersecting Blackness" keynote.

Special Thanks to the collaborators featured in this book: the magical Ellen Marie Hinchcliffe (From the Hive forever!); Duriel E. Harris, Kenyatta A.C. Hinkle, Rosamond S. King, Wura-Natasha Ogunji, Miré Regulus, and Awilda Rodríguez Lora (the brilliant ensemble of Call & Response); my original playmates Madhu H. Kaza and Rosamond. S. King (No 1. Gold); Moe Lionel (for love, friendship, and willingness to process); Zetta Elliott (for being my writing role model); Sun Yung Shin (for welcoming ghosts); and Stephen Houldsworth (for radical creative thinking on the fly).

To Jane Blocker for her generosity and her magical reply.

To Sarah Hollows & Julien Blundell for sharing their reflections.

To Wah-Ming Chang for her smart insights about typeface.

To Sayge Carroll & N. Rich for their lovely photos.

To Dennie Eagleson for gorgeous pictures, James Brown, and always being my pal.

To Rachel Moritz and Heather Christle for indispensable comments on earlier drafts of this book.

To the great Margo Jefferson, Mendi + Keith Obadike, and Anna Joy Springer for the blurbs.

To my CCM squad, the Accomplices, and especially Janice Lee who is my art angel goddess.

In memory of Maya Angelou.

In memory of Prince Rogers Nelson.

In memory of ntozake shange.

In memory of my four grandparents, my four godparents, and my maternal aunt and uncle.

To God, my family, André Civil & Kate Frances Smith Civil, my sister Yolaine, my godfamily, especially my godsister Kathryn B. Jones (whose hearty reading made my own heart swell); and to little Gabby who dreamed this all up. I hope to make her proud.

repeat

GABRIELLE CIVIL is a black feminist performance artist, originally from Detroit, MI. She has premiered fifty original solo and collaborative performance works around the world. Signature themes included race, body, art, politics, grief, and desire. Since 2014, she has been performing "Say My Name" (an action for 270 abducted Nigerian girls)" as an act of embodied remembering. She is the author of *Swallow the Fish* and *Tourist Art* (with Vladimir Cybil Charlier). She currently teaches Creative Writing and Critical Studies at the California Institute of the Arts. The aim of her work is to open up space.

OFFICIAL

THE**ACCOMPLICES**

GET OUT OF JAIL
✳ VOUCHER ✳

- -

Tear this out.
Skip that social event.
It's okay.
You don't have to go if you don't want to. Pick up
the book you just bought. Open to the first page.
You'll thank us by the third paragraph.

If friends ask why you were a no-show, show them
this voucher.
You'll be fine.

- -

We're thriving.